STATE OF THE BLUES

INTRODUCTION BY WILLIAM FERRIS

STATE OF THE BLUES

JEFF DUNAS

PREFACE BY JOHN LEE HOOKER

APERTURE

APERTURE GRATEFULLY ACKNOWLEDGES
THE COMMITMENT AND SUPPORT OF
THE HOUSE OF BLUES
WHICH MADE THIS PUBLICATION POSSIBLE.

THIS PUBLICATION ACCOMPANIES AN EXHIBITION OF "STATE OF THE BLUES,"
PRODUCED BY THE APERTURE FOUNDATION
WITH THE GENEROUS SUPPORT OF THE
DELTA BLUES MUSEUM, CLARKSDALE, MISSISSIPPI.

FOR McKINLEY, SAM, RILEY, ROBERT, PETER, LONNIE, GEORGE, CHESTER, ELMORE, JOHN LEE, AARON,
JIMMY, BUKKA, AND ALL THE OTHERS WHO HAVE GIVEN ME SO MUCH HAPPINESS FOR SO MANY YEARS.
FOR WOLFMAN JACK, WHO TURNED ME ON TO THE BLUES. FOR NIGEL AND GARY. —J.D.

CONTENTS STATE OF THE BLUES

Opposite: *B. B.'s Corner, 2nd and Court*, Indianola, Mississippi

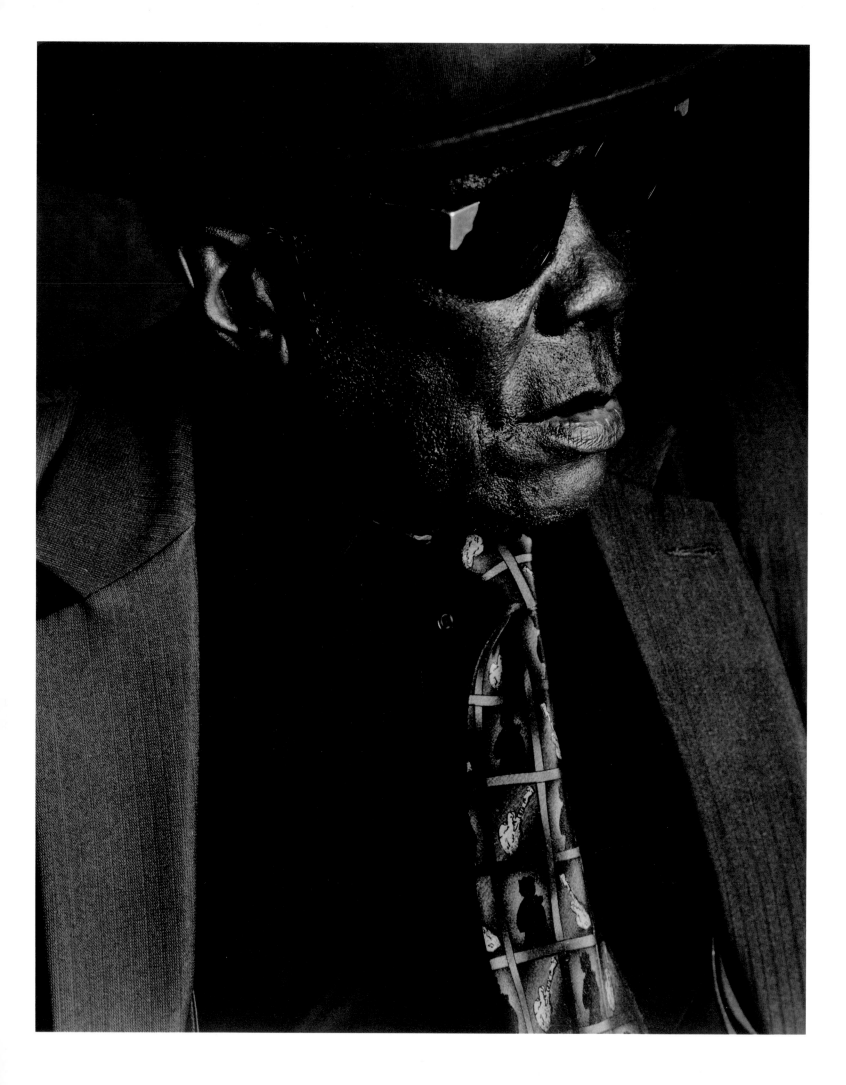

DB1

CE *John Lee Hooker*

a famous musician when I was a young man.

nna be a famous young man, and it happened.

py roads after that, but the road smoothed out.

us. I was scuffling on the farm in Mississippi,

ooth roads, though it took a while. When I was

blues wasn't big. As far as influences, Charley

on the Victrola. I would go wild. And my stepfa-

st influence on me. Blind Lemon Jefferson was

a lot too.

eryone was going up north, and they was mixing,

ity. I wasn't getting anywhere in Mississippi. I was

fourteen or fifteen years old, something like that. I ran away because they wouldn't

let me go otherwise. I had to do that or no one would ever have heard of me. I'd be

old in Mississippi and no one would have heard of me.

When I left home first I went to Memphis, but I wasn't there too long. Beale

Street was jumping hard—that was really the street for the black people having

parties. I worked at the New Daisy for a while as an usher. I used to play around

the house but wasn't anyone listening too much. I just played at house parties, no

clubs. I stayed there around six to eight months, maybe longer.

I went to Cincinnati. That was the next big town. It was across the Mason-Dixon line, and people could mix together. I worked at the Phillips Tank & Pump Company. I didn't do any professional playing there. Just at the place I was staying. A woman named Mom ran the place. I stayed in Cincinnati around a year and a half, maybe two.

Then I heard all this work was going on in Detroit, so I went there. That's where I grew up. Got real famous there with my song "Boogie Chillen."

As far as getting my start, in Detroit Elmer Barbee put me on the right track. And my stepfather Will Moore was it. He's the one that taught me how to play the guitar, him and Tony Hollins. My stepfather, what he showed me became "Boogie Chillen." I came into Detroit with it, played on that beat. I kept it up, put the lyrics together, and recorded it, and that was my big break and I didn't look back.

My first guitar was a Stella. My stepfather gave it to me and that's the guitar I left home with. He had two or three, so he gave me one to bang on and play. Played it for a few years, but when I got up to Detroit it got away from me. Never did record with it, but that's the one I played on. Then my first electric T-Bone [Walker] gave me.

In Detroit, I played at some bars, the Apex Bar on Russell Street, and the Town Bar on Grand Ripple. I was discovered at the Apex Bar by Elmer Barbee. He took me to Bernard Bessman and that's when I first got recorded. I'd already written "Hobo Blues" and "Boogie Chillen" and "When My First Wife Left Me." We went to him with a blank tape. He listened to my songs and then recorded me.

After me and my wife broke up, she took the house and one of the cars and I drove

out to California. I've lived in the San Francisco area ever since. There's a great music scene here. Music all around me. I really like that.

When I first started out it was in all-black nightclubs. I never played in a white club. Then whites started driftin' in, just a few. The whites liked the music, but things were segregated. Now it's mainly white audiences—there's hardly any blacks around. They like the rap music. Sometimes you get older blacks. To me, it doesn't bother me at all. I'm playing for the people, I'm not playing for the color. Most young blacks are into rap, funk, rock—not the blues. I'd like to teach 'em, the music is for all people.

Nowadays I listen to blues, good blues, good funk, slow blues, and up-tempo funk. Stevie Ray Vaughan was my young hero. He was special in the younger generation. Albert King, Little Walter, Muddy Waters, Robert Cray, Bonnie Raitt, on and on. I listen to John Lee Hooker a lot too, but I listen to all of them. I'm working on a new song now called "Supergroupie." There's a lot of them around, you know.

The blues is the roots of all music. It's the roots. Every other song has got some blues in it, 'cause blues is the roots of everything. Blues has been here since the world was born. Once there was women and men loving each other and breaking up, that's the blues. People heartaches, aches and pains, trouble and disappointment, money, no money, down-and-out, that causes the blues, and that affects everybody of every color, rich and poor.

The blues has got more message than anything else. It's more flashy now, but it's the same thing as before. It's come down low and come back up, but it'll never die. Now the whole world digs it.

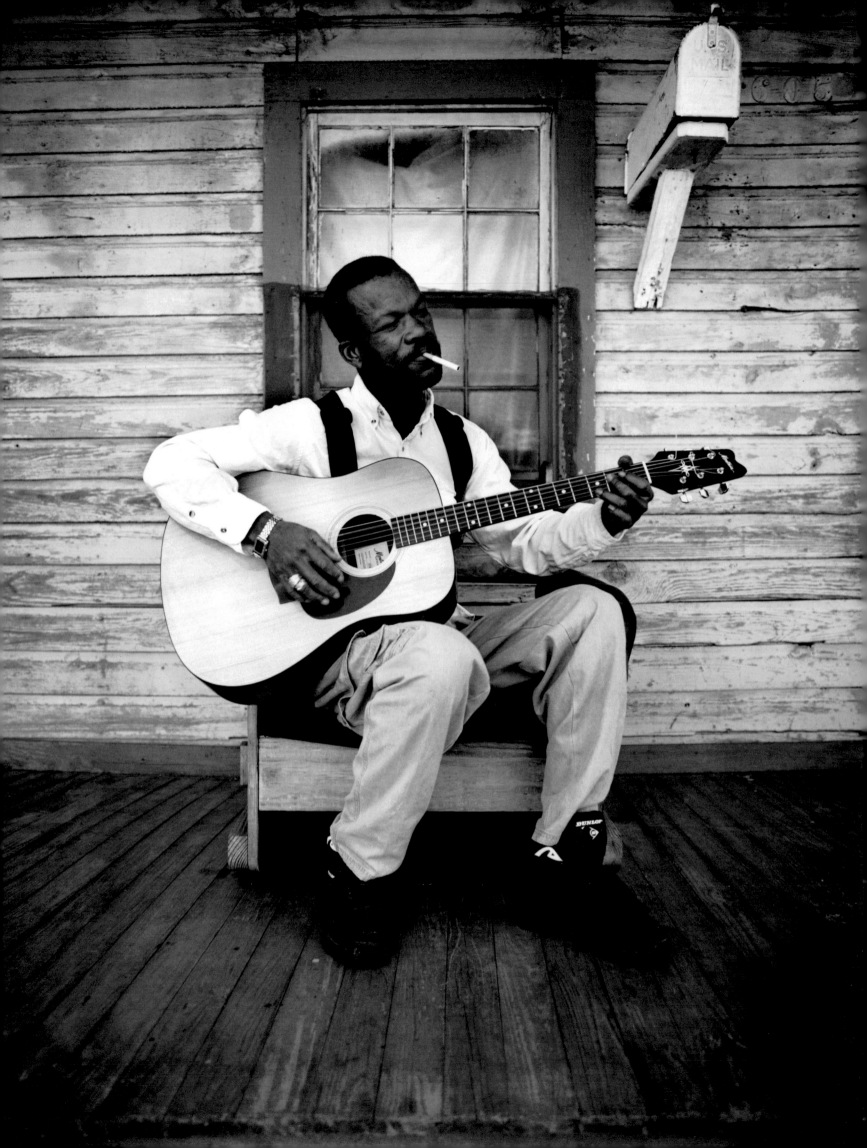

A INTRODUCTION *William Ferris*

s the millennium approaches, we might reflect on how American culture has unfolded over the past century. Of our political, our cultural, our personal worlds, what will be remembered? What will endure into the next century?

Surely no star will burn more brightly than the blues, a music that is truly a metaphor for the twentieth century. Blues artists chronicle the long, difficult journey traveled by blacks, and the familiar, plaintive sound of their music summons powerful memories for all Americans and for blues enthusiasts around the world.

Blues emerged as a distinct musical form in the American South toward the end of the nineteenth century. With roots both in sacred hymns and spirituals and in secular work chants and field hollers, blues artists celebrated the new freedom of blacks as musicians, like Huddie "Leadbelly" Ledbetter, who sang, "If anybody asks you who made up this song, tell 'em it was Huddie Ledbetter, done been here and gone."

Just as African musical performers known as "griots" recalled their history through music, blues artists in the American South captured the lives of their people with songs that forever shaped our nation's musical heritage. Blues bard Charley Patton chronicled historical events like the great flood of 1927 through verses that demonstrated a mastery of the oral tradition which might be compared with William Faulkner's literary achievement.

Early in this century, blues appeared throughout the South in states as diverse as Virginia, the Carolinas, Georgia, Alabama, Mississippi, Louisiana, Arkansas, Tennessee, and Texas. In each state, performers developed distinctive vocal and instrumental styles that allow the listener to distinguish between Piedmont and Mississippi Delta blues sounds.

Within the American South, the Mississippi Delta is viewed by many as the birthplace of the blues. Historian James Cobb calls the Delta's starkly rural landscape "the most southern place on earth." Like life evolving from the bowels of the ocean, the Mississippi Delta produced a powerful, haunting blues sound. As surely as the Mississippi River's powerful current has flowed along the western edge of the Delta, generation after generation of Delta blues artists have shaped the music. Their diverse, turgid sounds fascinate composers, writers, folklorists, and photographers, all of whom recognize the power of Delta blues and try to capture its worlds for their own audiences.

Early in this century, composer and performer W. C. Handy encountered the blues while performing with his band in the Mississippi Delta. In the small community of Tutwiler, Mississippi, Handy overheard a lone singer playing his guitar in the traditional Delta "bottle neck" style with open tuning. As he ran the blade of his knife along the guitar strings, the musician sang, "Goin' where the Southern crosses the Dog." Handy was haunted by the memory of the musician and later paid tribute to him through his composition "Yellow Dog Blues." Known as the "Father of the Blues," Handy was the first to compose blues lyrics, and his work inspired Harlem Renaissance poet Langston Hughes and other writers who developed blues as a poetic form.

The Mississippi Delta is home to both historic and mythic worlds associated with the blues. According to legend, Robert Johnson made a Faustian pact with the

Opposite: *Raymond "Pat" Thomas*, Leland, Mississippi

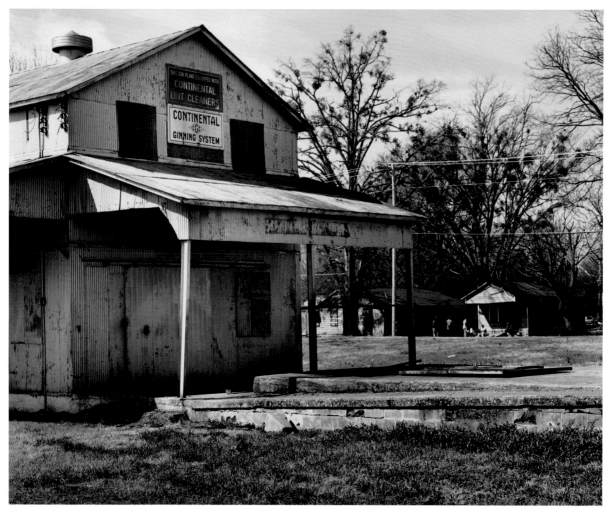

Continental Ginning System, River Fork, Mississippi

Devil at a celebrated crossroads in the Delta. In exchange for Johnson's soul, the Devil gave him supernatural powers as the greatest living blues musician. Johnson's haunting lyrics with their references to hellhounds on his trail allude to both the demonic world and the world of slavery that inspired his music.

Bessie Smith met her tragic death at perhaps the most celebrated musical crossroads in the Delta—Clarksdale, Mississippi. Fatally injured in a car accident on Highway 61, Smith was allegedly turned away from the emergency room of a local white hospital because she was black. She later bled to death in a black hotel, and her sad story inspired Edward Albee's *The Death of Bessie Smith*, a dramatic tribute to the Empress of the Blues. Clarksdale is also the setting of Tennessee Williams's *Cat on a Hot Tin Roof*, in which black field hands sing blues in the back-

ground as Big Daddy and his son Brick struggle with their family in a plantation home that overlooks 23,000 acres of "the richest land west of the Nile."

Throughout the twentieth century, the Delta's rich blues tradition has attracted generations of folklorists. In the 1940s, the father-and-son team John and Alan Lomax recorded work chants and blues as they were performed by inmates at Parchman Penitentiary. In *Adventures of a Ballad Hunter*, John Lomax recalled how prisoners at Parchman skillfully swung their sharp axes above their heads as they worked to the rhythms of work chants. Housed in the Library of Congress, these recordings are a powerful reminder of the Delta's rich blues tradition. Alan Lomax's recent book *The Land Where the Blues Began* is a moving account of these early recordings and the musicians that he and his father immortalized.

More recent recordings by folklorist David Evans explore African musical influences on fife-and-drum bands and one-strand, "diddley-bow" performers, both of whom influenced blues. Using his extensive interviews with musicians, Evans explains how blues performers compose their verses.

Since the 1960s, folklorist Worth Long has worked closely with Delta blues artists. With Alan Lomax, he featured both blues performers and work chant callers in the award-winning film *Land Where the Blues Began.* Long also helped develop the annual Delta Blues Festival in Greenville, Mississippi, and has traveled with blues artists to other festivals throughout the South and to the Smithsonian Festival on the Mall.

Generations of photographers have captured Delta blues artists and their worlds over the years. Farm Security Administration photographers like Russell Lee preserved historic scenes of Delta dancers and musicians that are housed in the Library of Congress. During the sixties, two photographers, William Eggleston and Alain Desvergnes, from Mississippi and France, respectively, photographed Mississippi Fred McDowell and his world in the Gravel Springs community near Senatobia. Their stark black-and-white images are part of a large, celebrated body of work that has inspired generations of younger photographers.

During the seventies and eighties, Roland Freeman and Robert Jones did important photographic studies of blues artists in the Delta. Freeman's portraits of Lonnie Holly from Lexington, with his one-string guitar, have been widely exhibited and published. Robert Jones photographed Delta musicians in their homes and on stage at the Delta Blues Festival. Jones also did important photographic studies of the all-black Delta town of Mound Bayou.

And more recently, Birney Imes published vivid color images of blues juke joints in his book *Juke Joints*. These images capture the colorful, hand-painted signs and murals on the walls of small buildings where blues is performed and suggest how the music is framed by its own art.

During the past two decades, blues festivals in the Delta have become significant institutions for blues in the region. The Delta Blues Festival in Greenville, the Sunflower River Blues Festival in Clarksdale, the Robert Johnson Festival in Greenwood, and the B. B. King Blues Festival in Indianola are annual events that celebrate local artists and their music for audiences that sometimes number more than 50,000.

For over three decades the Delta Blues Museum in Clarksdale has featured exhibits, library resources, and public lectures and performances on the blues. The Museum and the city of Clarksdale are currently developing a performance center that will feature blues artists on a regular basis.

At the University of Mississippi, *Living Blues*, the nation's oldest blues magazine, is published bimonthly with regular features on Delta blues artists. The University's Blues Archives is the finest research collection available on the music. Featuring the personal record collection of B. B. King, the Living Blues archive, and the Kenneth and Rochelle Goldstein Folklore Library, the Blues Archive was used by Quincy Jones and Steven Spielberg to assist with their production of *The Color Purple*. Thousands of students and scholars have also used collections in the Archive for their own study of the blues.

Perhaps the most dramatic chapter in the history of Delta blues artists is their journey from Mississippi to Chicago. In what Swedish sociologist Gunnar Myrdhal

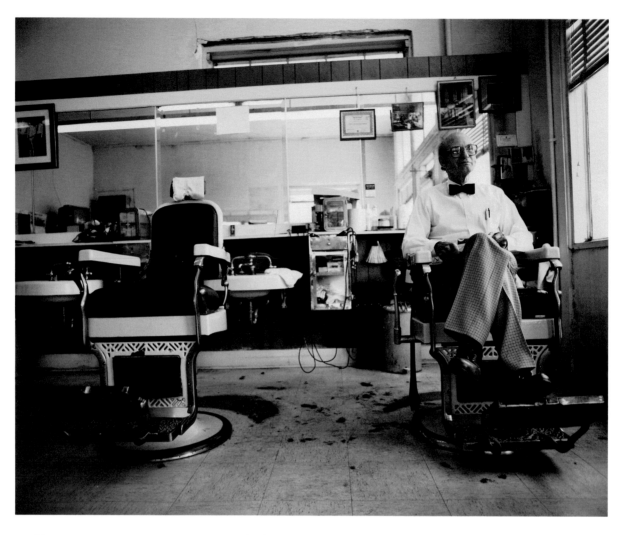

Above: *Ernest Oliver, Jackson Avenue,* Oxford, Mississippi. Below: *Bobo Juke Joint,* Bobo, Mississippi

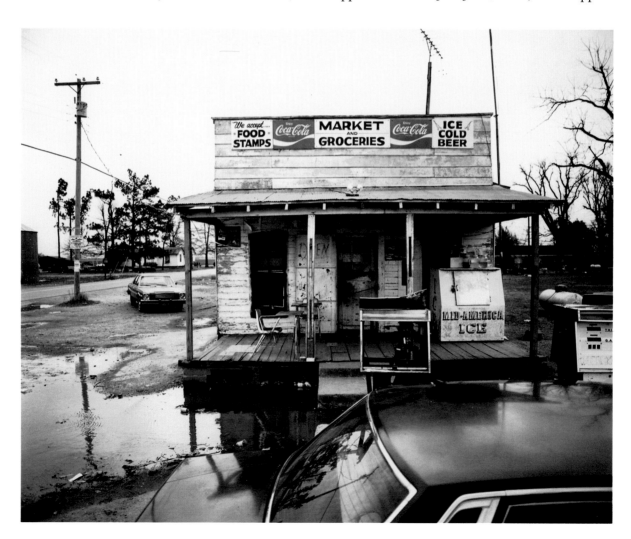

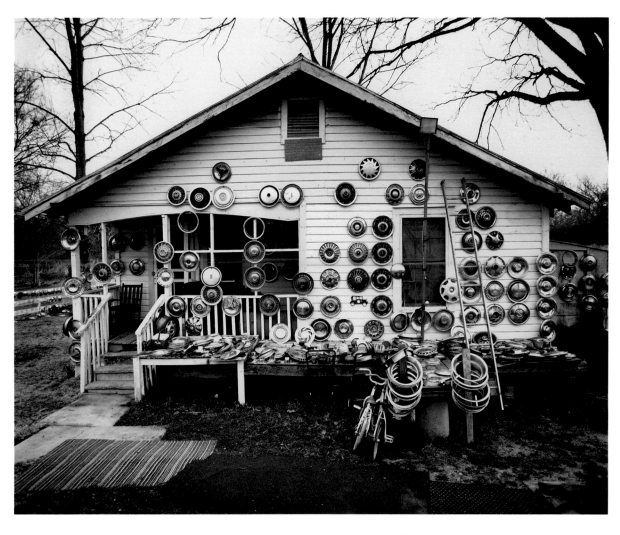

Above: *Highway 61*, Natchez, Mississippi. Below: Tunica, Mississippi

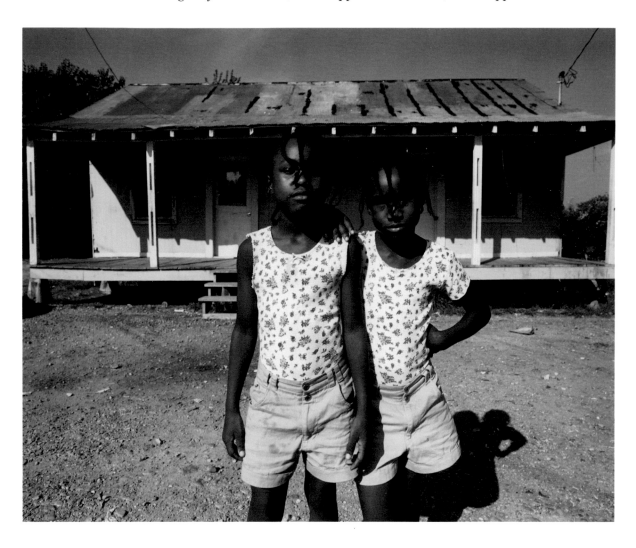

termed the "great central migration," tens of thousands of blacks fled their rural worlds of poverty and tenant farming and sought a better life in the North. By car, bus, and train they arrived in Chicago, and their music forever marked the city.

Just as Richard Wright chronicled his Mississippi and Chicago worlds through his novels *Black Boy* and *Native Son*, blues artist Muddy Waters used his music to celebrate both his birthplace in the Mississippi Delta and his adopted home in Chicago. Moving from Delta juke joints to Chicago blues clubs, he and other Mississippi blues artists developed a faster beat and used electrically amplified instruments to create what became known as the "Chicago sound."

Maxwell Street is to Chicago blues what Beale Street is to Memphis blues. In clubs and on sidewalks along Maxwell Street, blues became a familiar Chicago sound. In their recording studio, Phil and Leonard Chess issued classic sounds of Chicago blues on Chess Records, just as Sam Phillips recorded traditional Delta blues in his acclaimed Sun Records Studio in Memphis. The Chess tradition of Chicago blues recordings is continued today by Bruce Iglauer through his Alligator Records, and Chicago artists are celebrated at the Chicago Blues Festival, the nation's largest festival, which attracts more than 500,000 visitors annually.

Like Elwood in the *Blues Brothers* film, Americans are clearly on a journey in search of the blues. Hollywood productions such as *The Color Purple* and *Crossroads* prominently feature traditional blues artists, and the House of Blues has built highly successful clubs in Cambridge, Massachusetts; New Orleans, Louisiana; Los Angeles, California; and Chicago, Illinois. On Sunset Boulevard in Los Angeles, the House of Blues club is clad with rusty tin stripped from a cotton ware-house in Clarksdale, Mississippi. And the decaying log cabin where Muddy Waters was born on Stovall's plantation has been moved by truck and displayed at House of Blues clubs around the nation. With black folk art displayed on their walls, the House of Blues clubs signal the popularization of blues as a mainstream American music.

The blues continues to draw artists who are inspired by its musical worlds. The publication of these powerful photographs by Jeff Dunas is a significant chapter in this saga. Dunas aptly mixes intimate portraits of individual artists with scenes from musical clubs and other key points along the so-called Delta Blues Highways— Highway 61 and Highway 49. Like earlier photographers who worked with the blues, Dunas uses black-and-white photographs to underscore the stark reality of the musical tradition. His portraits of musicians are both intimate and moving, as his close-up photographs and the selective toning of his prints reveal warmth and strength in the facial expressions of each musician. As Dunas enters the private space of blues artists with his camera, he captures soulful moments through a glance of their eyes, a brief smile, an intimacy achieved only through the camera of a sensitive photographer.

Each blues performer brings to the camera his or her own poised, elegant demeanor, and Dunas adeptly captures their personalities through his photography. His portraits flow in a rich and beautiful sequence through the faces of Luther Allison, Bobby "Blue" Bland, Charles Brown, James Brown, Solomon Burke, William Clarke, James Cotton, Floyd Dixon, Lowell Fulson, Buddy Guy, John Lee Hooker, Linda Hopkins, Taj Mahal, Little Milton, Charlie Musselwhite, Koko Taylor, Rufus Thomas, Johnny "Guitar" Watson, Junior Wells, Joe Williams, and so many others. Just as Walker Evans

Opposite: *Clines Tucker, Neighborhood Grocery,* Rosedale, Mississippi

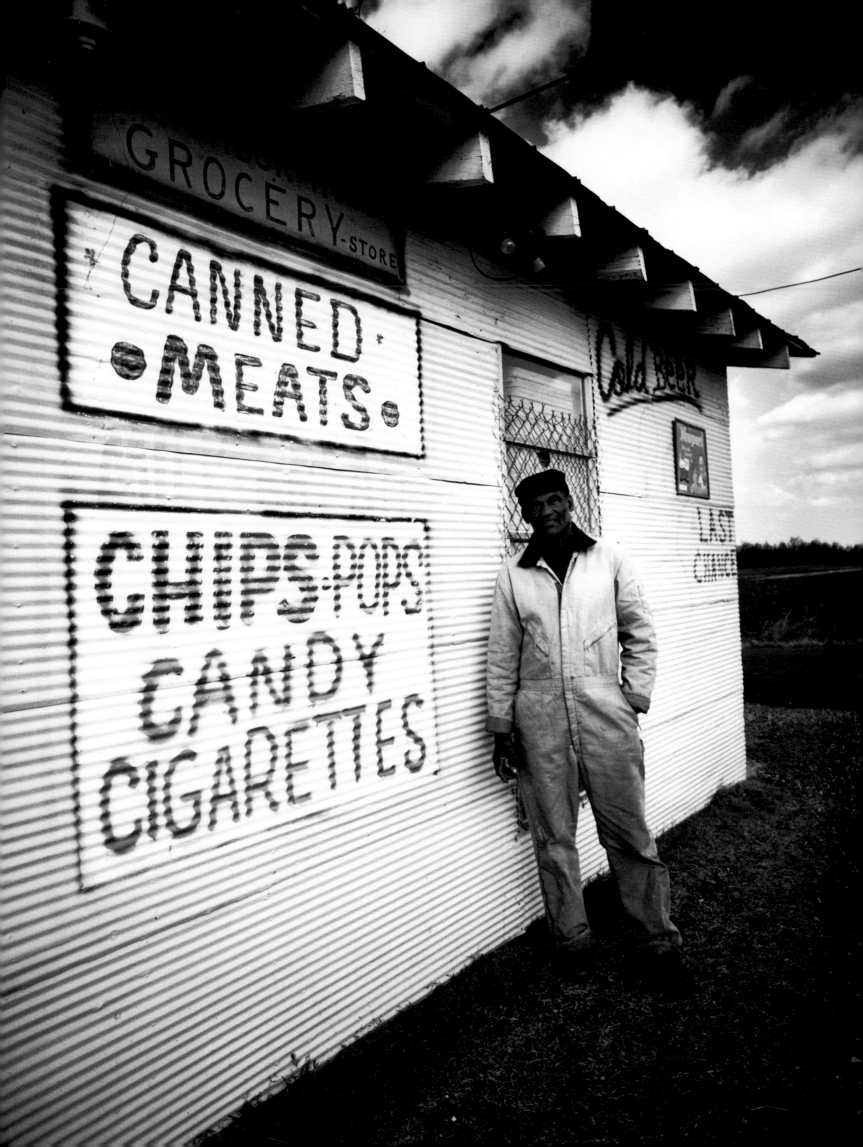

wrestled to capture the soul of white sharecroppers in Hale County, Alabama, Jeff Dunas frames blues artists with studied deliberation. In their faces, in their dress, and in the way they carry themselves, he reveals a blues style that suggests both an elegance and a control of their world.

Through music each blues artist achieves a relationship with life that is unique. As blues artists voice their experiences through song, they share them with their audience as a lesson, a primer for survival. As we look back at our past and as we ponder our future, the blues is a sure, tested resource for our journey.

Jeff Dunas' photography poises us for our travels as his images sweep us along the Delta's Blues Highways. Along the way we encounter both elegant and modest landmarks: a grocery store, barber shop, deserted barn, cotton gin, cafe, motel, pickup truck, and soda fountain. In each, Dunas explores the "state of the blues." He presents the blues at once rooted in the Mississippi Delta and as a starkly modern phenomenon that stands timeless, forever familiar on these pages. His work is a stunning tribute to blues as art and to the blues artists who have shaped our lives so indelibly through their music.

As surely as each new generation reaffirms their love for the blues, blues performers will continue to emerge from the Delta. And as others journey into Delta blues worlds, they will remember with special pleasure Jeff Dunas' fine photographs.

Opposite: Between Beula and Scott, Mississippi

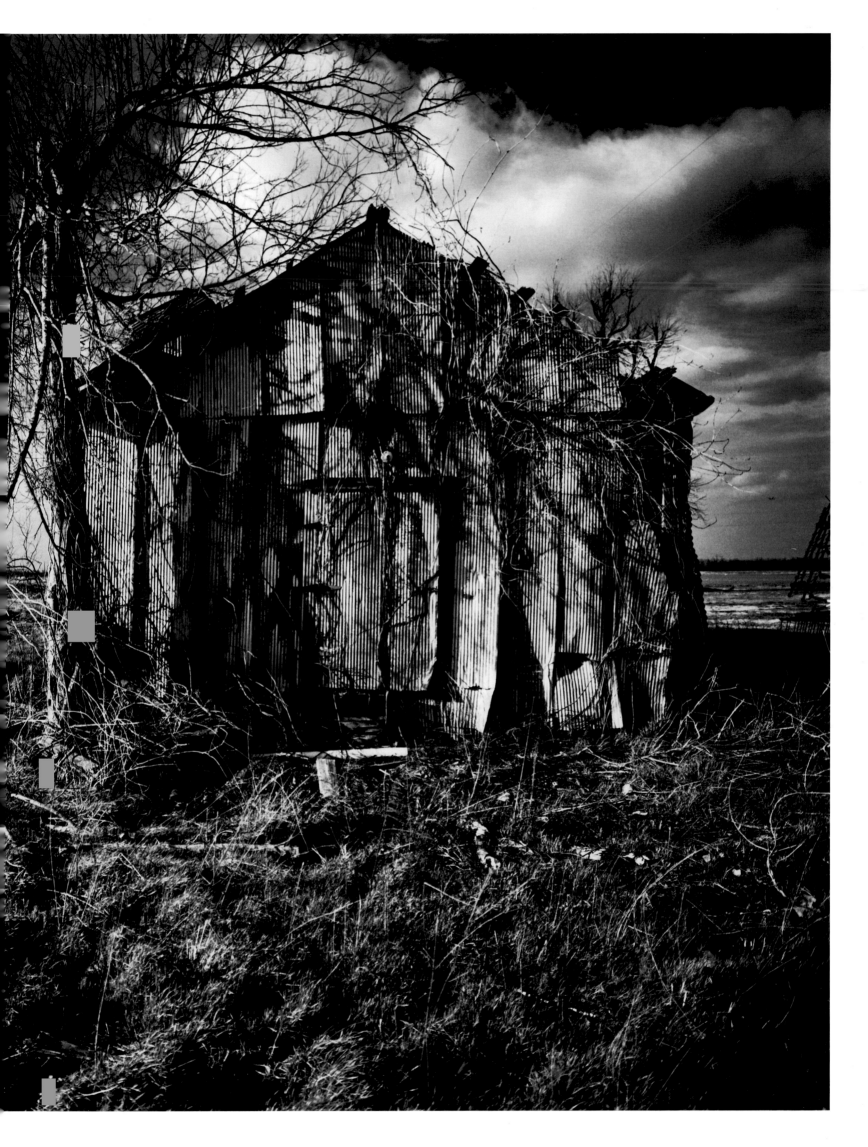

PORTRAITS I

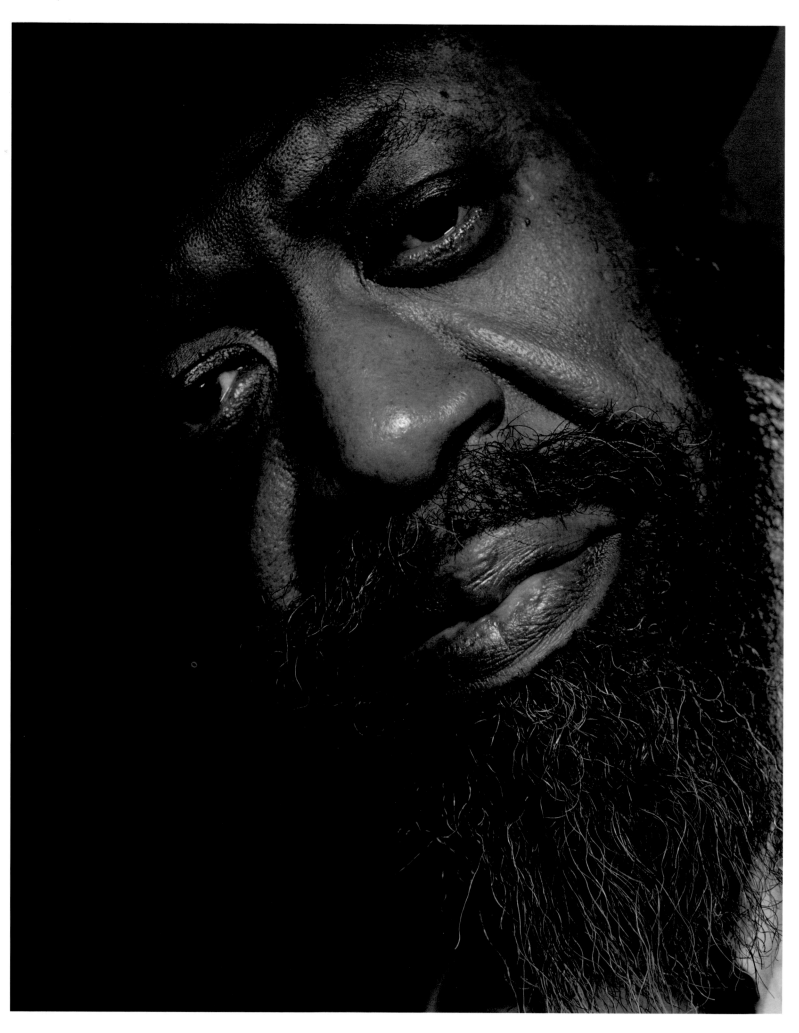

SON SEALS (FRANK SEALS)
Osceola, Arkansas

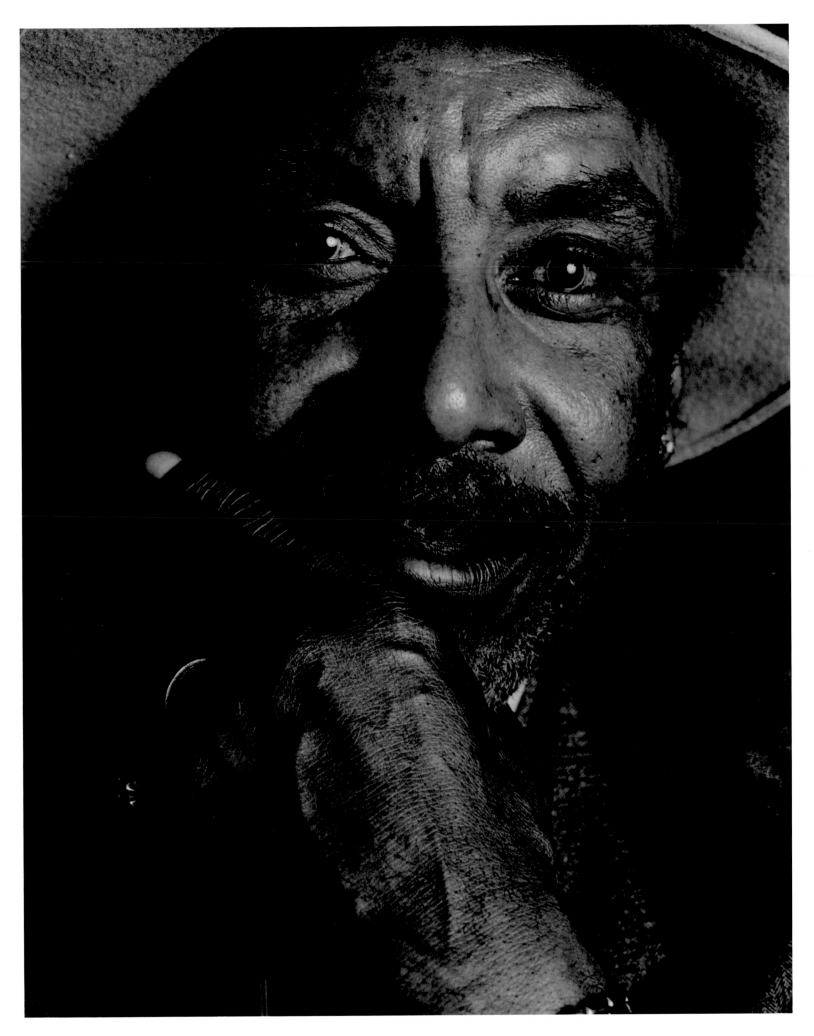

JOHNNY DYER
River Fork, Mississippi

23

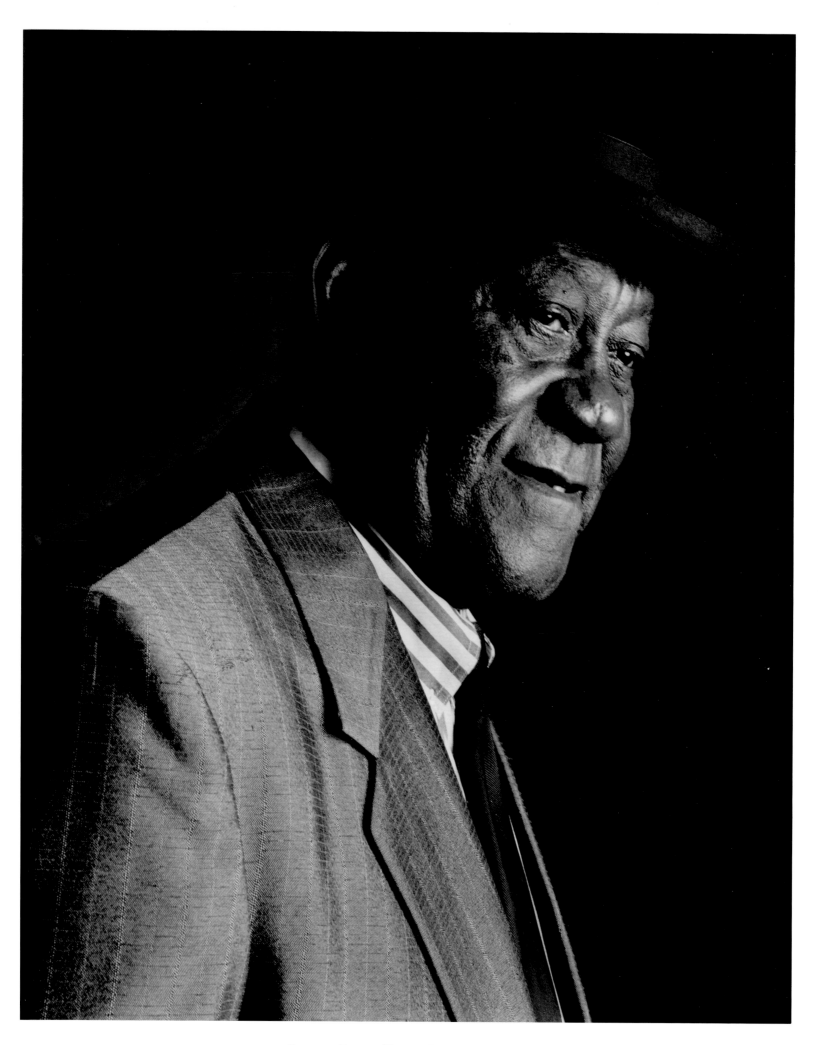

SNOOKY PRYOR (JAMES EDWARD PRYOR)
Lambert, Mississippi

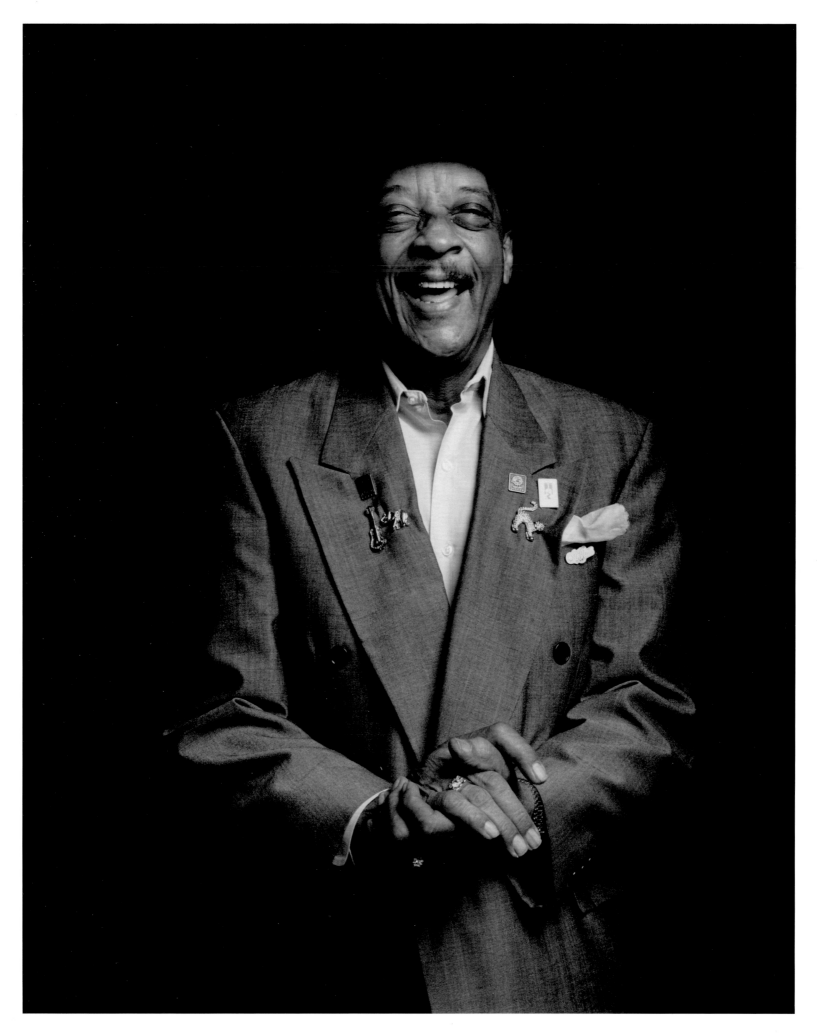

HUBERT SUMLIN
Greenwood, Mississippi

My family told me that the blues started in the South. I've read that it happened in the southern parts, especially in Mississippi, Georgia, Alabama, through that area. . . . It's been said that within a hundred miles, most of the blues singers was born and started to play—within a hundred miles of each other.

—B. B. KING

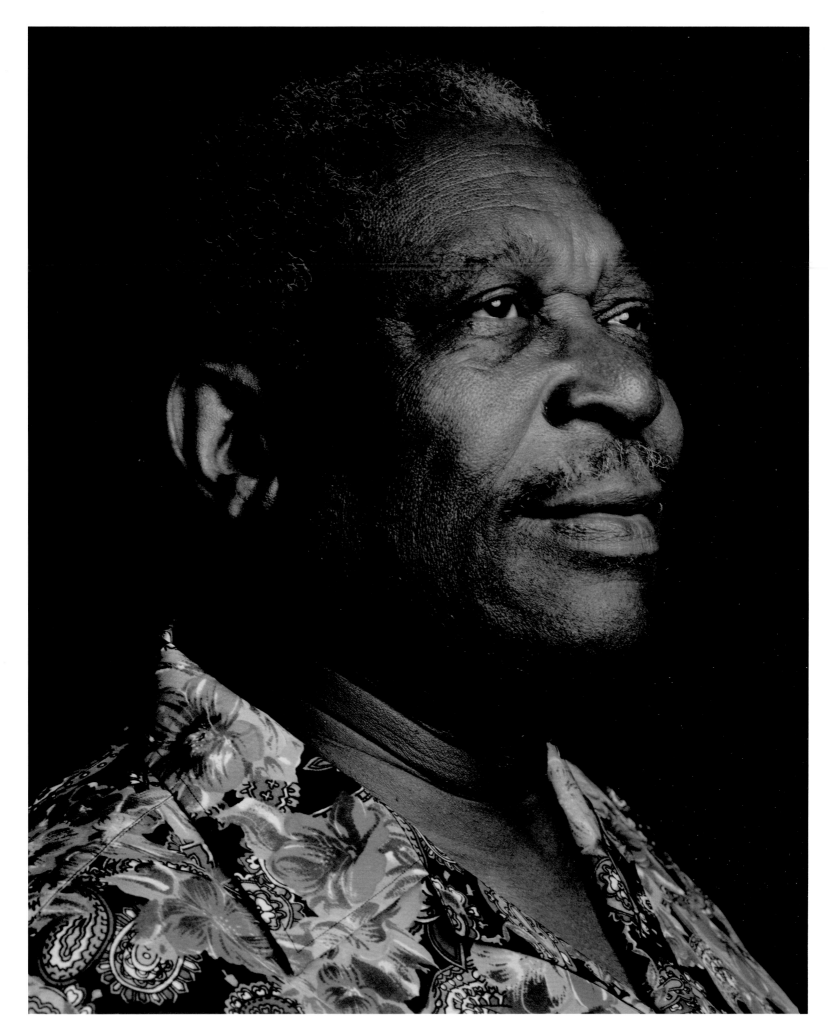

B. B. KING (RILEY B. KING)
Barclair, Mississippi

27

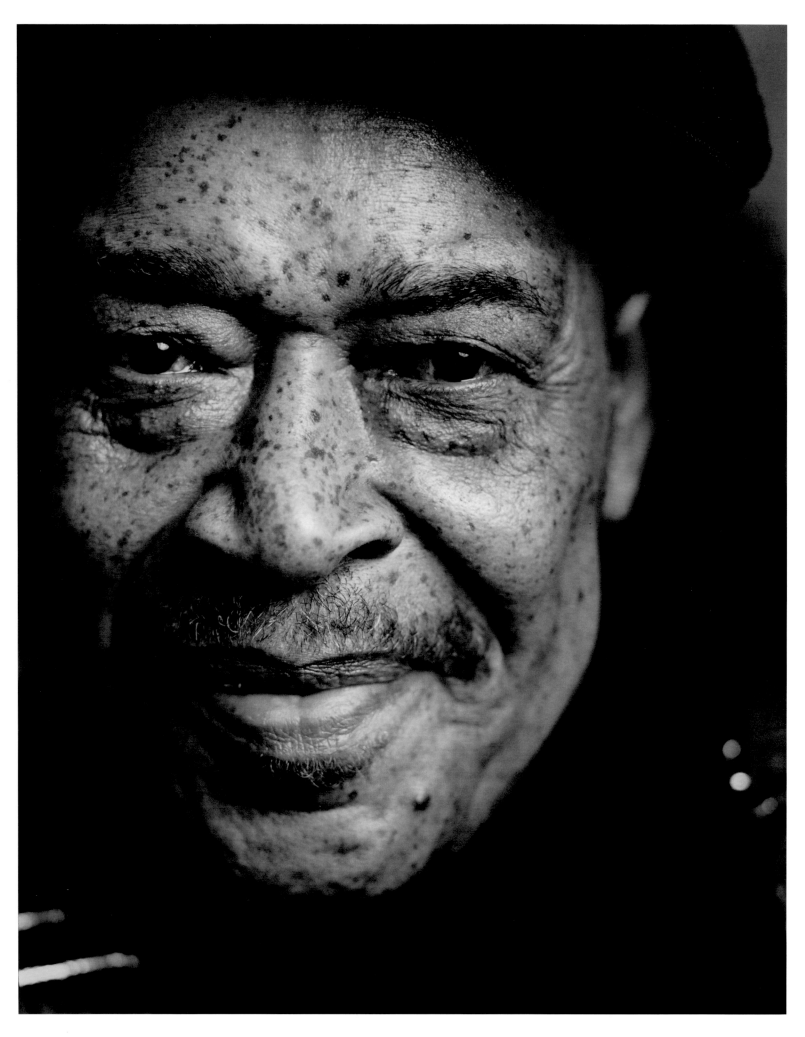

JAMES COTTON
Tunica, Mississippi

28

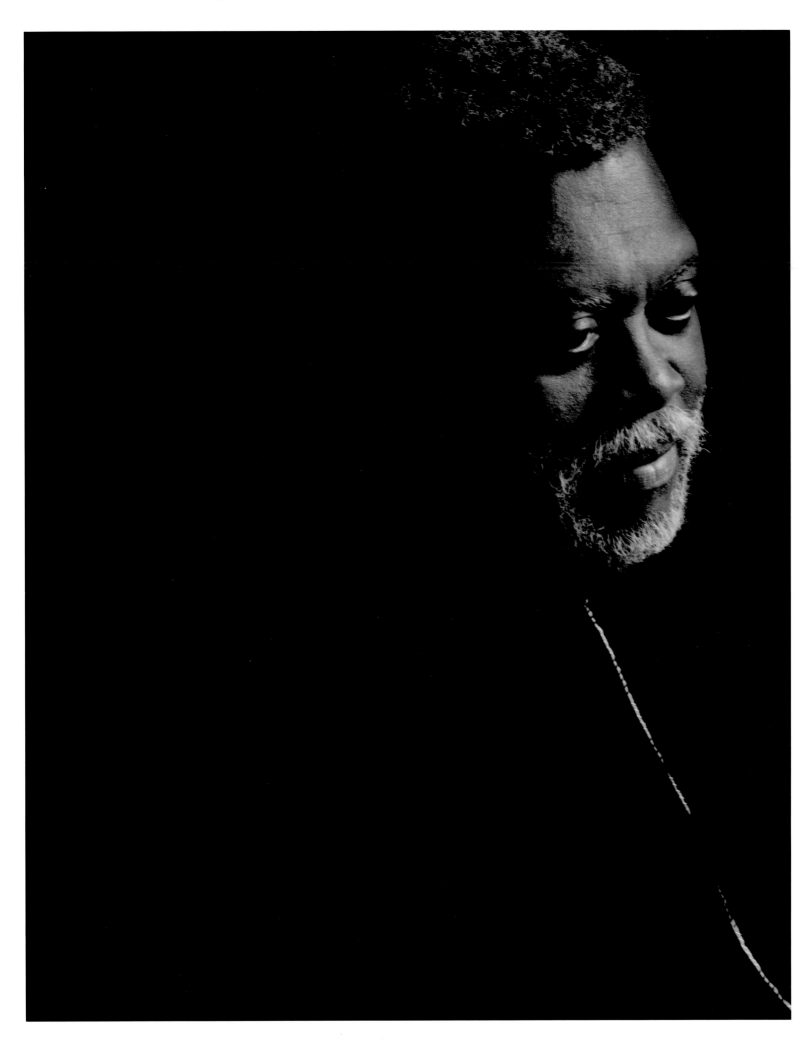

BIG JAY McNEELY (CECIL McNEELY)
Los Angeles, California

29

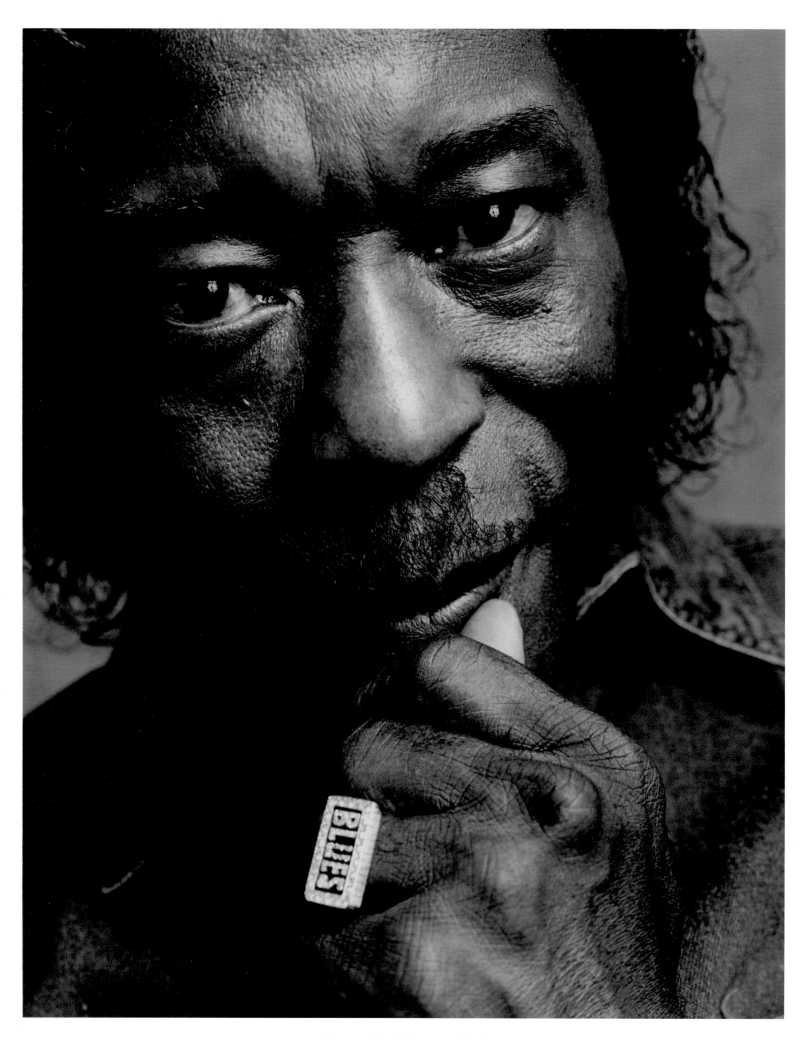

BUDDY GUY (GEORGE GUY)
Lettsworth, Louisiana

30

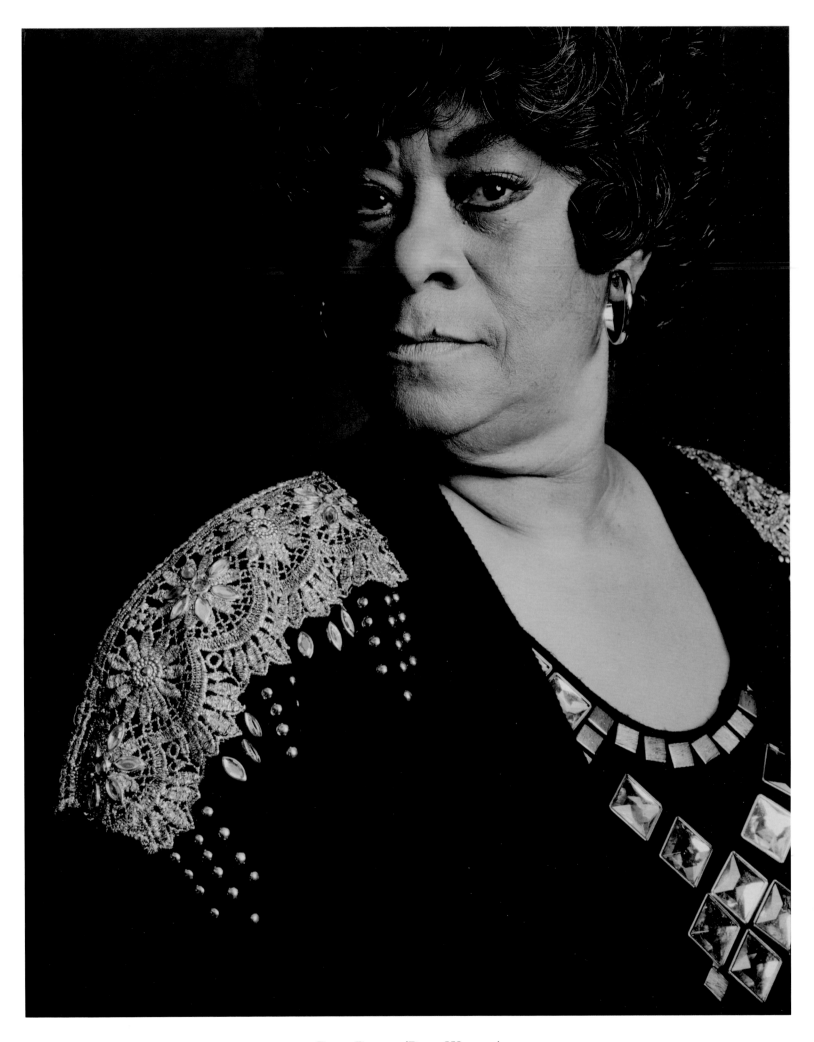

RUTH BROWN (RUTH WESTON)
Portsmouth, Virginia

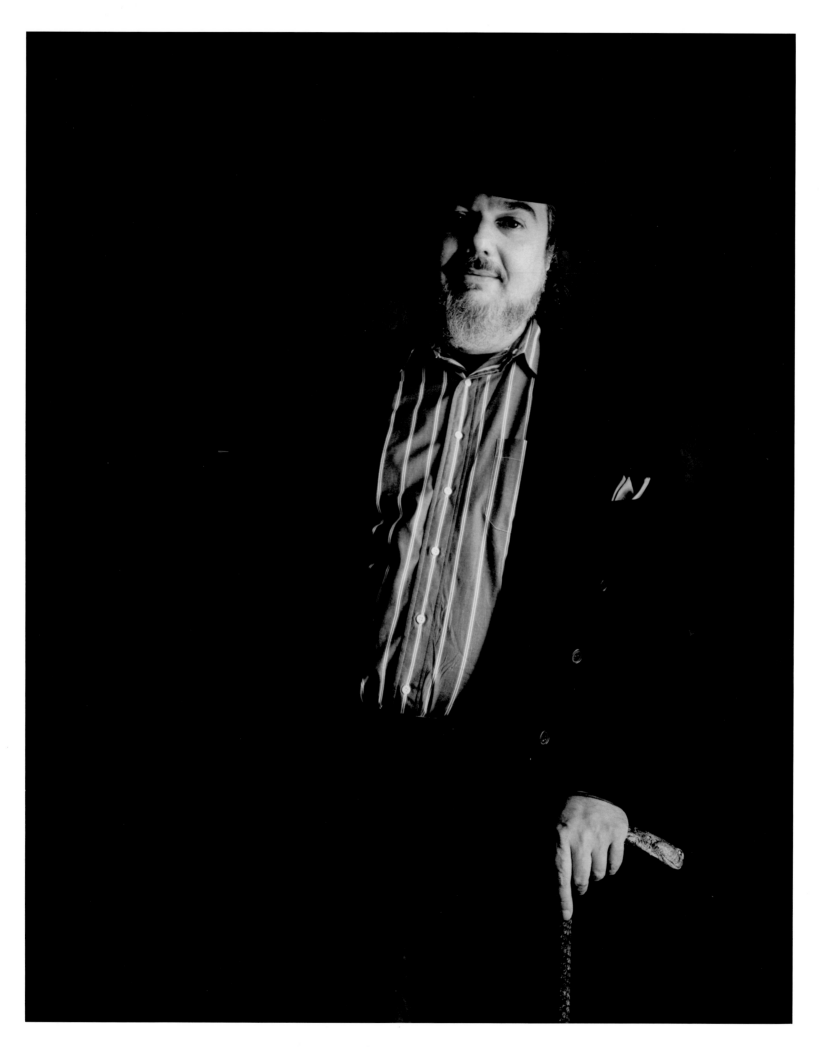

DR. JOHN (MALCOLM REBENNACK)
New Orleans, Louisiana

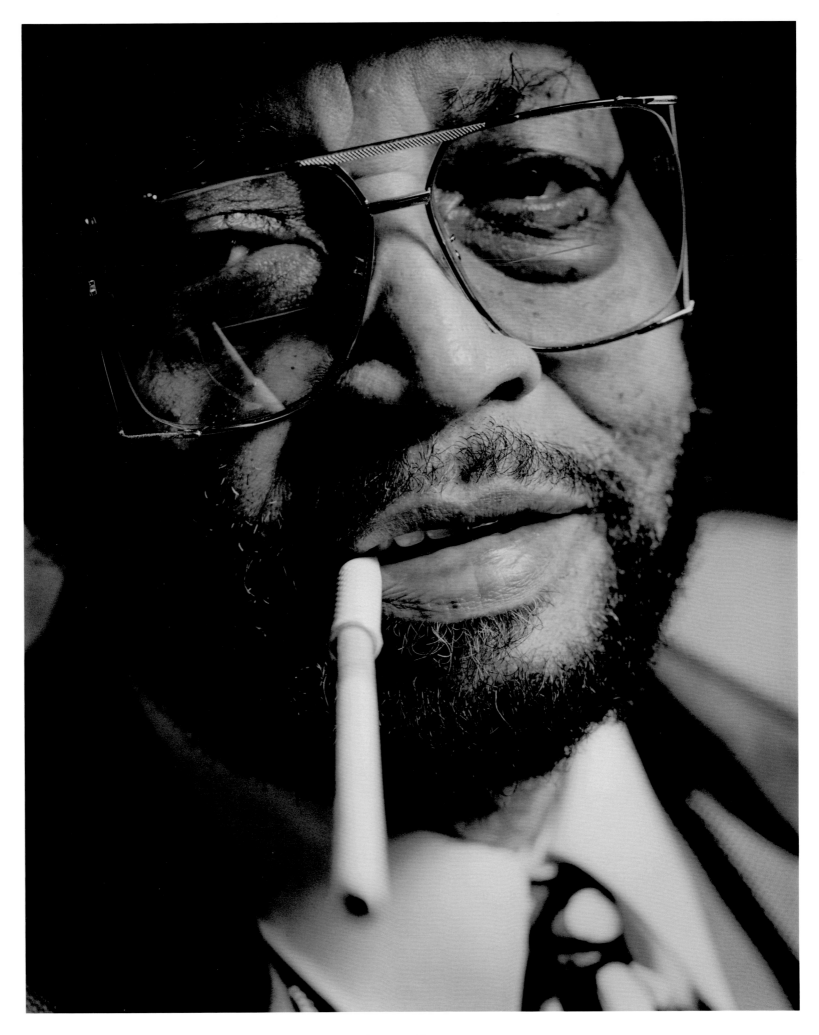

LOWELL FULSON
Tulsa, Oklahoma

33

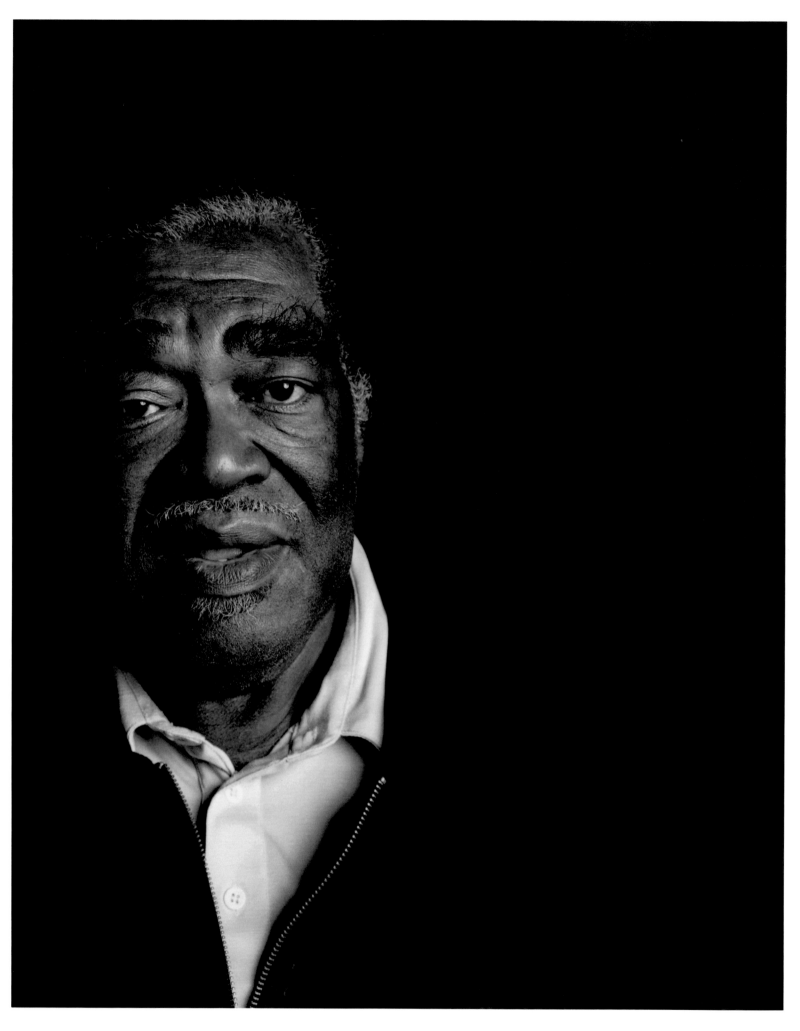

BIG DADDY KINSEY (LESTER KINSEY)
Pleasant Grove, Mississippi

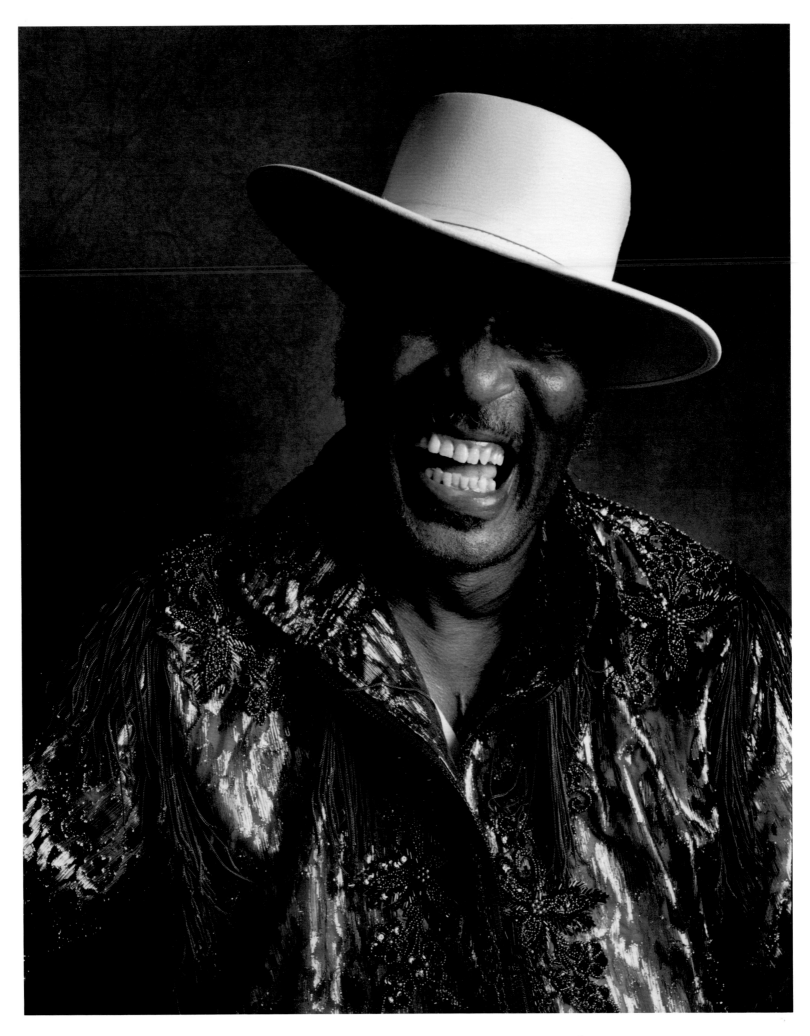

EDDIE "THE CHIEF" CLEARWATER (EDWARD HARRINGTON)
Macon, Mississippi

35

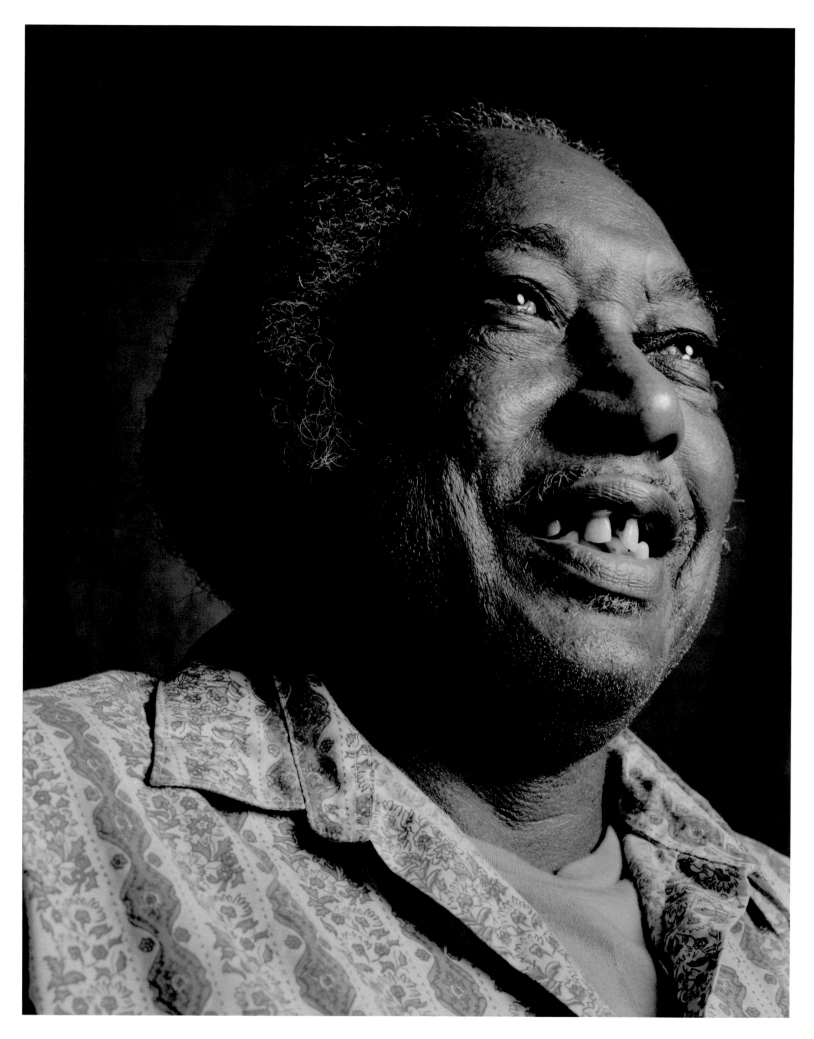

R. L. BURNSIDE
Oxford, Mississippi

36

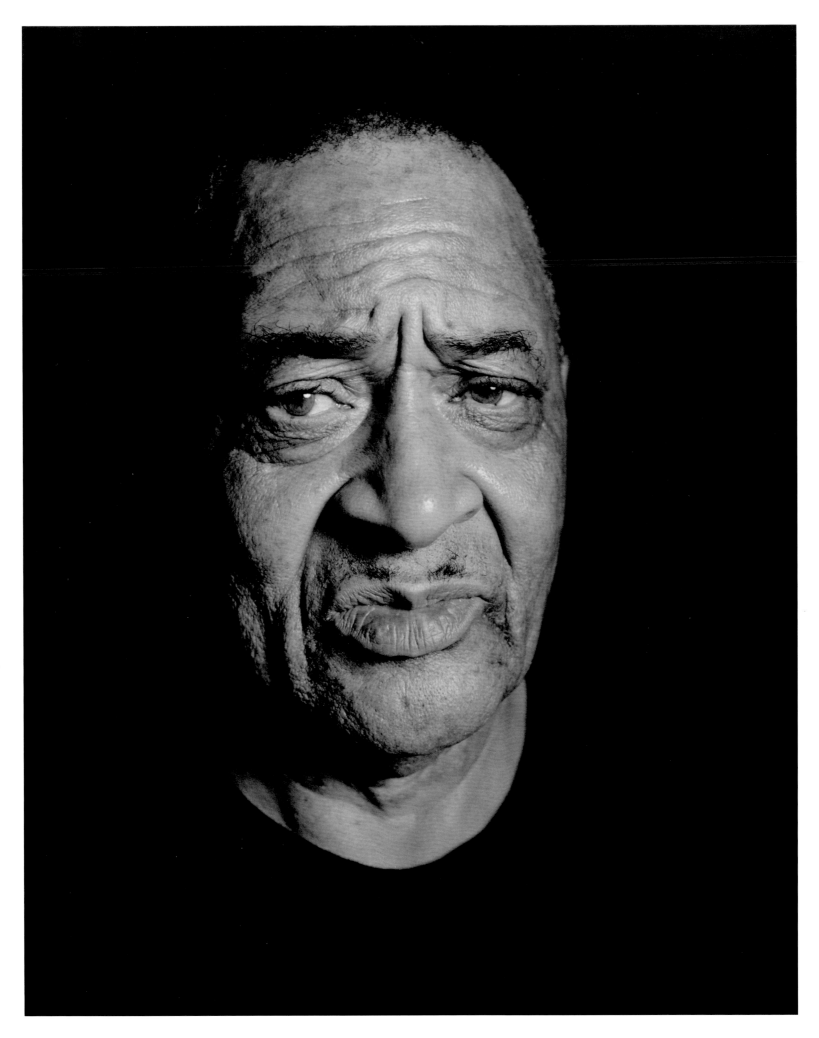

JUNIOR KIMBROUGH (DAVID KIMBROUGH)
Hudsonville, Mississippi

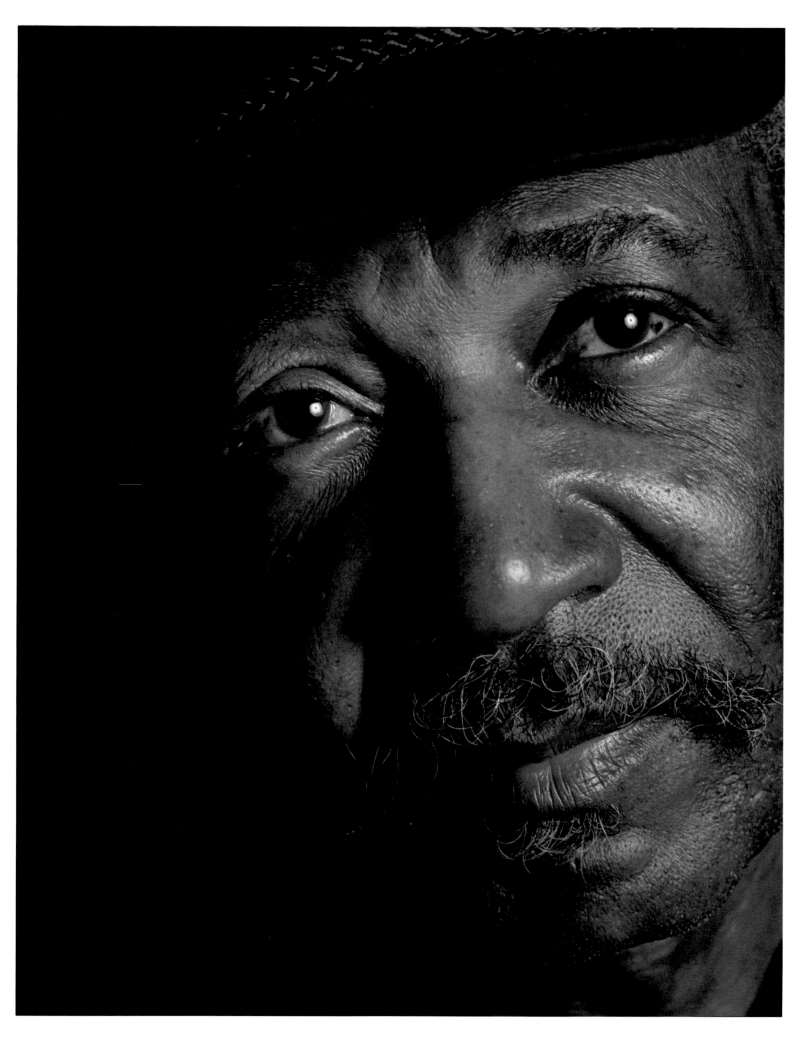

LAZY LESTER (LESLIE JOHNSON)
Torras, Louisiana

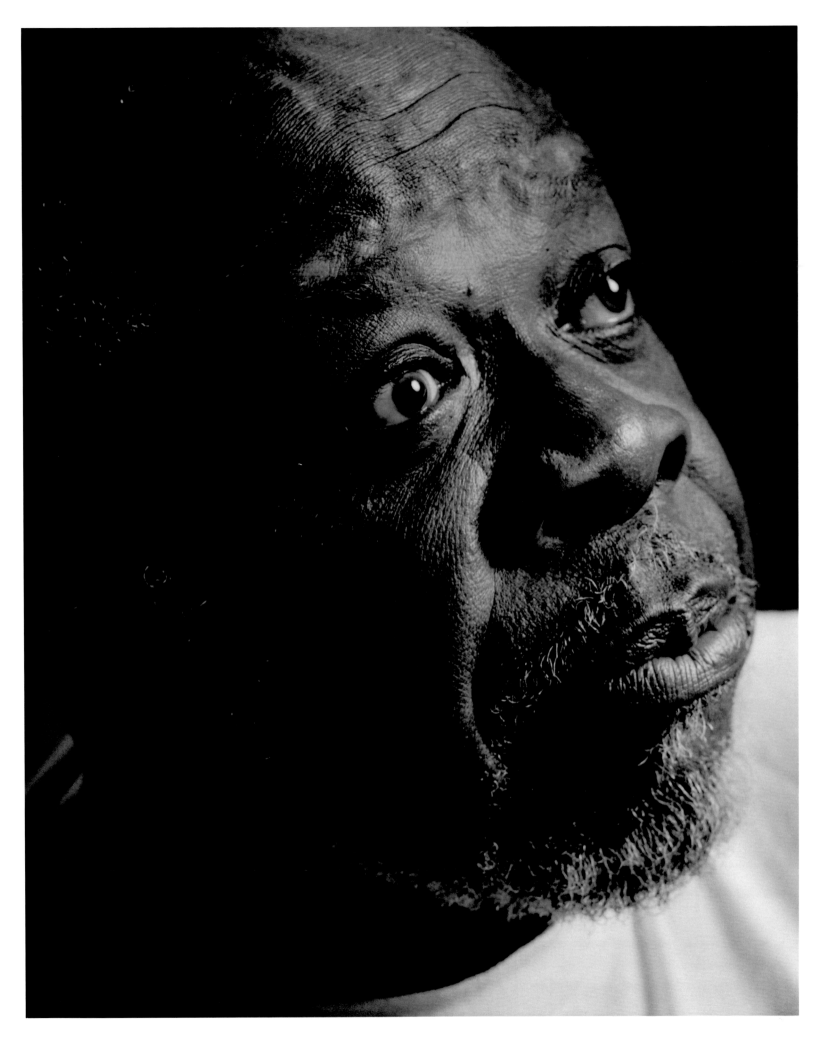

RUFUS THOMAS
Cayce, Mississippi

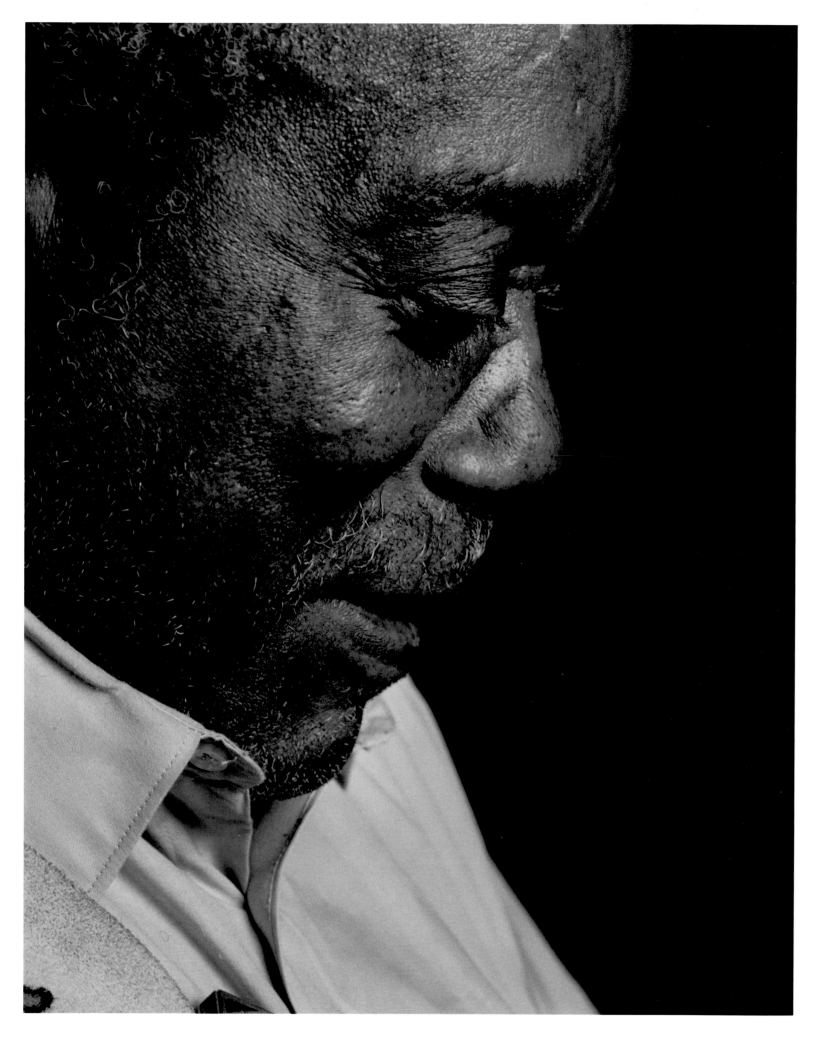

SAM MYERS
Laurel, Mississippi

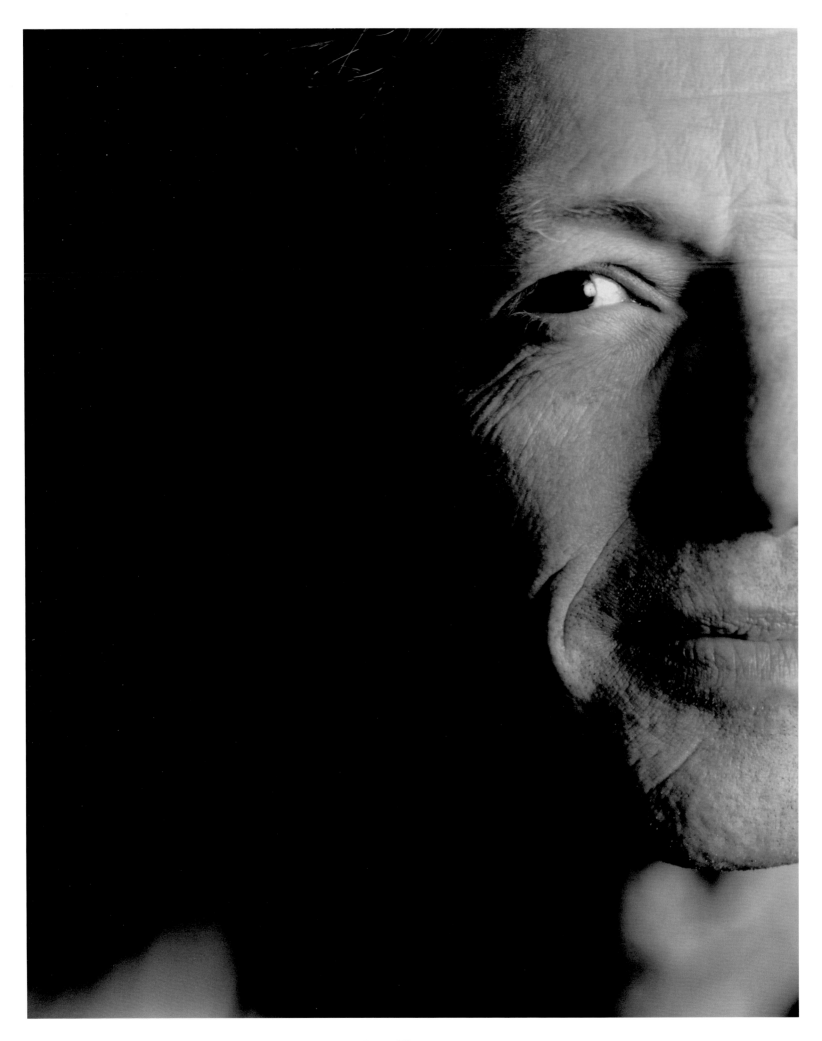

JOHN HAMMOND
New York, New York

41

My blues is not designed to make people feel sad. My music is designed to make people get up, pep up, look up and enjoy the music that I'm performing. Make them feel good about themselves! Have a good time, if it ain't but one night where they can listen to me sing.

—KOKO TAYLOR

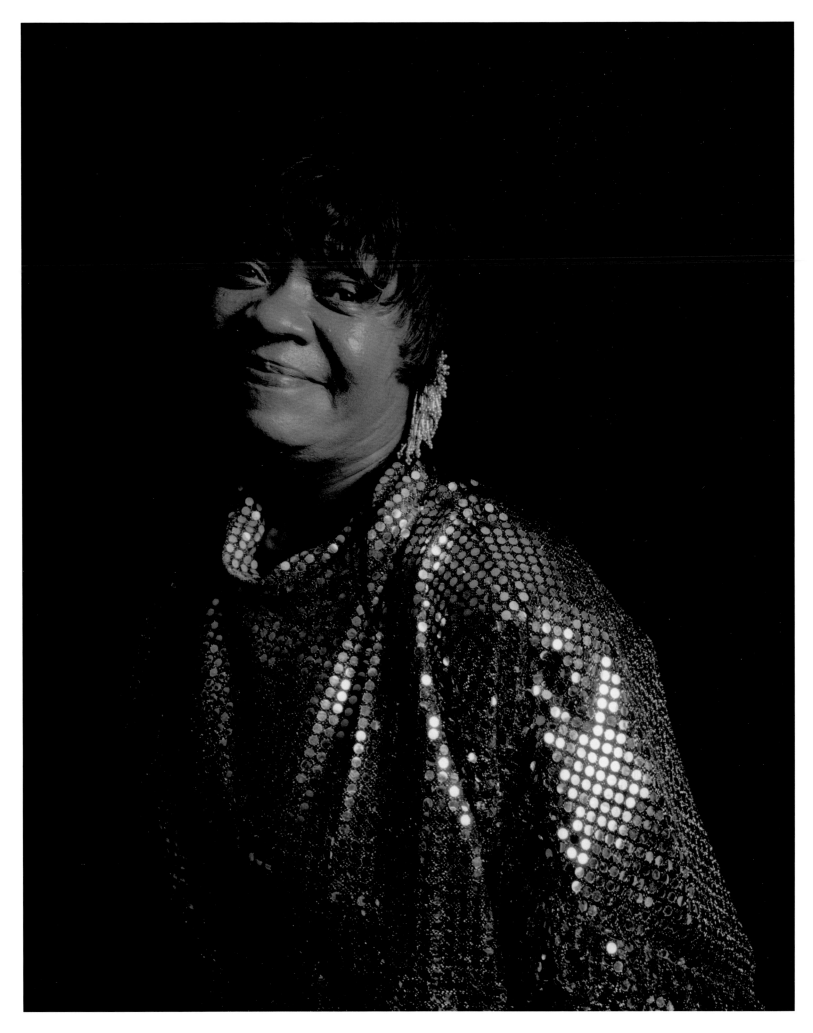

KOKO TAYLOR (CORA WALTON)
Memphis, Tennessee

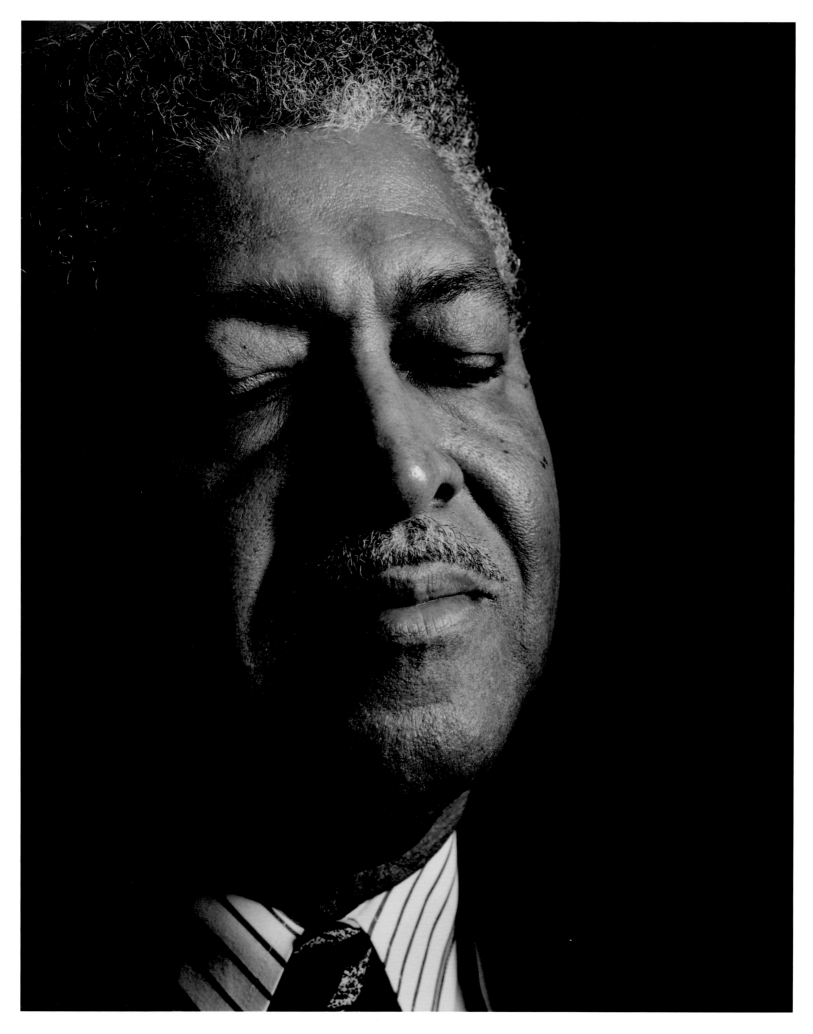

SAM LAY
Birmingham, Alabama

44

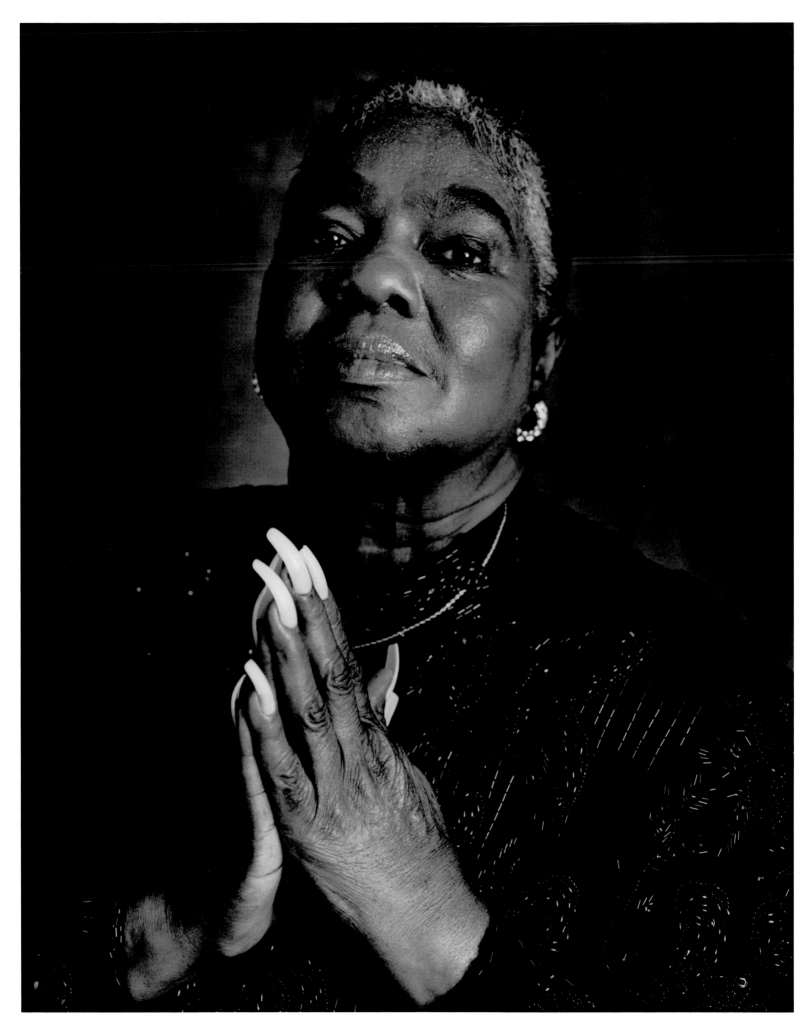

LINDA HOPKINS
New Orleans, Louisiana

45

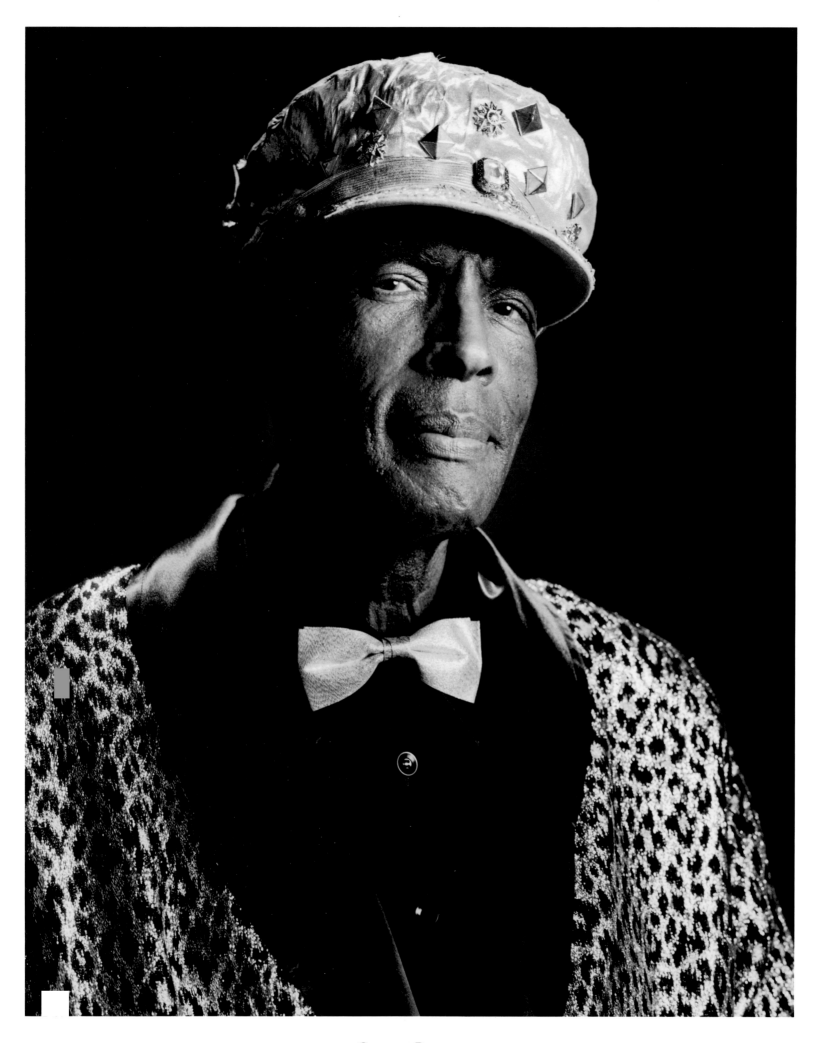

CHARLES BROWN
Texas City, Texas

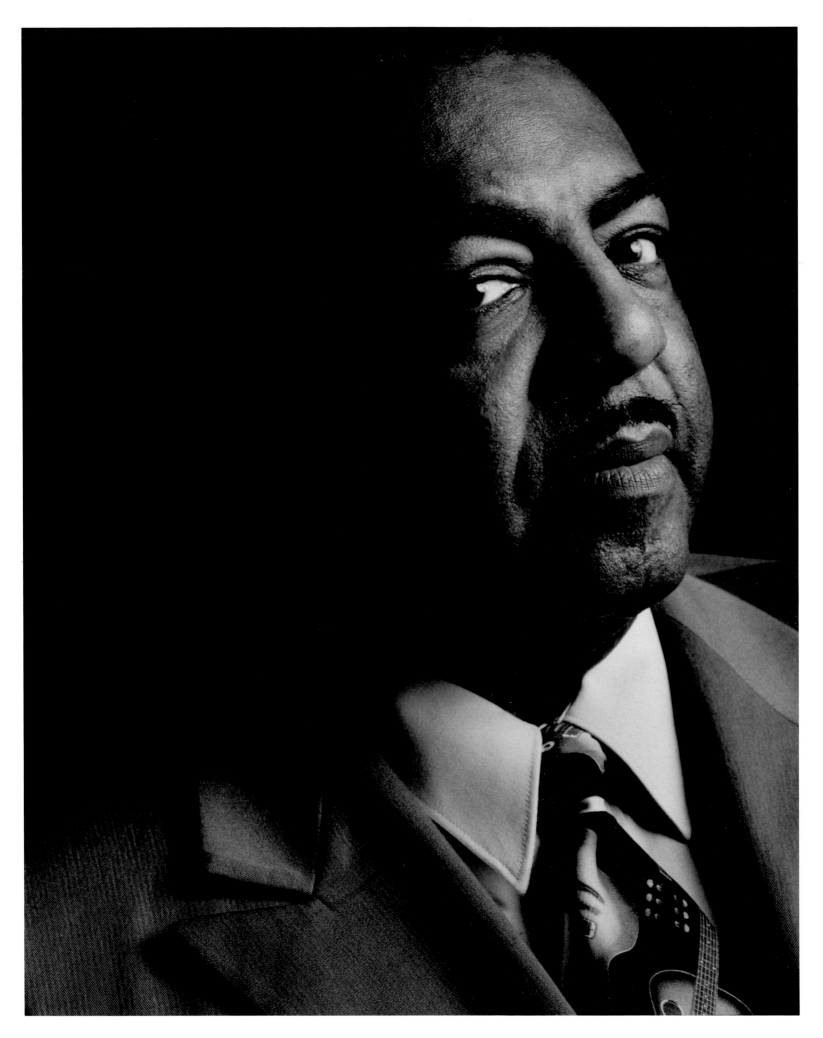

"Texas" Pete Mayes
Anahuac, Texas

47

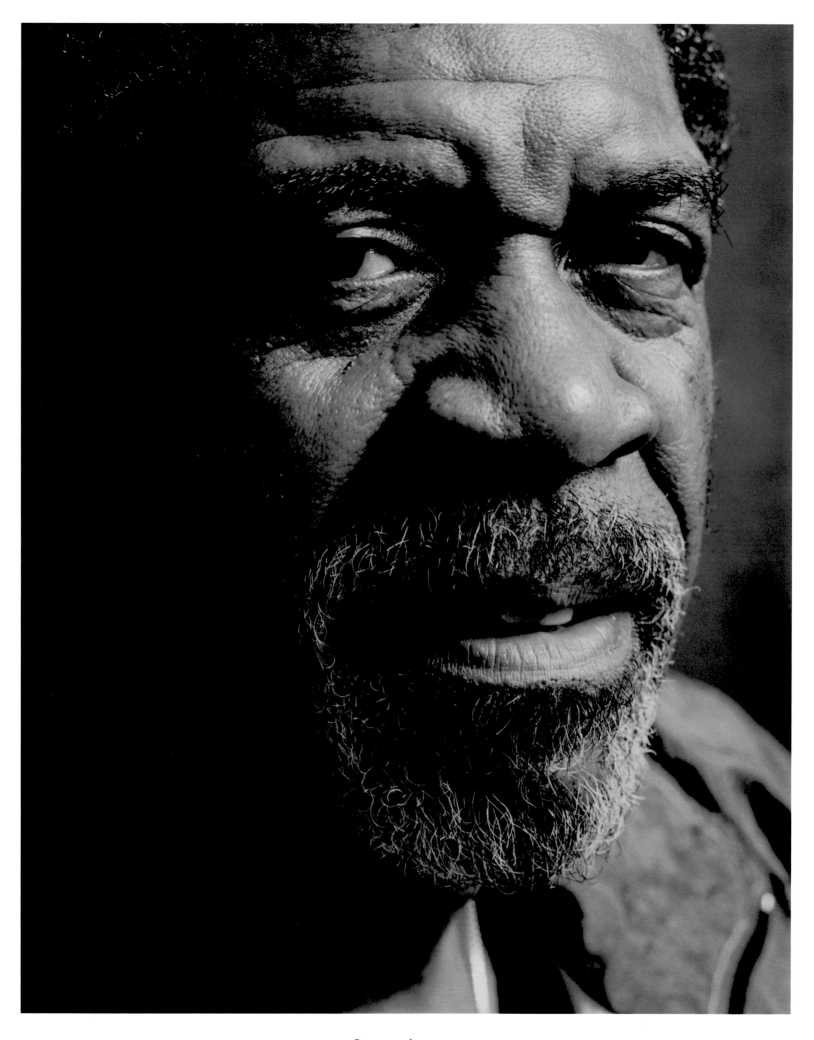

LUTHER ALLISON
Mayflower, Arkansas

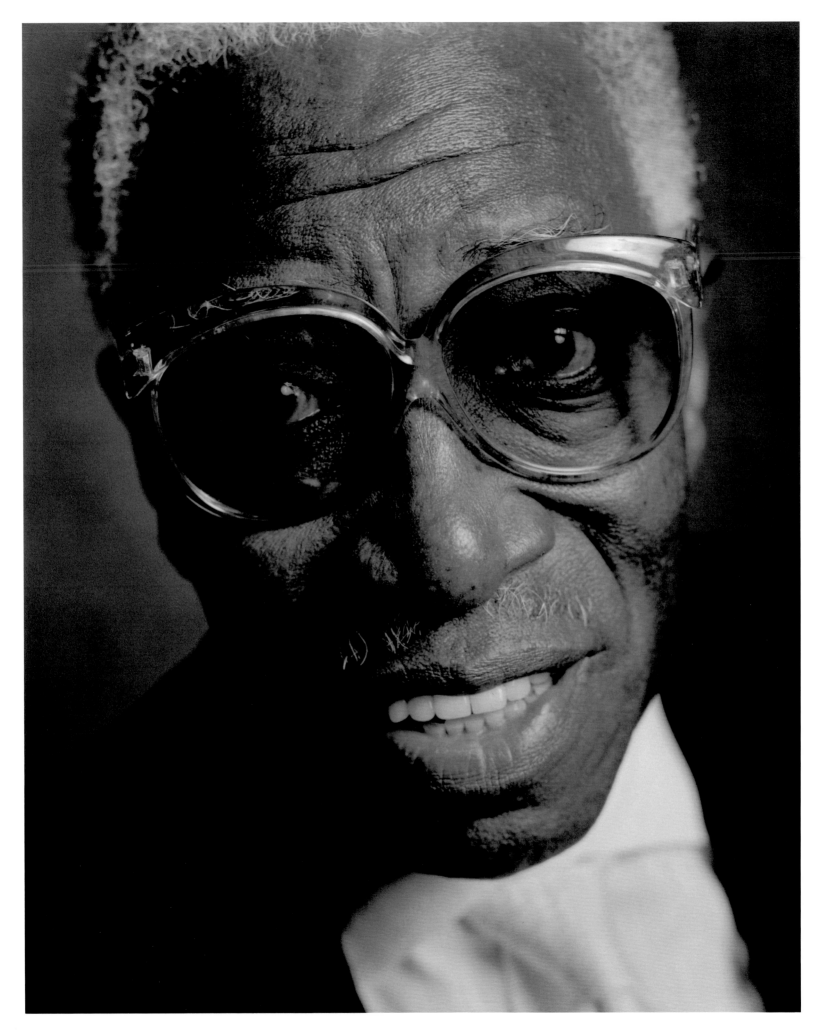

JOE WILLIAMS (JOSEPH GOREED)
Cordele, Georgia

49

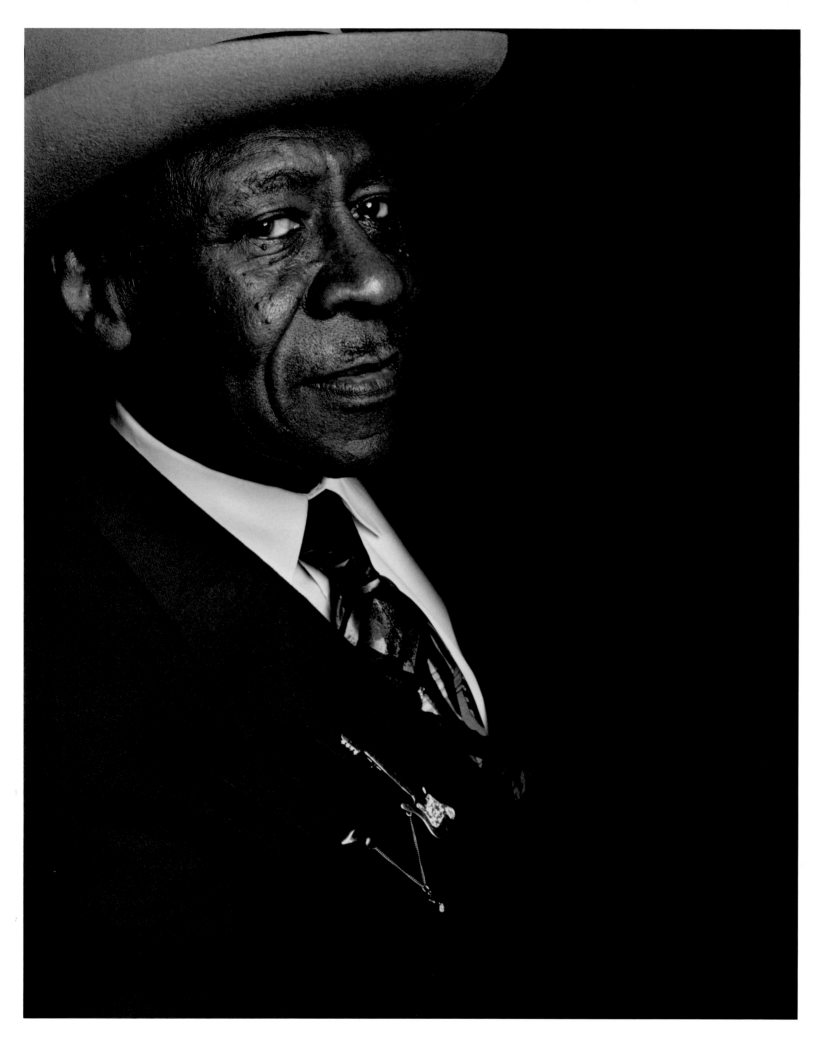

ROBERT STROGER
Hayti, Missouri

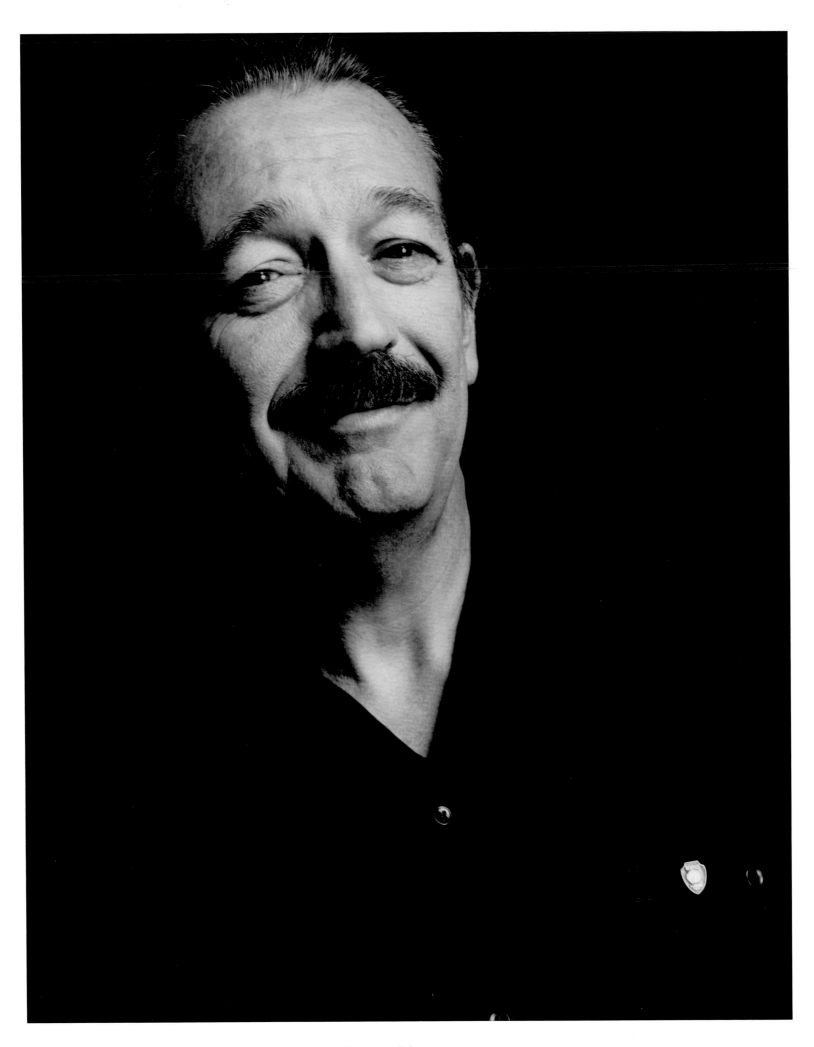

CHARLIE MUSSELWHITE
Kosciusko, Mississippi

51

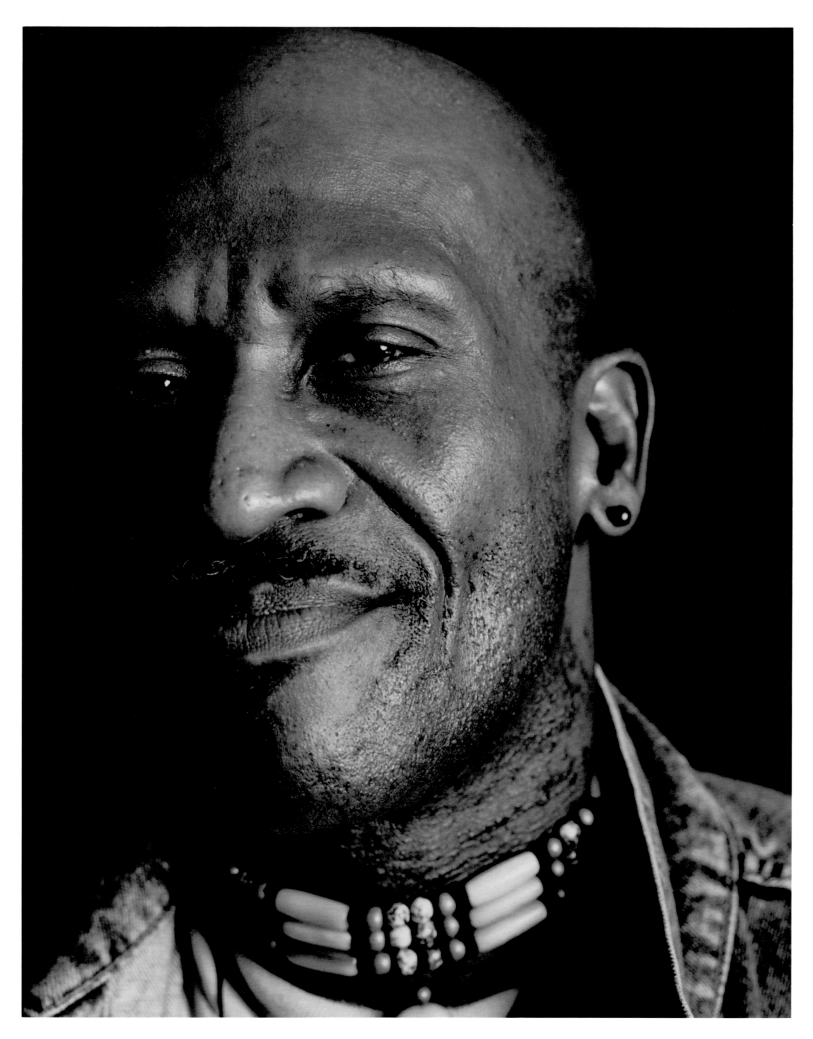

TAJ MAHAL (HENRY ST. CLAIRE FREDERICKS)
New York, New York

52

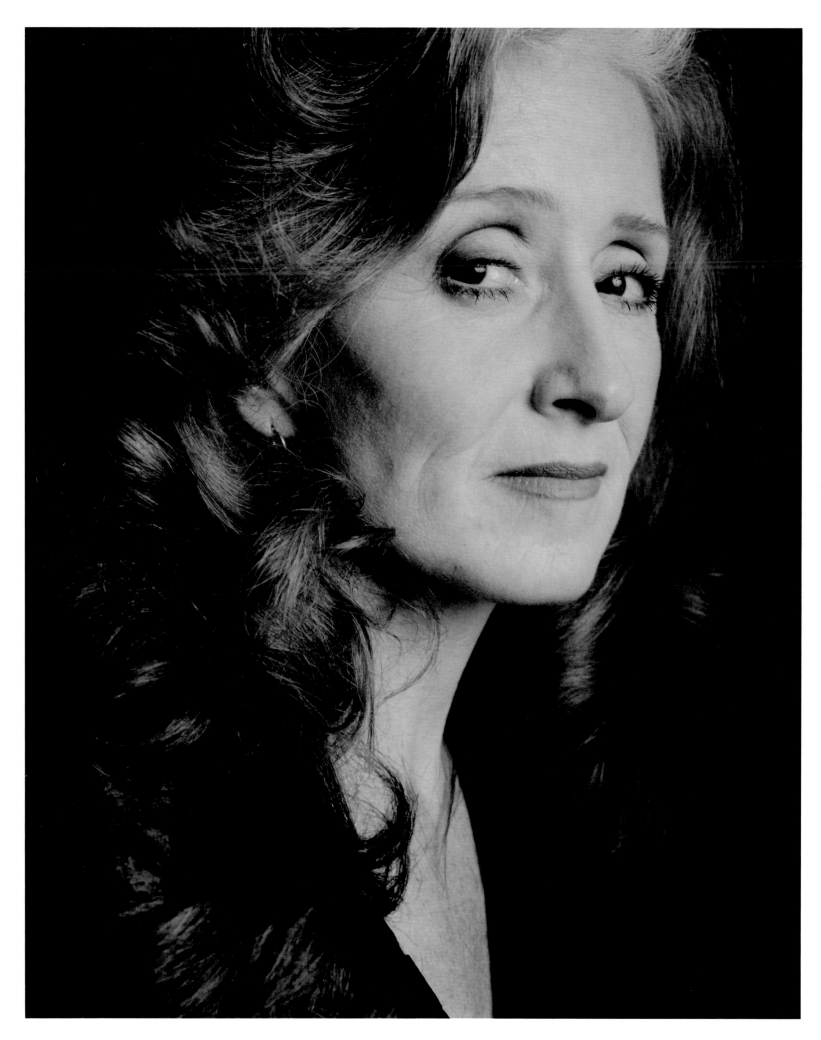

BONNIE RAITT
Burbank, California

53

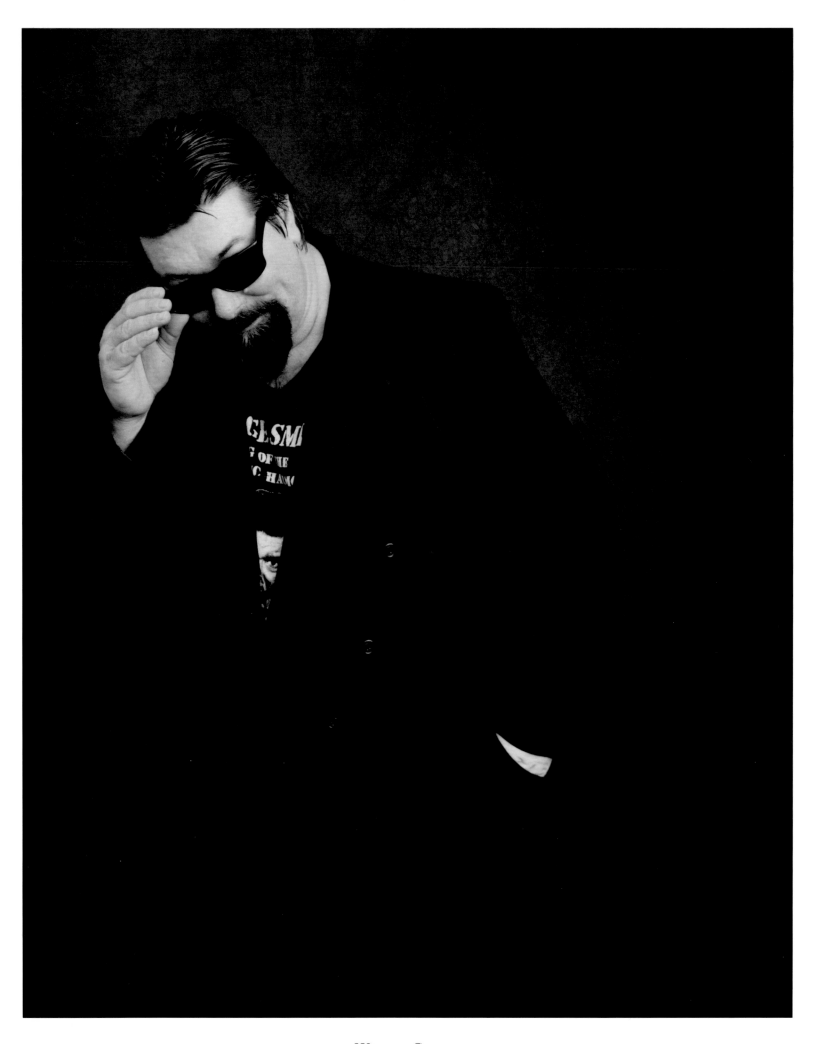

WILLIAM CLARKE
Inglewood, California

54

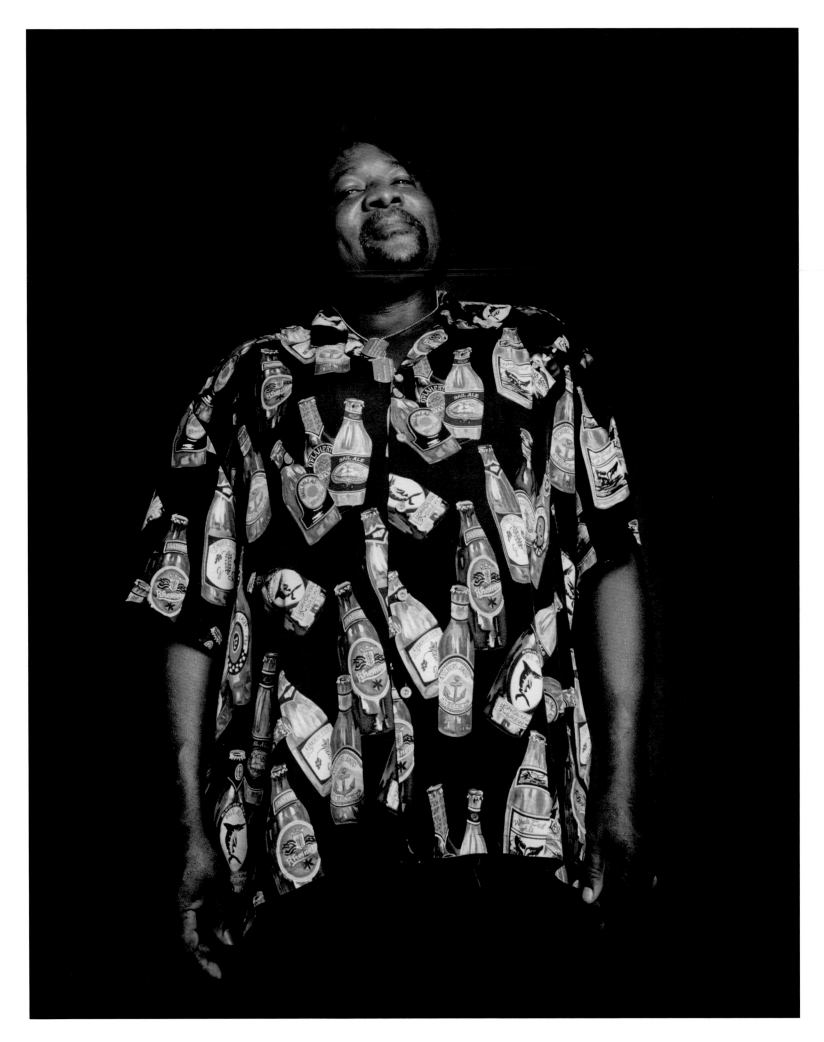

BIG JACK JOHNSON
Lambert, Mississippi

55

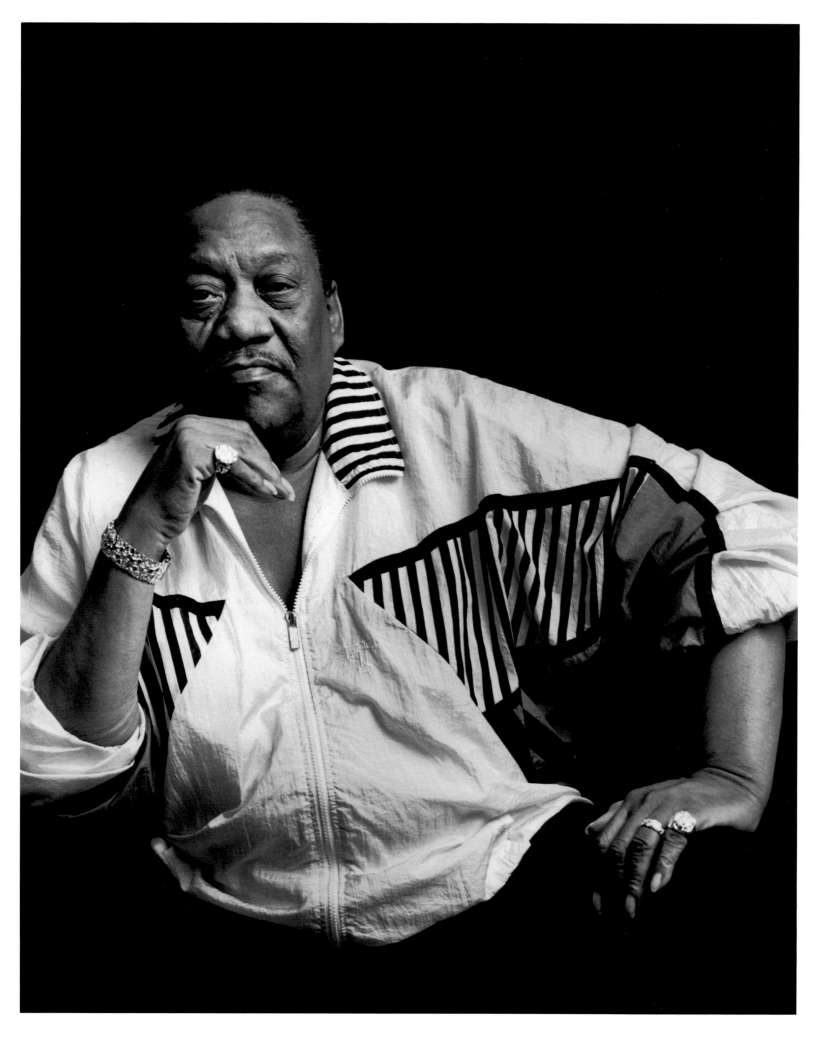

BOBBY "BLUE" BLAND
Rosemark, Tennessee

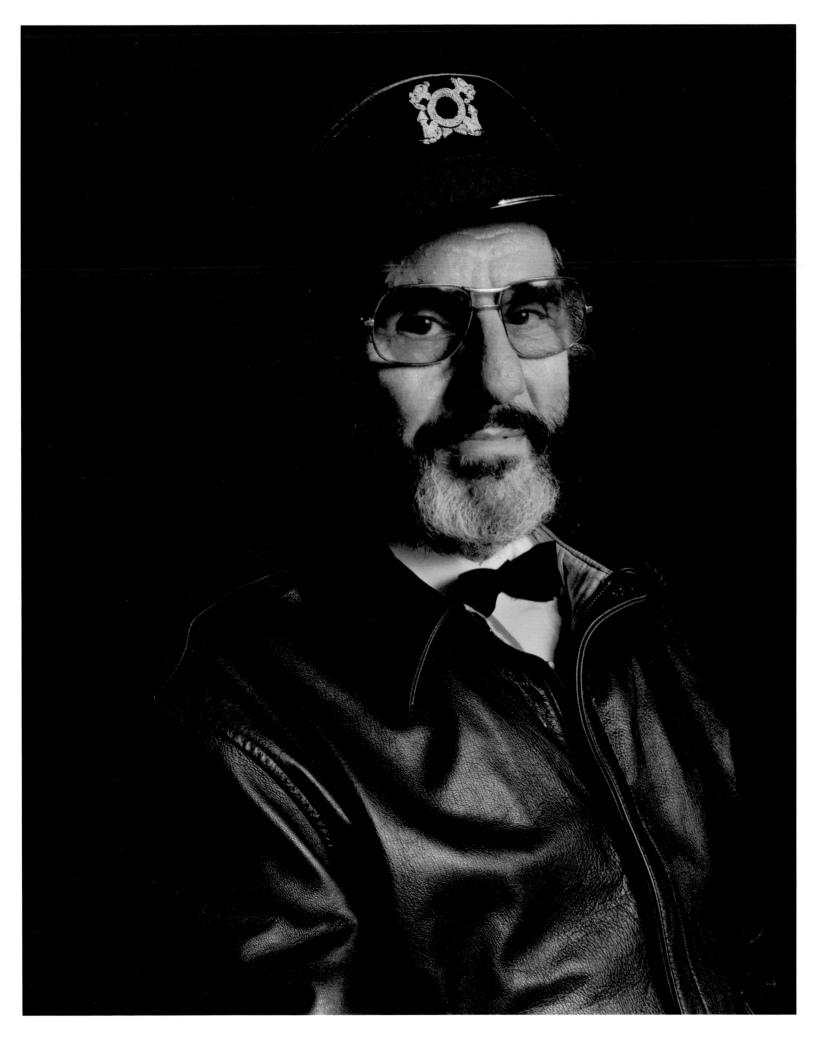

JOHNNY OTIS (JOHN VELIOTES)
Vallejo, California

The state of the blues is a state of mind. For me it's a positive thing and not a negative thing, which it is for a lot of people. They callin' for help or trying to tell people how much problems they've had in life. . . . When I write the blues, I try to help everybody, from little children up to grandpa and grandma. It should be positive. It don't have to be sad.

—CLARENCE "GATEMOUTH" BROWN

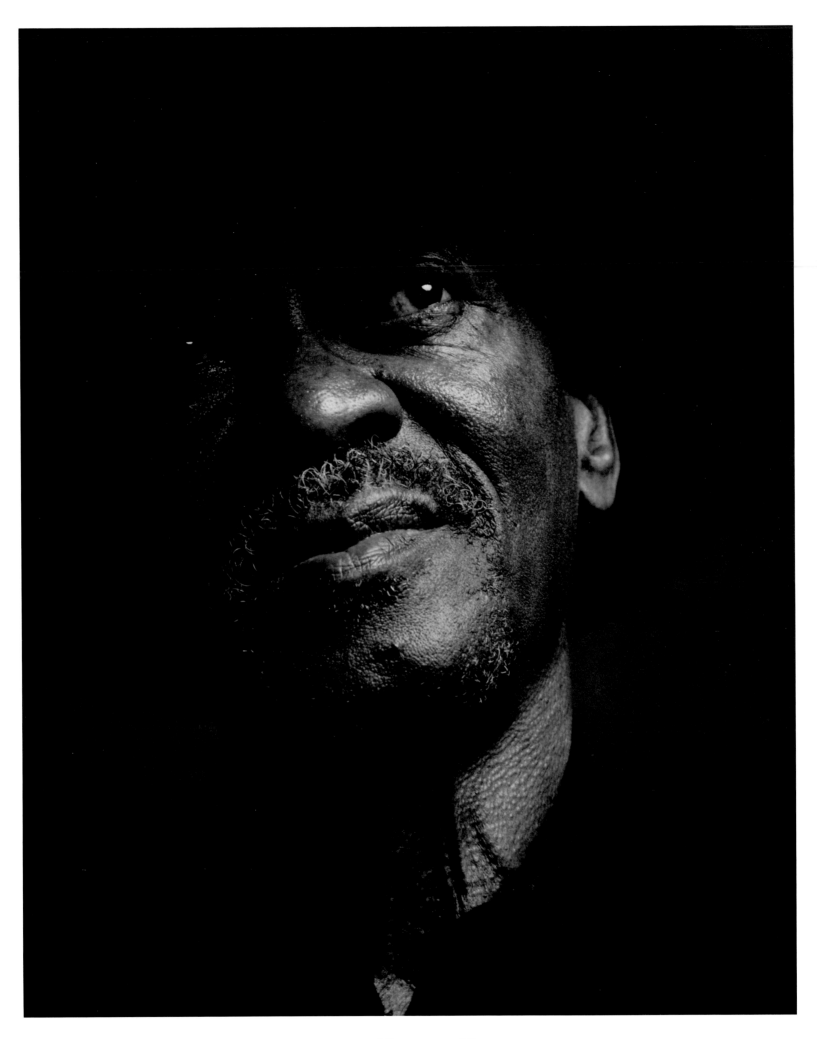

CLARENCE "GATEMOUTH" BROWN
Vinton, Louisiana

59

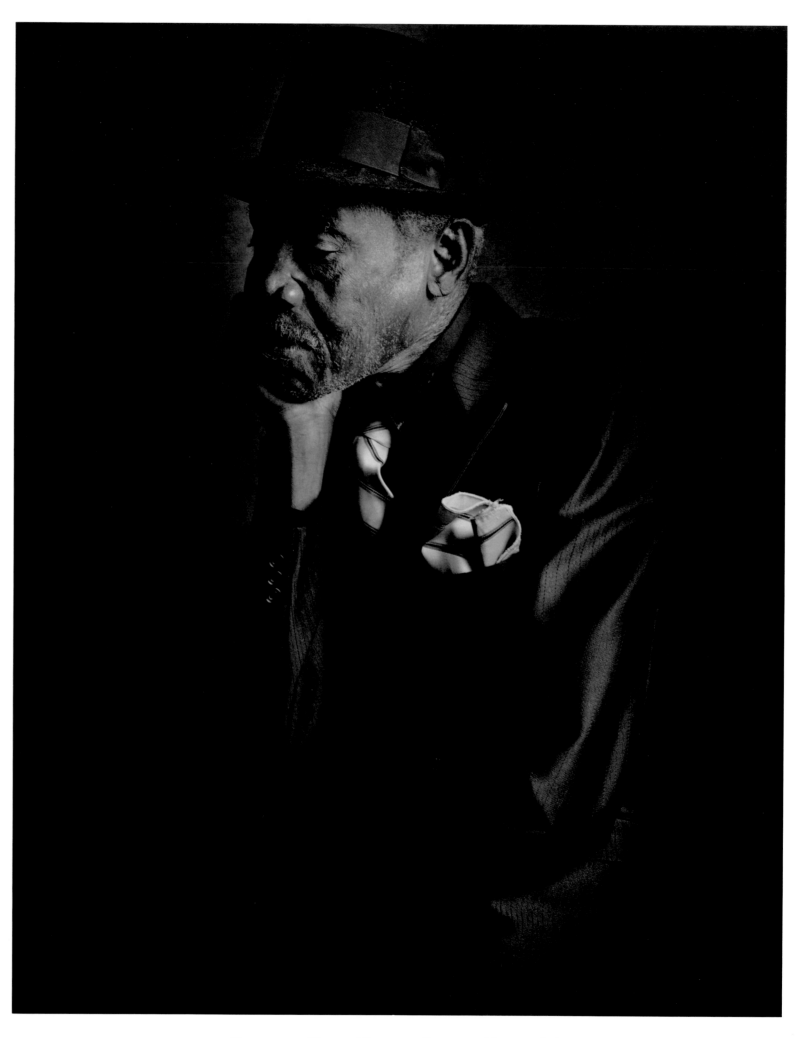

PEPPERMINT HARRIS (HARRISON LAMOTTA NELSON, JR.)
Texarkana, Texas

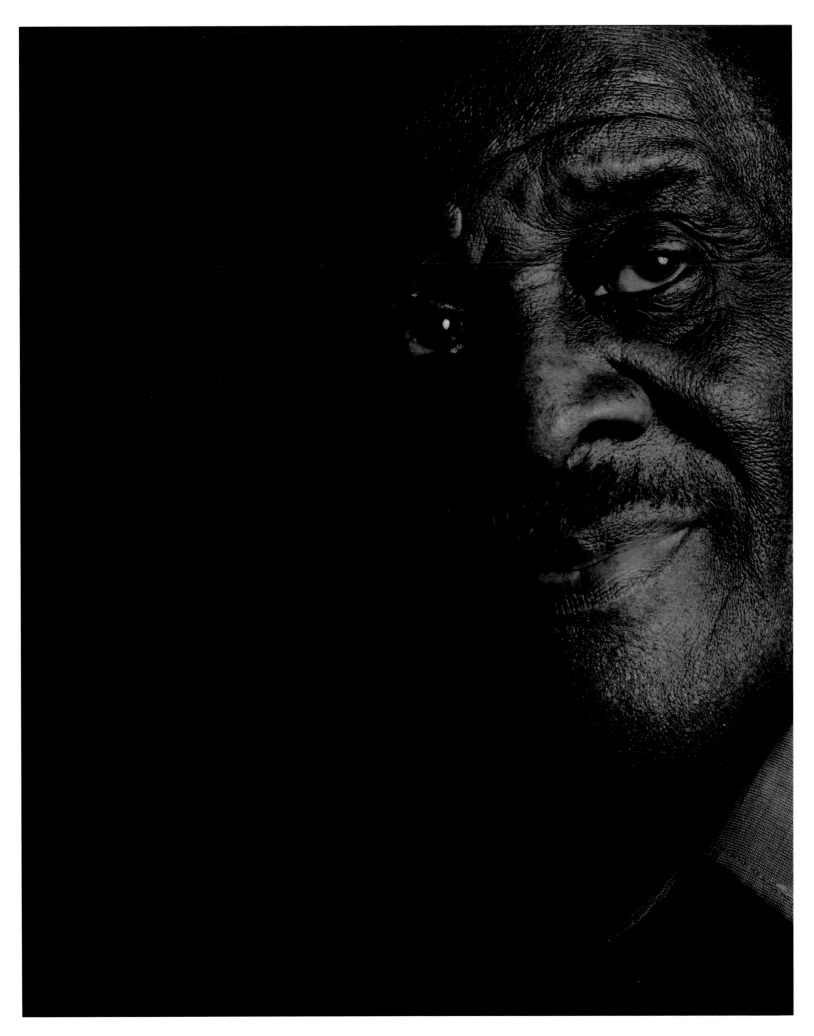

JIMMY McCRACKLIN
Helena, Arkansas

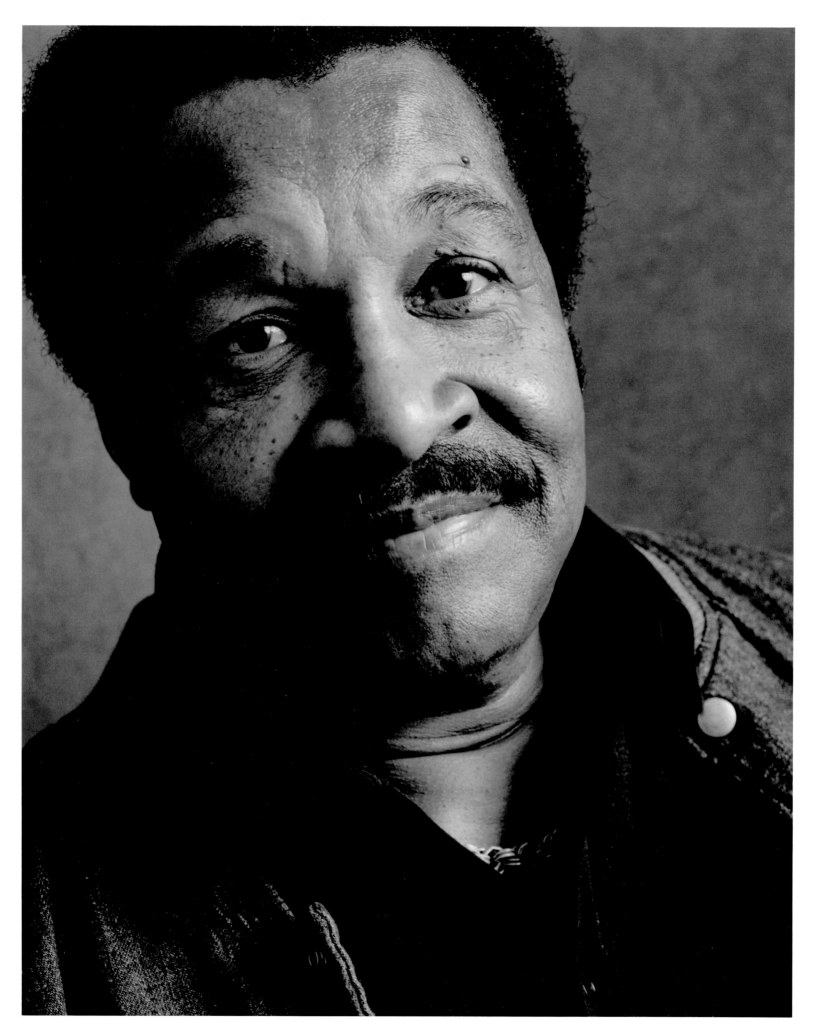

LITTLE MILTON (MILTON CAMPBELL)
Inverness, Mississippi

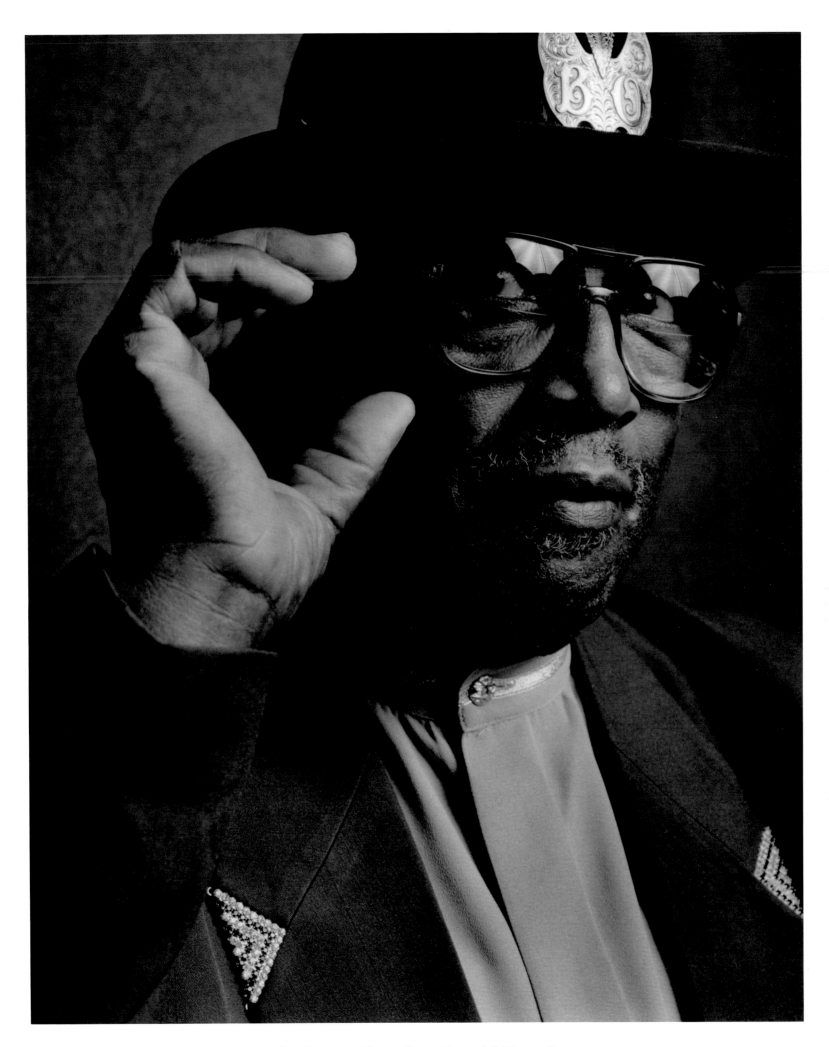

BO DIDDLEY (ELLAS OTHA BATES MCDANIEL)
McComb, Mississippi

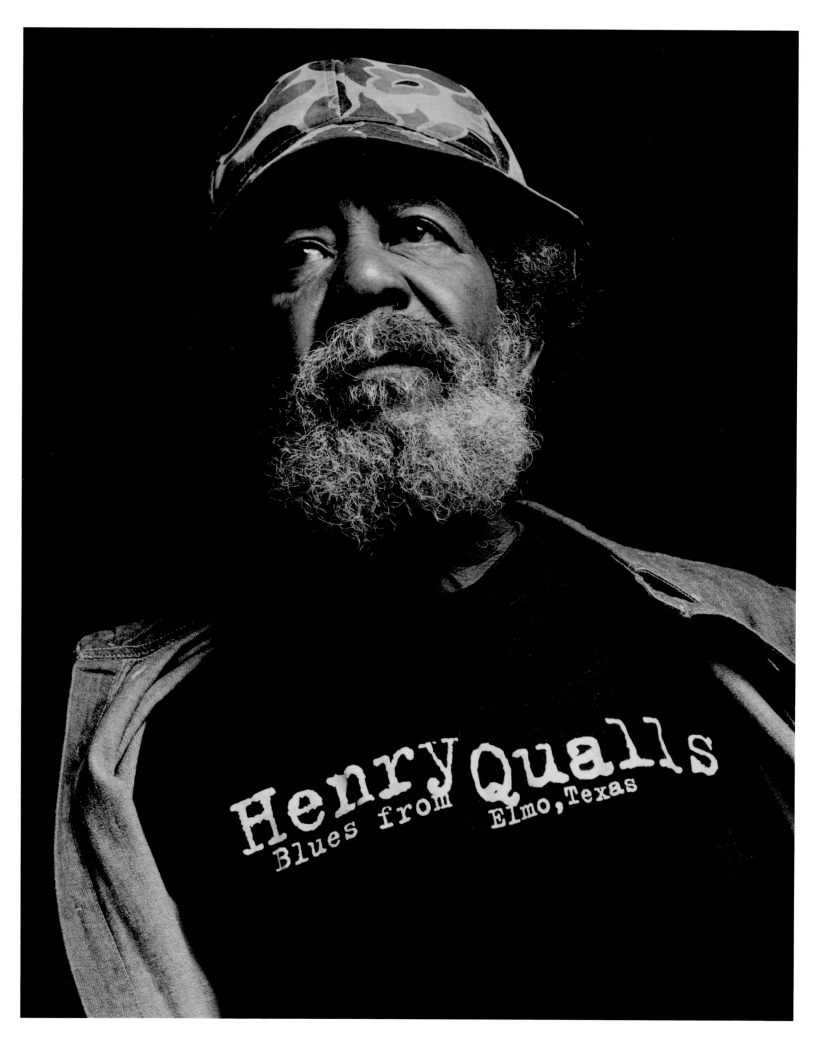

HENRY QUALLS
Elmo, Texas

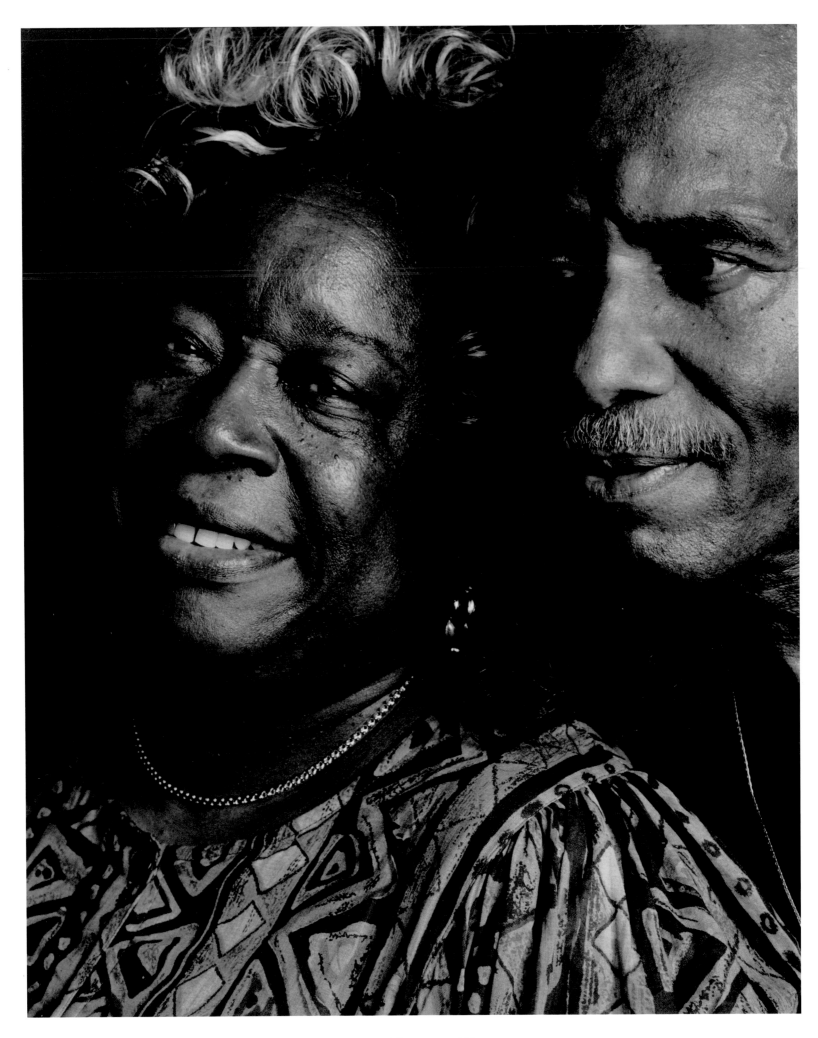

CAROL FRAN / CLARENCE HOLLIMON
Lafayette, Louisiana / Houston, Texas

65

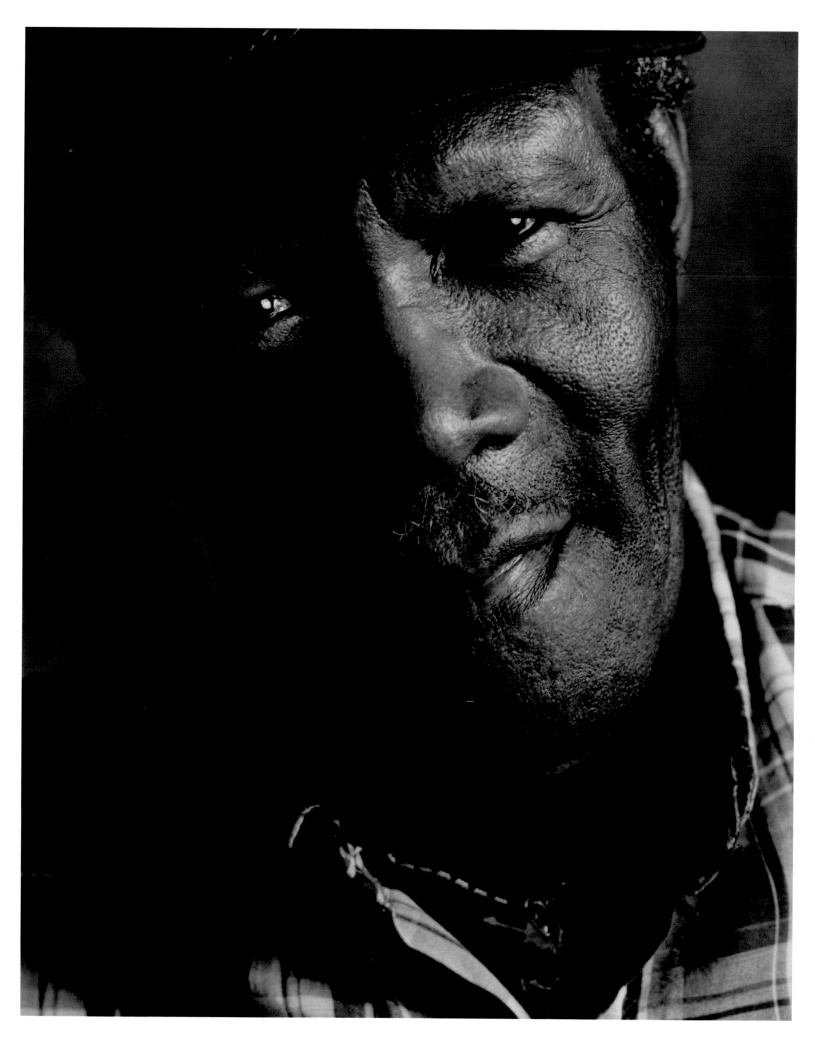

SMOKEY WILSON (ROBERT LEE WILSON)
Glenn Allen, Mississippi

66

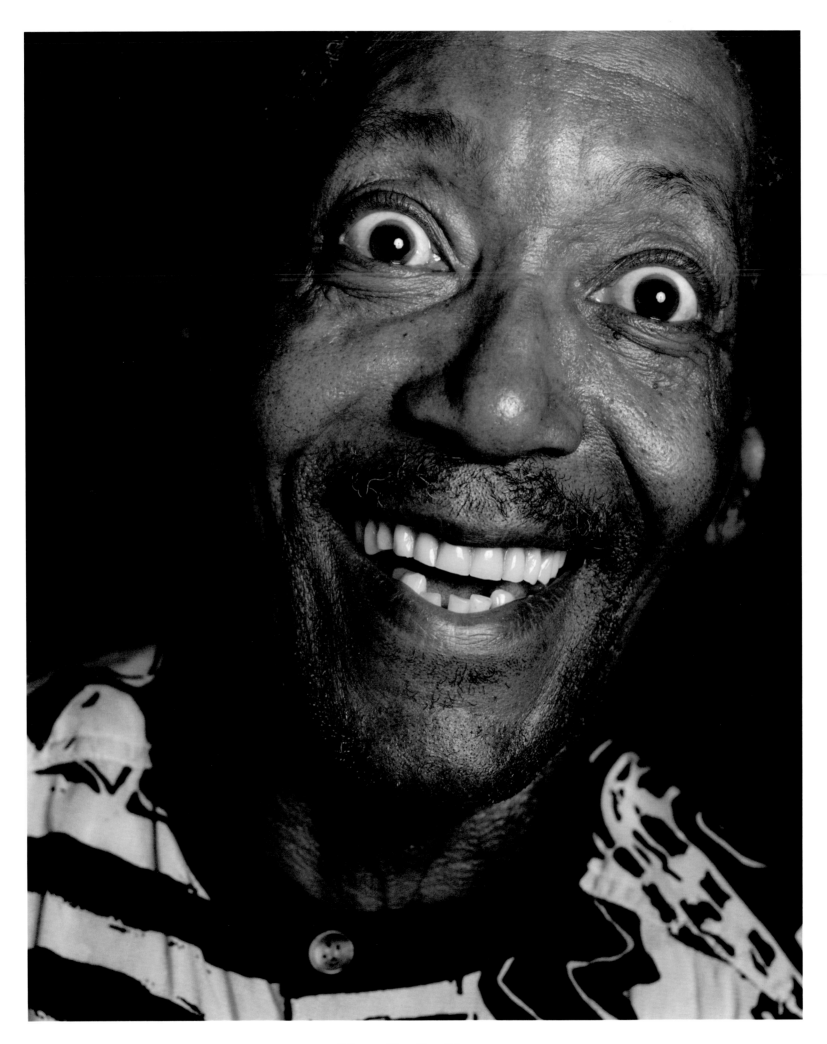

WILLIE "BIG EYES" SMITH
Helena, Arkansas

INTERVIEWS

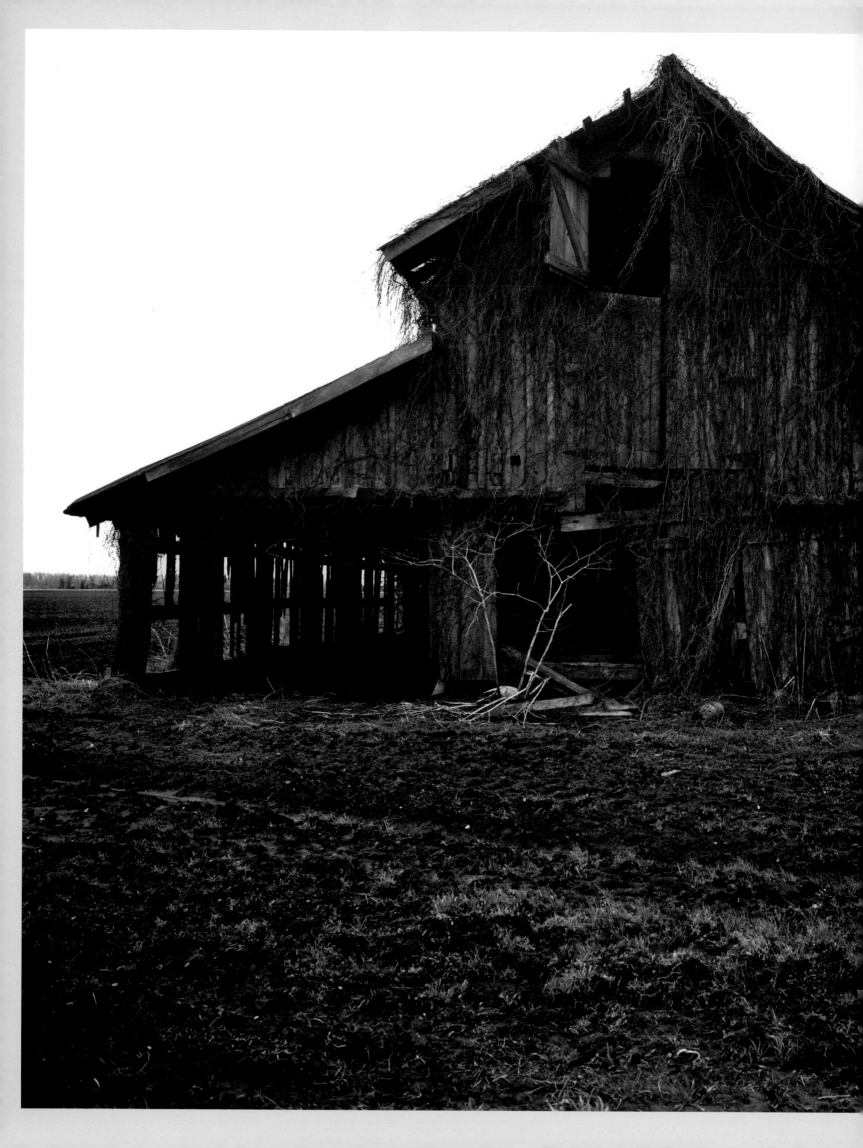

ORIGINS OF THE BLUES

Well, you know, the blues has been here since day one. In the afternoon, as the sun is going down in the West, and everything is quiet, and you can hear a voice way back down in there on a clear afternoon. Voices carry. You can hear a voice way back down in the bottom saying, 'Let's go back to working hard. The man ain't mean, the camp's all right. But the cook ain't clean.' Now, that man has got the blues, and he's letting you know about them.

—Rufus Thomas

Bobo Barn, Bobo, Mississippi

T he blues is a reminder of hard times, oppression and slavery. That's what it's all about. A lot of people try to erase that because of the modern times going on today, but in my day it wasn't like it is today. Times is good for a lot of people like myself now, but then the blues was about slavery.

—KOKO TAYLOR

"I was told by my parents and grandparents that their parents told them that the blues are field hollers, if that make any sense. A guy be plowing sometime, and, 'If I feel to-mor-ro-oh like I feel today, if I feel tomorrow like I feel today, I'm gonna make my getaway.' He's trying to run away. He's a slave, you know. Then these guys would get so good at doing this till they would entertain the rest of the slaves. They became like real entertainers for the slaves. Then there were disciples. I'm one of them."

—B. B. KING

"The blues started in the slave times. My personal opinion is that it came out of oppression."

—BILLY BOY ARNOLD

"In the slave ships, when they were coming over, there was so much oppression. . . . On the ships they would start hummin' and moanin' because they were sore and there was maggots and filth and stink in the bottom of the ships. So they was just moanin' and groanin'. Somebody would just sing something. So it came out of the hurt."

—JIMMY DAWKINS

"Blues came from holler songs. People used to work in the fields, and they worked from slavery, and they'd work all day long, and they didn't have nothing to do because they was tired and everything, and somebody came along and they started singing a song. They started singing the songs, and they're called the holler songs. In the '20s, Ma Rainey and Bessie Smith and Ida Cox and all of those back in the '20s, they started playing it and named it the blues. But before then it was holler songs."

—HONEYBOY EDWARDS

"The blues didn't start in the North. It was continued in the North in different places, but it started in the South and came out of conditions of oppression and suffering, and it was due to the strength of character of the people that performed it and played it that it is what it is today."

—JOE LOUIS WALKER

"In my opinion, the blues actually started in Africa, more so than the cotton fields. But we didn't know it as blues then, or blues music."

—SAM LAY

"Well, it goes way back. It goes back to slavery, really. It was a form of getting messages across to other plantations—one group of slaves communicating with another group, but without the masters knowing what was going on. You know, they did it in a discreet way, where you might hear one guy, 'I'm goin' to leave in the morn-in. I'm gon' leave in the morn-nn-ing.' Then another one would say, 'When the su-un goes down.' So in other words, that means when the sun go down, they gonna be gone. In other words, escaping, you know. Catching that underground train, you know. But really

most of them brought the blues from Africa, but it was a different kind of blues."

—BIG DADDY KINSEY

"Some folk might say that blues ain't nothing but a woman wanting to see her man, blues ain't nothing but a man wanting to see his woman. But that's not always the case. Blues is a feeling that you get when you don't get anything else."

—RUFUS THOMAS

"The blues have a different meaning to every blues artist. I mean, to me it might mean one thing, and to the next guy it means another, but it's all from the life he's lived and the experiences he's had. And a lot of it is from sadness, loneliness and so on, if your woman treating you wrong. It's just from being mostly mistreated in life. And we have to face reality. I mean, the black man has been mistreated as long as I can remember. And that's enough to create the blues, really."

—BIG DADDY KINSEY

"From listening to people, a lot of people, musicians, it came from people picking cotton in the fields, singing, to keep going and stuff. The singing I guess was kind of off-bred from gospel, but they were singing their own problem songs, I would say."

—LONNIE BROOKS

"I'll tell you the whole damned truth. It's about racism. Lack of communication between white people and black people back in the old days. That's the only damned reason they would sing! Blacks would never tell their story to the whites directly. They have a culture and a history second to nobody. One of the greatest cultures in the world. It was like a little kid trying to talk and nobody wants to listen! So they started singing about their world and their life. This is what blues is! They'd be singing in the cotton fields or on the plantations. When they got off on the weekends, they'd come into town and sit on the sea wall, sit by the train station, or the Red Ball store, or one of the juke joints where they could pick up a couple of dollars. They were singing about their experiences, their everyday lives, about history. Since you wouldn't listen to them, didn't have time for them, and they couldn't talk to you, they would sing about it instead. They would sing instead of talking."

—SONNY PAYNE

"See, the reason why the blues is so international, it covers all human beings; everybody who ever lived has had the blues or will have the blues. If you ain't got your rent money next month, you've got the blues. If your best girl quit you, you've got the blues. If you get fired off your job, you've got the blues. And that doesn't cover just blacks; that covers anybody. If you have a job at $100,000, your girl thinks you're doing great and everything, and you get busted—you blow the job. You go get a couple of belts of liquor, you're scared to come home. . . . You've got the blues. How you going to pay for that boat? How are you going to pay for those new cars? How you gonna keep that woman? That's the blues. She'll be the first to go. You'll still have the boat, but you won't have her. It's a basic human experience."

—BILLY BOY ARNOLD

Well, it's played from the heart. It's played from the soul. The real inner man. It's the spirit of him playing his inner feelings through an instrument. But it's pain and hurt.

—JIMMY DAWKINS

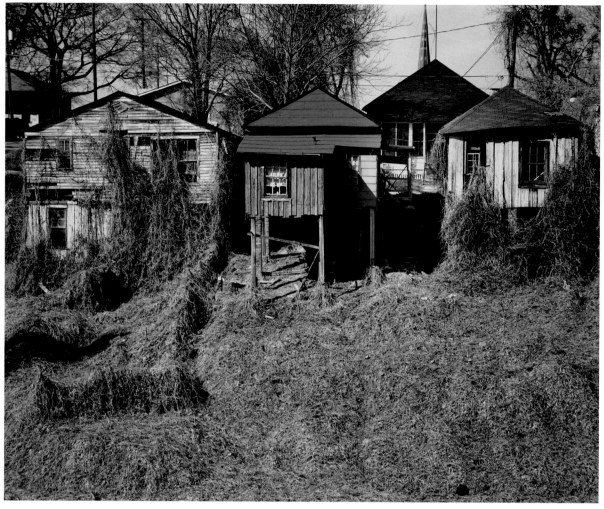

Vicksburg, Mississippi

THE SOUTH

"My family told me that the blues started in the South. I've read that it happened in the southern parts, especially in Mississippi, Georgia, Alabama, through that area. I don't know why that area, but Mississippi seemed to have got most of the blues singers in that area. It's been said that within a hundred miles, most of the blues singers was born and started to play—within a hundred miles of each other. So for example, myself, John Lee Hooker, Jimmy Reed, Koko Taylor, and I could just go on and name you many, many more, within that hundred-mile range. A few of the other states, too . . . like Louisiana had Lonnie Johnson. We've got Texans like Blind Lemon Jefferson and T-Bone Walker; they truly was born in Texas."

—B. B. King

"And the reason why it started in the South is because that's where the slaves were brought to work the fields, and that's where they were oppressed. Now, Mississippi is noted to be the worst Jim Crow state of them all, the most suppressed state. All the blacks were brought to the South. They took them off the boats down South to pick the cotton and work the fields and do the manual labor to build up the country. All blacks came from the South. And the reason why Mississippi, it had all the plantations. That's where they had a lot of work, and that's where the most supreme effort was to suppress the blacks and mistreat them. So the blacks in Mississippi, on the plantation, you had to have the blues. In Mississippi you are sad most of the time, because you're oppressed, not a free man, here's a man got control over you, telling you what to do, here's a man who have power of life or death over you. So you start singing the blues. See, the blues is sort of like a way out. You know what I mean? It gives you something to go on. You sing about it, and it sort of eases the misery of everyday life."

—Billy Boy Arnold

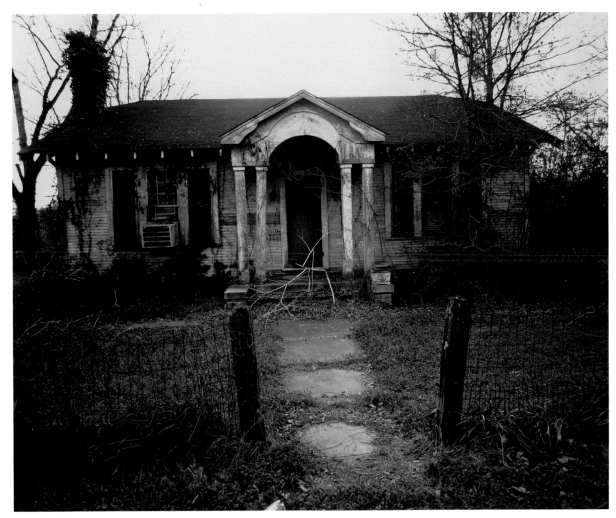

Morgan City, Mississippi

"It's just about black culture. That's the bottom line. It just was black people's destiny to sing the blues. But it has different meanings to everybody. But one thing, it was created in the Mississippi cotton fields in the Delta, getting messages from one plantation to the other. That's how it really got started in the United States, is communication."

—BIG DADDY KINSEY

"The Delta is where it was born and raised. You don't forget your hometown do you? After it caught on here, it caught on in Louisiana and Tennessee."

—SONNY PAYNE

"I think that's where it started from, because nearly everybody that I met who played blues was from Mississippi. I asked them, 'Where are you from?' 'Mississippi.' There were a few of them from around Memphis, but most of the blues players that really did something with it was from Mississippi. Well, anywhere in the South everybody

wanted to get away. I mean, it's still like that usually. Man, a lot of times I went through there, and girls find out you're from Illinois, 'Can I go back with you?' I said, 'I don't think my wife would like that.'"

—LONNIE BROOKS

"That's where the problems were with the black people in the cotton fields and living with disappointment and no equal rights. That's why it's natural the heartaches and disappointments of the blues came from the South. In the North, they had equal rights. . . . My father was a sharecropper—we didn't go hungry but things was racial, you had to stay by yourself. The Chinese too. We couldn't go with the white race. Chinese and black and Mexican could mix. A Mexican guy worked for my father. They never considered Mexican or Chinese like white, and you couldn't mix. I don't think it made a big difference on my music, though."

—JOHN LEE HOOKER

75

W ell, you can be from anywhere. If you like something, you like it. That's how I feel about it. A lot of people think that if you're not from Mississippi, you're not real, but hey, man, I'll tell you what. One of the greatest harmonica players in the world came from Louisiana—Little Walter.

—LONNIE BROOKS

"I'd quote Big Bill Broonzy. It didn't start in the North. It started in the South. You see, black people all over the world, on all the islands—there's no blues. Because they wasn't as severely oppressed as they were in America. Have you ever heard of the Willie Lynch Papers? Okay, if you read the Willie Lynch Papers, you know why the blues existed and were born in North America. He's a white guy who wrote a paper about how to suppress and to destroy the mental capacity of the black slaves. This paper was designed to pit them against each other, man against woman, woman against man, child against adult. That's why the black people are in sort of disarray compared to other people. A lot of blacks killed whites in the South, too. But whites didn't want to admit it. They called them crazy, because the blacks got out of hand. That's why the Willie Lynch Paper was designed, because they were actually afraid of the blacks having an uprising, yes. So the Willie Lynch Paper was designed to destroy them mentally, so they would never think of having an uprising. That's why the Ku Klux Klan came in. Well, this is where the blues came from. See, when they brought the blacks here from Africa, they were just people like anybody else. The blues came about from oppression. If there hadn't been any oppression, there probably wouldn't have been any blues."

—BILLY BOY ARNOLD

"I can recall years ago, as a little boy, I picked cotton. Didn't chop cotton but I picked cotton. Never picked a hundred pounds of cotton in my life. I picked ninety-eight. That's as far as I could get to a hundred pounds of cotton."

—RUFUS THOMAS

"Well, it was so hard, man. It was so hard in the Delta. You know, people working even in my time. They called it sharecropping. Well, I'm just saying during my generation in general that's all black people done in Mississippi, period, was farm. Either drove tractors or stuff like that. It's a bad situation when your man works all the year, sixteen hours a day, sometimes beyond that, and then make a good crop, and then at the end of the year the proprietor or the plantation owner tells him, 'Well, John, you almost got out of debt.' In other words, come out of the hole. Well, that's enough to give a man the blues. You know what I'm saying?"

—BIG DADDY KINSEY

"My Daddy was a farmer. And to not even think about the work—you could work a little bit longer and a little bit harder—I used to just make up songs. I'd hear a little bit of something, I couldn't remember it all, and I'd just use my own words to it. And most of it was blues. And my mama, she wanted me to be a preacher."

—LONNIE BROOKS

"Cotton and gin, that's all through the Delta. After they run all the black people away from there, then the govern-

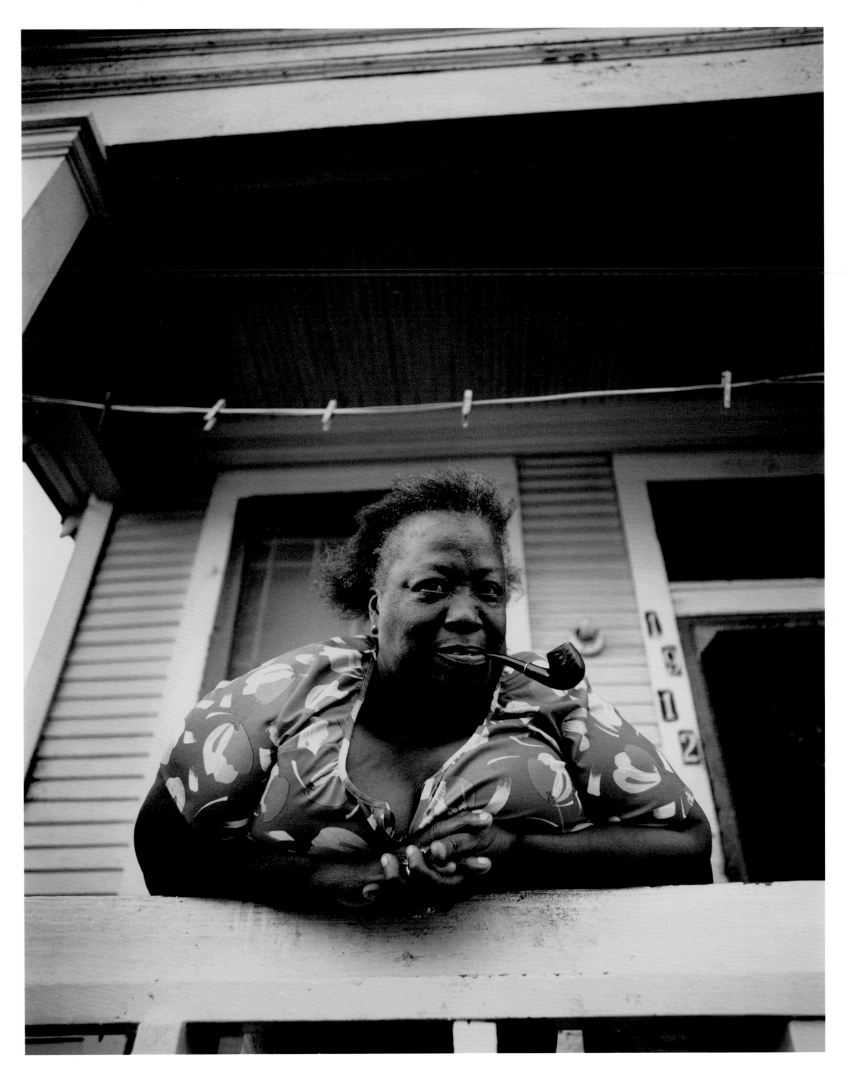

Eloise Random, Garden District, New Orleans, Louisiana

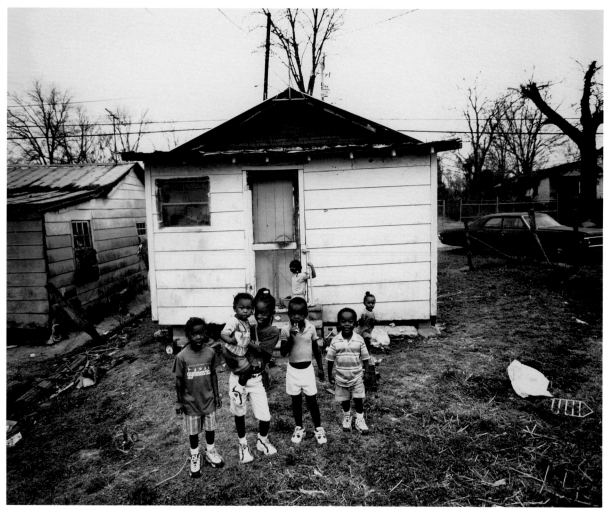

Whitney Family, Port Gibson, Mississippi

ment came in and opened up casinos and things in there just to bring that money back into the state. Because they got cotton, but they got them mechanicals picking the cotton now, and the cotton got such a bad sample that they can't make no money off of it. But they don't care, because they're getting it picked for free. They don't care how bad the sample is. They're making something. But to get the best sample, good and white, you have to pay to pick it and everything with your hands. Them mechanicals might pick a bale, in probably two hours got a bale but it's so nasty a dog won't lay on it—the sample's bad."

—HONEYBOY EDWARDS

"When I was a kid I had to go to the farm and pick cotton. I didn't have no daddy. We grew up down South. I used to put a croker sack on. A croker sack is a short sack. When I got bigger, I used to put on a long seven-foot sack. I used to have kneepads to put on my knees, because your back gets sore. You're picking cotton, you're bending over all the time doing it, picking cotton. . . . But that's what we had to do. That way you can pick three hundred or four hundred pounds of cotton in a day. Well, by being three or four of us in the family, about every three days we'd have a bale. Yeah, it would be five or six hundred pounds after they'd take the seeds out of it. If we wanted to take it to the gin, we'd have five hundred or a thousand pounds in the wagon. We'd have mules pull the wagon to the gin, where they gin the cotton. They'd take the seeds out and use the seeds for oil and different stuff, and they'd take the cotton and make clothes.

"Far as I could pick was three hundred. I had a brother who could pick five hundred and fifty. I used to get a whupping all the time because I couldn't pick no more cotton than that. I just couldn't do it. I'd be sitting on my sack, blowing my harp. Yeah! I'd get enough cotton in my sack, I'd sit on my sack, blowing my harp. My mama would come back there and hit me behind with that switch.

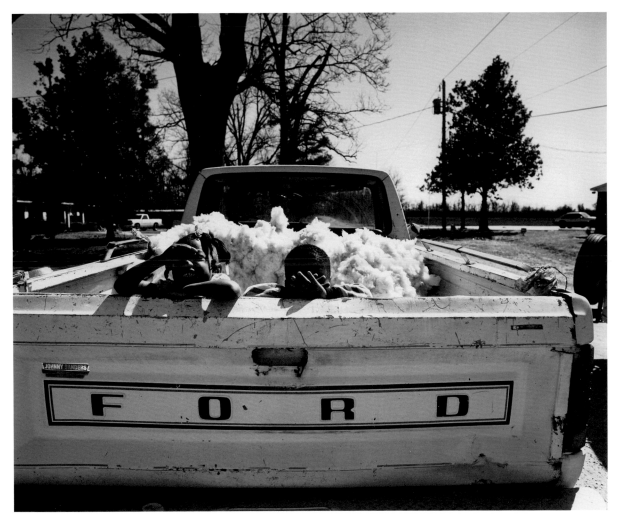

Kids in the Cotton, Glendora, Mississippi

"We worked from sunup to sundown. When you could see, that's when you started working. And everything you make, you had to give the man who owned the cows and the horses. They'd get half of what you'd make. Sometimes you'd never get out of debt. You were always working, and when the end of the year comes you're $500 sometimes in the hole, so you'd have to go back in debt again for next year. Then next year you'd get a little better crop and then you'd come out of debt. It was hard on the farm, but now it's much different. They've got cotton-pickers and everything now."

—LITTLE MACK SIMMONS

"The people left the farm, and come to Chicago to get jobs, they went to Detroit, they went to California, they went to get jobs. Because when they got them machines to work in the field, they run the people away from there. Because a lot of people would be there right now if they'd get something to do. There wasn't nothin' to do. They had to leave there to eat. There wasn't anything for them to do."

—HONEYBOY EDWARDS

"I grew up on a sharecropper's farm. I know all about that, really. Could you blame them for wanting to get out of there? I got out of there when I could. I can truly say that I had a good life, and I had a good start. A lot of things that could have been going on in my life today that's not going on, and I'm mighty proud of it. I feel a lot of that came from being raised up the way that I was."

—KOKO TAYLOR

"Well, there was two reasons the blacks left the South. One reason they wanted to leave was the oppression. And in Chicago, Detroit, and the cities, there was less oppression. You wasn't on the plantation. The North had the reputation of being a little more liberal towards blacks. There's racism all the time. It never, ever stopped, even today."

—JIMMY DAWKINS

Texas produced its share of blues singers. . . . There was also the New Orleans sound. . . . Each area picks up on sort of a sound. You call this the New Orleans sound, you call that the Chicago sound. The Chicago sound is nothing but the Delta blues.

—BILLY BOY ARNOLD

"And a lot of the people like myself who started out, we didn't know much about the music business, some of us right off the plantation. We didn't know anything, no more than that we thought we had a talent, we thought it was something people would like to hear. Some of us had been kind of told that we had talent, because you're on the plantation or you're in a little town, and you play and sing or whatever you did, people would praise you for it. So it gave you confidence. Made you think that you had something that people would want to hear. Then when you did get to the big city, where everything is going on, you found out that you wasn't as talented as you thought you were. But I didn't see going to Chicago, New York, or any other place at that time. For me, from Indianola, Mississippi, to Memphis, Tennessee. Memphis is where I thought it was—and where I still think it is. It to me was a place . . . they used to call it 'the home of the blues,' and a lot of us still think so."

—B. B. KING

"Well, the reason why there ain't no New York sound, New York has always been an international city. It wasn't a place for the steel mills and stockyards and a lot of jobs. Most of the blacks from the East Coast came right up the East Coast to New York. It's a different type of job. People from Mississippi and Tennessee and all that came right to Chicago for all the jobs. People passed the word that here you can get a job doing this and doing that. So they came here, and that's why the music—Chicago is a blues-based city.

"Texas produced a variety of blues singers: Little Esther Phillips, Lowell Fulson, Lightnin' Hopkins, Lil' Son Jackson, "Gatemouth" Brown (who was originally from Louisiana), T-Bone Walker come out of Texas. So a lot of people came out of the Texas sound. Albert Collins came from Texas, but he played in Chicago.

"There was the New Orleans sound. Lloyd Price. Listen to 'Lawdy, Miss Clawdy'—the original Lloyd Price. Fats Domino. Smiley Lewis. Professor Longhair. They come out of the New Orleans sound. Each area picks up on sort of a sound. You call this the New Orleans sound, you call that the Chicago sound. The Chicago sound is nothing but the Delta blues. Everybody's talking about the Chicago sound. Well, back then all these RCA-Victor guys was dominating, they was playin' in the clubs. Lonnie Johnson and Sonny Boy Williamson played at 45th and State together. Memphis Slim played the West Side, at Ralph's Club. Big Bill Broonzy was playing at Gatewood's. Those guys were on the scene. Tampa Red and them was playing all around Chicago. Memphis Minnie. And Muddy and them then was playing at small, insignificant clubs, like on the West Side around Maxwell Street, Roosevelt Road. Not the major clubs, because they wasn't major artists.

"The Chicago sound then was Sonny Boy Williamson [I] and all these guys. Sonny Boy was one of the major artists of that time. So you say the Chicago sound, but all those guys was from everywhere in the South . . . Mississippi and Georgia and Tennessee and everywhere else."

—BILLY BOY ARNOLD

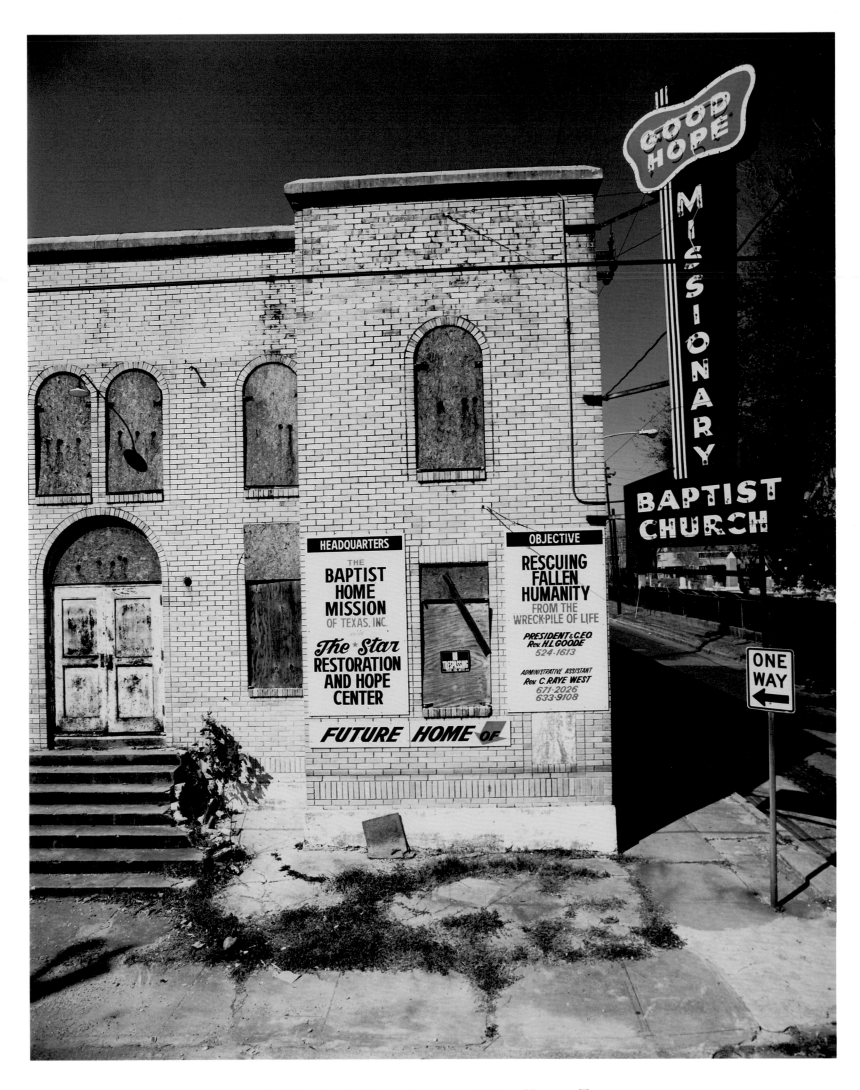

Good Hope Baptist Church, Saulnier and Wilson, Houston, Texas

THE BLUES TRADITION

The guy that I think has done more for blues than most people, which is why we called him the Godfather, was Muddy Waters. So when Muddy Waters went to Chicago, Chicago opened its arms and let him in. Then a lot of the young people, and especially young white people, started to listen to Muddy Waters. Muddy Waters is the guy to me who did it.

—B. B. King

Muddy's Cabin, Stovall Plantation, Stovall, Mississippi

I t wasn't too many people around where I grew up at that had record players, or gramophones or whatever you call them. My aunt had one, and she had some of Blind Lemon Jefferson's records . . . I'd play lick for lick what he was playing.
—BIG DADDY KINSEY

"Everything is in stages. They had stages in the '20s and '30s, people like Son House, who to me was one of the real true giants, maybe not as popular as Robert Johnson, but among musicians highly respected. You had a lot of people—Peetie Wheatstraw (The Devil's Son-in-Law), and Blind Willie McTell, Blind Willie Johnson—all these players before electric. Then you had players like Sonny Boy Williamson I and Big Bill Broonzy, when they was out of Chicago, when they moved to Chicago. Then you had guys like Muddy Waters, who was important, because he made the big transition from acoustic to electric. I mean, he pretty much wrote the book on how to play Chicago blues, which is one of the biggest pages of blues history. Because any town you go to and any city where there's blues, somebody is going to be playing Chicago blues. I mean, Muddy Waters is mainly responsible for that."
—JOE LOUIS WALKER

"Well, I was born in '27, and I started listening to different forms of music, I guess, around the age of seven, in the early '30s. It wasn't too many people around where I grew up at that had record players, we call them, or gramophones or whatever you call them . . . the one you wind up and turn on. My aunt had one, and she had some of Blind Lemon Jefferson's records. That's really how I started off playing the guitar. I'd sit down in front of that Victrola and listen to his records and play lick for lick what he was playing. It was very easy to play. I don't know how . . . I heard one guy playing slide, and he was playing in open G, I believe, and I learned how to tune my guitar in that key and started messing with the slide. That's when I really got interested in it."
—BIG DADDY KINSEY

"See, in the 1920s, the piano players was dominating the blues. Every rent party, every juke joint had a piano. There was two main instruments in the blues, guitar and piano. Piano was dominant. Guitar was secondary. In 1937, the harmonica came on the scene as the third blues instrument in the hands of John Lee "Sonny Boy" Williamson. Today in the blues, the piano is obsolete, the guitar is number one, the harmonica is number two."
—BILLY BOY ARNOLD

"Well, the piano is about the older one, but the gih-tar is next. Guitar is next. You take back in the '30s up until the '40s, the piano players give guitar players a hard time back in them days. A lot of good guitar players, but they couldn't make no money. The piano made a little more because you had piano dives then, piano clubs. Piano always loud. You didn't have to put no amplifier or nothing on it. And it gave the guitar players a hard time. But if you take in the early '40s, when they made that electric guitar and put that speaker on it, then the guitar players began to give the piano players a hard time! Because they can't take their piano everywhere. You've got to go where a piano's at. If you take your amplifier and your guitar, you can go anywhere there's a bigger crowd.

See, when they put that electricity on that guitar, you made something. It was 1931. That's when they first came out. But we couldn't get none then, because it cost

84

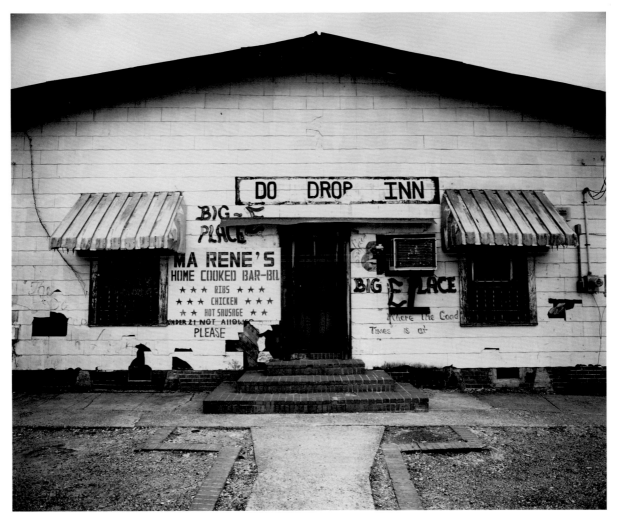

Do Drop Inn, South Lake Street, Duncan, Mississippi

so much money. Most of the black boys, there wasn't no jobs—and that wasn't too long after the Depression. So we didn't have no money. The only people had them electric guitars was them big farms with the white boys going to school, and all the white kids had electric guitars. I didn't get an electric guitar until the forties. I had a Nashville, a big Nashville studio guitar, and I was playing on Franklin Street there in St. Louis, went back in the alley where we was gathering one morning, shoved my guitar back in the corner, shooting . . . watching the dice. I wasn't watching my guitar. . . . When I looked around, my guitar was gone. Somebody stole it."

—HONEYBOY EDWARDS

"Honeyboy Edwards used to come up here to Helena [Arkansas] when we were doing the King Biscuit Show live on York Street, every damned day of the week. He'd ask me, 'Sonny, when you goin' to let me play some on the radio?' I'd tell him I wasn't the one he had to talk to. He'd go on back there and ask four or five days in a row. One time I asked the boss, 'Would you let that sombitch play his guitar and sing?' So he starts singing the West Helena Blues! I couldn't barely get him off! Hell, I used to see him coming into town all the time but I'd never heard him play. So there he was playing and I said, 'Well I'll be damned! He's better than [W. C.] Clay was.' Clay had replaced Robert Jr. [Lockwood] on the show by that time."

—SONNY PAYNE

"It was a time, I believe, when blues singers were not popular people. They were shunned in towns, talked about, this-that-and-the-other, and now it's sort of went full circle, where blues singers are looked up to and guys can make a living. Now guys don't have to play on street corners like Blind Lemon Jefferson and guys like that had to do."

—JOE LOUIS WALKER

ROBERT JOHNSON

"See, people like our fathers and our mothers knew Robert Johnson when his records came out. He only made a few records. But we wouldn't know nothing about it, because his records were obsolete. People that was old enough to be our fathers, they knew who Robert Johnson was. And he was a big hit with the black audience when he came up. See, let me show you why Robert Johnson was so significant. Look how many styles came out of Robert Johnson. Muddy came from Robert Johnson, of course Robert Lockwood, Homesick James, all the slide players. Elmore James."

—BILLY BOY ARNOLD

"In '35 I was twenty years old, and I really started playing the blues. I was playing harp and guitar. I used to play on the streets, nickels and dimes, on up to '37. In '37 I met Robert Johnson. He was twenty-six, and I was twenty-two; I met him Saturday at one o'clock. He was standing on Johnson Street, guitar in his arm. One woman walked up to him and said, 'Mister, can you play "Terraplane Blues"?' He said, 'Miss, that's my number.' She said, 'I don't care if you're half-drunk, whose number it is. If you play . . .' Robert started playing that guitar. Seen him standing on the street and people started ganging up on him like a mule in a stable. So many people around, I couldn't get to him. When I could get up to him I said, 'Are you Robert Johnson?' He said, 'Yes.' I was trying to ask him did he know my cousin, because she already had told me that he used to go with her. That was her boyfriend. Yeah. I said, 'You know Willie Mae Powell who live in Tunica?' He said, 'Willie Mae, yeah.' He said, 'That's my girlfriend.' I said, 'That's my first cousin, too.' Then we started talking there. I stayed with Robert all of '37, until winter. I left in the winter of '37, and I went to New Orleans, Vicksburg, and I came back in '38 in March. I got with him again in March, and I was with him until the night he got poisoned. He died on the seventeenth day of August, 1938. Robert was a good boy. Easy. I never heard him cuss. Never did hear him cuss."

—HONEYBOY EDWARDS

"I was with Memphis Slim. We was in Paris. He didn't like to be around him. He said Robert Johnson would go to cussin' God. He was at some of those roadhouses when he played outside of Memphis, western Arkansas and different places. Sunnyland Slim, I've heard him talk some of the same talk. Not about the Devil. But Memphis Slim said he would talk so much nasty talk and down God Almighty so much that he would be scared, and a lot of people would leave the juke joints and go out of the house because he was so devilish, talking against God. And Memphis Slim said he was scared to be around him."

—JIMMY DAWKINS

"I think most of his stuff was original. Honeyboy say he made a pact with the Devil. I don't know how true that was."

—BILLY BOY ARNOLD

"You hear it more than just that. You read it and you hear it. Pact with the Devil down at the crossroads."

—JIMMY DAWKINS

Sometimes I'd play with Robert from twelve until three or four in the morning. We played all night long, all night. You'd never quit then. You stayed drunk and played till sunrise Sunday morning.

—HONEYBOY EDWARDS

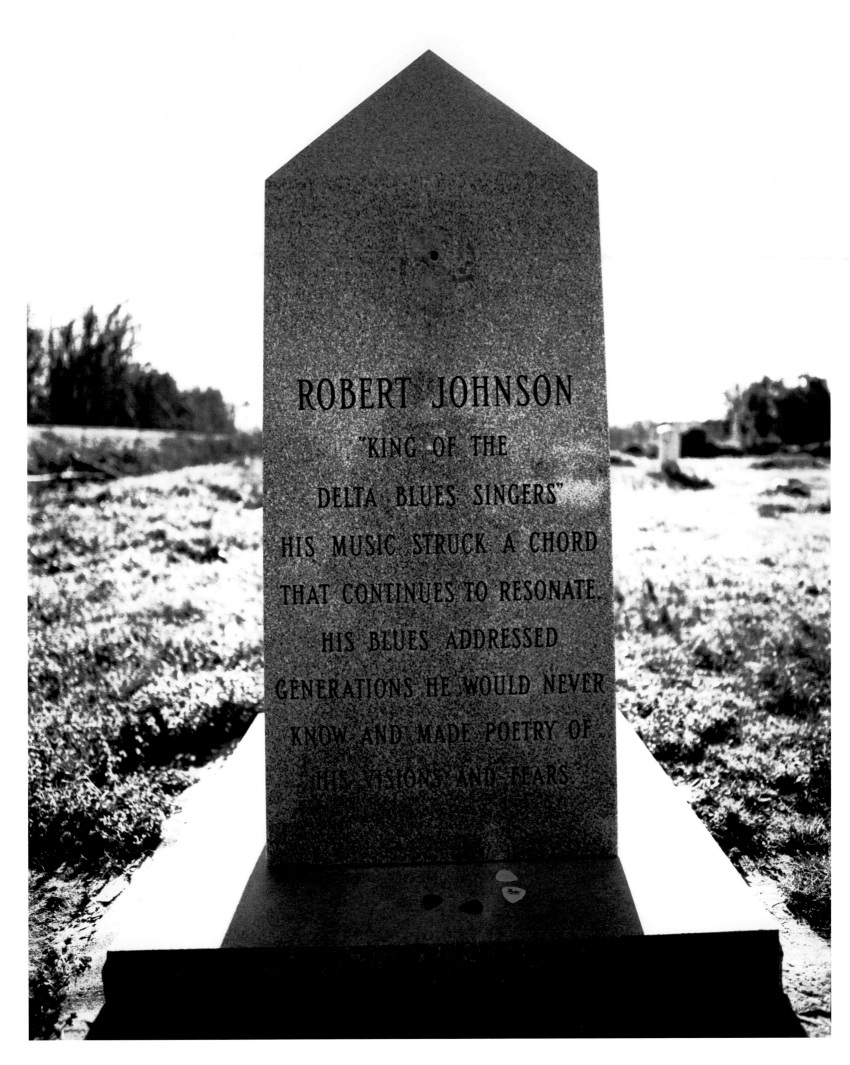

ROBERT JOHNSON
"KING OF THE
DELTA BLUES SINGERS"
HIS MUSIC STRUCK A CHORD
THAT CONTINUES TO RESONATE.
HIS BLUES ADDRESSED
GENERATIONS HE WOULD NEVER
KNOW AND MADE POETRY OF
HIS VISIONS AND FEARS.

Robert Johnson Memorial, New Zion Cemetery, Morgan City, Mississippi

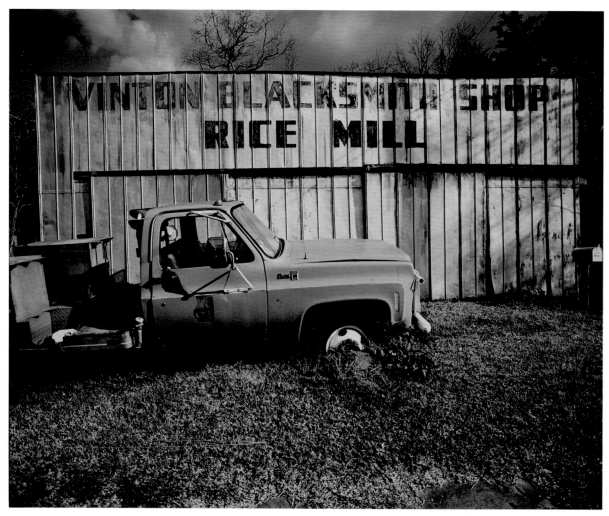

Rice Mill, Vinton, Louisiana

SONNY BOY WILLIAMSON I

"Sonny Boy the original was the man. There's about a hundred twenty-five of his recordings. He recorded consistently from 1937 to 1947. 'Good Morning, Little Schoolgirl' was a smash hit. Big Joe Williams played on 'Good Morning, Schoolgirl.' He said when Sonny Boy made 'Good Morning, Schoolgirl' the flip side was 'Sugar Mama.' He said he went over all the blues singers that was recording at that time, in 1937. He went over all of them in popularity. It was a two-sided hit . . . the rave of the black audience. And no harp player had ever appeared playing harp like that. He had a beautiful way of singing. He had what Jimmy Reed had. He had a unique sound, and it was a real bluesy sound. So that's how the harmonica got famous. And all the harmonica blowers owe a debt, directly or indirectly, to John Lee Williamson—not Rice Miller [Sonny Boy Williamson II]."

—Billy Boy Arnold

"I've heard John Williamson and his playing wasn't that great. He sang horribly. You have to listen to someone, listen to what they're doing. I had heard the two of them, and everyone I've met in my lifetime agreed that Sonny Boy I was nowhere near as good as Sonny Boy II."

—Sonny Payne

"John Lee Williamson made his first record in '37. Muddy made his first records in '43. Or '41 I think they were recorded. But Muddy wasn't ready. Elmore wasn't ready in the '40s. Wolf then wasn't ready. John Lee "Sonny Boy" Williamson was eighteen years old or twenty years old. His style was there. Smash hit. First record was a smash hit. All his records, if you listen to those records, you see how he evolved up to that time."

—Billy Boy Arnold

"Well, in Chicago, Sonny Boy Williamson was a big influence, but he didn't live long enough to really get it

well going. Rice Miller come in and took it from him. I mean, really, Rice. . . . As far as I'm concerned, of the two Sonny Boys, Rice was the most popular one. But it might have been because he lived longer. The first one, he was kind of . . . you know, he was kind of like Little Walter. Fighting and stuff like that. That's why he didn't live long. I think somebody stabbed him to death."

—BIG DADDY KINSEY

"Well, personally speaking, I'd say John Lee "Sonny Boy" Williamson was the most popular. Of Big Bill [Broonzy], Memphis Minnie, and all those people, the audience really liked him. His wife said one time he was sick, and a club owner told him, 'Well, if you could just sit on the bandstand, don't play, let the band play, as long as the people know you're here, they'd be happy.' And he just sat on the bandstand while the band played, and the people were just overjoyed. And he could leave one club and take sixty people with him. At intermission, when he would go down the street to another tavern, all the people would follow him down there. He was the most influential in Chicago.

"Memphis Slim didn't really like him because he was more popular. I mean, record-wise. The audiences really dug him. So when they had a gig, everybody wanted Sonny Boy to play, and didn't care whether Memphis Slim or Big Bill and them played at all. But that made them kind of jealous of Sonny Boy, because he was a crowd-pleaser. So they had to have him on gigs because the club owners and the audiences wanted him."

—BILLY BOY ARNOLD

SONNY BOY WILLIAMSON II

"See, when Sonny Boy died in 1948, Rice Miller had been imitating him for ten or fifteen years down South. So when Sonny Boy died in 1948, he made a record, and called himself Sonny Boy Williamson. Actually, Rice Miller is the prowler. He is not Sonny Boy Williamson,

he never was Sonny Boy Williamson. But he called himself Sonny Boy."

—BILLY BOY ARNOLD

"I'll put it to you this way. To me, Sonny Boy II was one of the finest men I ever met in my life. You're not going to get me to say he was a no good son of a bitch! I met him in 1940. They [Sonny Boy I and Sonny Boy II] never met to my knowledge. Yank Rachell didn't like Sonny Boy II. I don't know why. He claimed Sonny Boy I was better. He was full of shit! Sonny Boy I couldn't carry Rice Miller's harmonica case. In my opinion, Rice was a far better entertainer than any of them, and I grew up in a black neighborhood and I know the blues. I've heard it all my life."

—SONNY PAYNE

"I remember Rice Miller back around '51, '52. He stayed all night at my house! He played out in a farm out there. These farmers didn't want to go to the town, so they had something like road houses. You could get you some wine or some beer or some whiskey, whatever you drink, and a musician would play out there. So they had this big place . . . to us it was real big. It would hold maybe three hundred or four hundred people. Oh, man, they had places down South. And they had him out there. They only had about two or three people come out to see him, and he didn't have enough money to get back home. I think he was living in Chicago. We didn't have a telephone then. We went out to see him, me and my friend. He said, 'Man, I don't know where to stay. I ain't got no money to get a hotel. I ain't got but fifty cents in my pocket.' He played for the door. Ain't nobody come in! And he come back with us, and we let him sleep on the couch. He stayed there about three or four days, man. He kept calling Chess, because I think he was recording for Chess, and he couldn't get Chess. Chess had to send him some money to get back home. They would send him on the road to push the records, and he didn't have no money, and he was catching a bus to go where he was

When people ask me if Sonny Boy was a fascinating guy, I tell them, 'As long as you were buying the drinks!' Sonny Boy used foul language. People said he was a no good son of a bitch. That's bullshit. He respected me and I respected him.

— SONNY PAYNE

going. Catch a train or bus. That's how he did his gigs. He'd go out. . . . Well, he didn't have nothin' to carry but his clothes and his harmonica."

— LONNIE BROOKS

"Sonny Boy II put the whole damned harmonica in his big-ass mouth! He used to go to the music store and buy a little old harmonica for about fifty cents, little bitty thing—and blow the hell out of it."

— SONNY PAYNE

"Now, Rice Miller, what I loved about him was, he played good and he blowed with his nose, the harmonica and all that. I remember that from when I was a little kid, and my daddy took me to see him."

— JIMMY DAWKINS

"I never knew or saw Robert Johnson. But Sonny Boy and I used to work together up here. I never saw him down there. He was a good musician and a tough old goat—he wouldn't back down for nothing."

— JOHN LEE HOOKER

"Sonny Boy and Robert Jr. Lockwood came into KFFA, Helena, two weeks after it opened, about getting themselves a show. The manager, Sam Anderson, sent them over to the Interstate Grocery Company, the makers of King Biscuit Flour, to ask for the job. Max Moore, the owner of Interstate, told them, 'You both got the job. You'll show up at KFFA Monday at 12:00, play from 12:15 to 12:30, and I'll give you both $12.50 per week for six days a week. You do five days on the radio and the sixth day, Saturday, you'll go to grocery stores and play to promote the product. It's been on the market since 1930 and I can't sell the damned stuff!"

— SONNY PAYNE

"Sonny Boy Williamson II . . . Rice Miller. That's the only one I've ever seen personally. Rice Miller. He could do all kinds of stuff with his harp. He'd blow it in his nose. I don't do that with my harp. He could blow it with his nose. Yeah, he did. He could choke a harp with his nose, too. That's something else. Take the harp and put it in his nose and choke it."

— LITTLE MACK SIMMONS

"When people ask me if Sonny Boy was a fascinating guy, I tell them, 'As long as you were buying the drinks!' Sonny Boy used foul language. People said he was a no good son of a bitch. That's bullshit. He respected me and I respected him. He was his own worst enemy. My boss used to send me down, at least three times a month on a Monday, to get his ass out of jail. The reason he got into trouble was this: he would be approached by one of his musicians or friends, and ask him, 'Sonny Boy, is there any way possible that you could loan me two dollars?' Sonny Boy would say, 'Yeah. But I want to know when you gonna pay me back. I don't care if it's a year from now but I want to know what day and when and then I'll loan you two dollars.'

" 'Oh man, I'm gonna pay you back tomorrow!'

" 'Are you sure about that?'

" 'Yes I'm sure.'

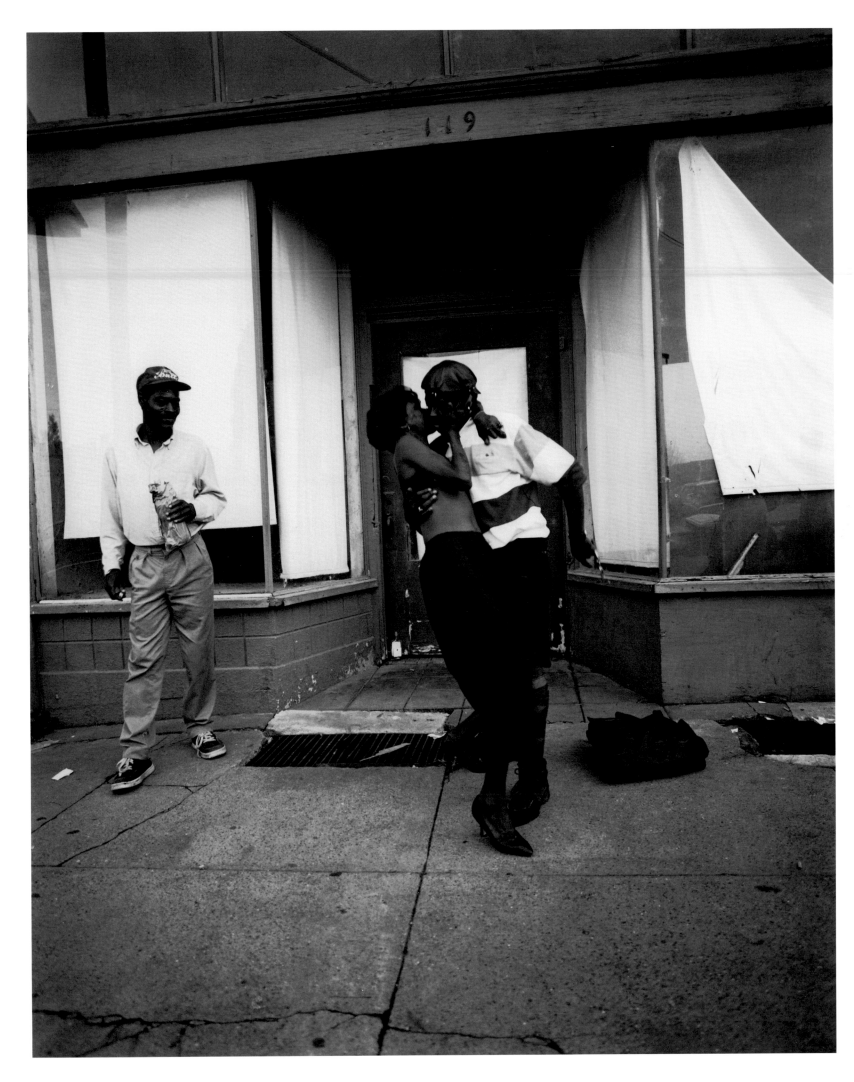

Hanging out in Helena, Helena, Arkansas

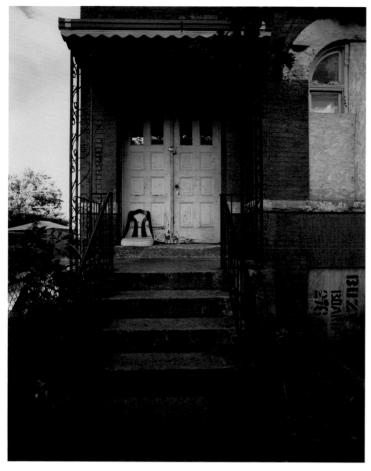

Muddy's House, Chicago's South Side

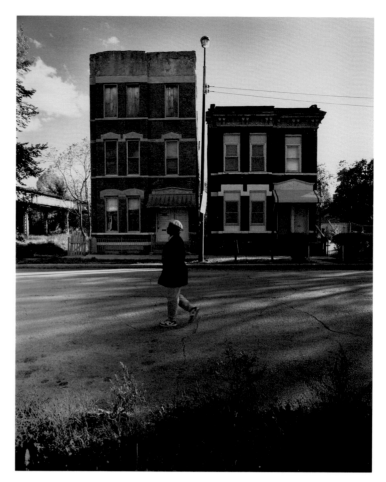

Home Sweet Home, West Side, Chicago

"Sonny Boy would say, 'OK, here's your two dollars. I want my money back tomorrow. I need it!' Then tomorrow the guy wouldn't be around. He'd go after the guy, beat the shit outta him and get his two dollars and wind up in jail. Then Sam Anderson would give me seventy-five cents, sometimes it was a dollar, to go and get him out so he could do the radio show. Sonny Boy took you at your word. He didn't like people who lied to him. That's why he did the famous song 'I Ain't Fattening No More Frogs for Snakes.' People still ask me to play that record. See, snakes love frogs. They love them frogs. On Sonny Boy's first trip to Europe in about 1952 or 1953, he ran into a crooked manager. The manager told him he'd pay him $5,000 at the end of the tour for the trip plus his hotel and transportation expenses. Sonny Boy wanted to buy his Maddy a house. Sonny Boy took him at his word. He didn't know how to write but he could figure. When that tour was over, he came back to New York and he told the manager, 'Well, we had a good tour. I'm ready for my money. I'm going to build my Maddy a house.' Well, that

manager bullshitted him and ended up only giving him $1,200. The manager told him that he ran up a big bar bill during the tour. Sonny Boy told him he paid for his own drinks. The manager told him he ran up a big food bill. Sonny Boy showed him all the receipts he had kept for his food. He only got $1,200 and couldn't buy his Maddy her house. He had sense enough not to beat the shit out of him. He said, 'I ain't fattening no more frogs for snakes.'"

—SONNY PAYNE

MUDDY WATERS

"The guy that I think has done more for blues than most people, which is why we called him the Godfather, was Muddy Waters. So when Muddy Waters went to Chicago, Chicago opened its arms and let him in. Then a lot of the young people, and especially young white people, started to listen to Muddy Waters. Muddy Waters is the

guy to me who did it. Muddy Waters. Before him you had Big Bill Broonzy. But Muddy Waters. There is nobody who'd done more for the blues as a whole than Muddy Waters. Muddy had his style. Regardless to what jazz did, regardless to what country or anything else, Muddy had his style and he stayed with it. And it still stands today with most of us as a guideline for playing real, true blues."

—B. B. KING

"Muddy was not that much of a lead. I mean, he played some guitar. He's singing like Son House, Robert Johnson. Muddy didn't have a total sound of his own."

—BILLY BOY ARNOLD

"He just slashed through it a little more than some bands. He wasn't much of a guitar player."

—JIMMY DAWKINS

"In my opinion Muddy started the Chicago blues sound. I have no doubts on it. I have no doubts about it at all. I can't rightfully say he did, but I can say in my opinion, yeah."

—SAM LAY

"When you ask whether it's Delta blues or urban blues and so on, I think it had to do with a guy that went there, like Muddy Waters went there. It was Muddy Waters. They can put the sophisticated name, 'urban' and so on. But still to me, it's still, if you want to say Delta blues, Muddy Waters. To me, I wished I could have been a part of all of that."

—B. B. KING

"It's funny how people can name somebody as the greatest. Robert Jr. [Lockwood] said that Muddy couldn't sing nor play. But record-wise everybody's saying Muddy's the greatest and all this. That's a matter of opinion. Muddy made some great records. But technically, from a guy like Robert Jr.'s standpoint, no. See, Robert Jr. is not a guitar player by fashion. He is a guitar player. That's why he did all that great work with Sonny Boy and Little Walter and Doc Clayton. He is a musician. So when you ask a musician about a guy like Muddy or Lightnin' Hopkins or someone like that, he's not trying to put him down, but he's coming from his point of view—that he's not a musician, not a guitar player per se. Like Lonnie Johnson or somebody like that."

—BILLY BOY ARNOLD

"I heard this guy that everybody was calling Muddy Waters out of Clarksdale, Stovall Farm. He had got popular, and he started traveling all around the state of Mississippi playing Mississippi fish fries. Saturday night, fry night . . . fish fries. They called them suppers. You know, guys was having big parties at their house on weekends. And one particular time he played very close to where I grew up, a big plantation. So I think I must have been thirteen years old at that time. I sneaked off this particular Friday night that Muddy was going to be there. I couldn't go in, I was too young to go in, but you know the old farmhouses, man, they had cracks all outside— you could see inside it! And I went and got me a good hiding spot outside, and I could peek inside. That's when I really got the blues bug. That's when the blues bug really hit me, after hearing Muddy. I would say he was my greatest influence.

"As far as I'm concerned, I've met a lot of good bluesmen, but for Mississippi Delta blues, I think he was tops. Chicago blues was started by Muddy Waters and Jimmy Rogers. Him and Jimmy Rogers, I give those two absolute credit for the Chicago blues style. They brought it here. I think they were directly responsible. Because Sunnyland Slim, he had a lot to do with getting bluesmen here. He went and got Muddy. Muddy had a job driving a truck. But Sunnyland Slim knowed that he was a good guitar player for the kind of music that Chess wanted, and Sunnyland Slim went on the job. He said, 'Man, park this truck. Go up there and make you some money, too.'"

—BIG DADDY KINSEY

I tried to play like most of those who I idolized, but I could never play like any of them. Finally, T-Bone Walker, when I heard him I went crazy for the guitar—I mean, really crazy. But I think deep down, my trying so hard, a little of it may have stuck with me, and that has made the style of B. B. King.

—B. B. KING

"I met Mack [Muddy's real name was McKinley Morganfield] one time in Helena. I asked him why he'd wanna live up there with all them damned people in Chicago? He told me 'Shit! I make more money in one night up there than I do here in a month!' That was in about 1949 or 1950."

—SONNY PAYNE

"It took a combination of Muddy Waters and Little Walter to replace John Lee Williamson. Because the black people really like harmonica. Sonny Boy was a great harp player on records at the time. And Walter's harmonica playing was, I would say, 70 percent of the success of Muddy's records—personally. Walter's harmonica was so significant on Muddy's records that Leonard [Chess] had to put 'Muddy and his Guitar,' because everybody thought Muddy was blowing that harp. Black people would say, 'Muddy Waters sure can blow that harmonica.'"

—BILLY BOY ARNOLD

"Little Walter was a great guy and one of the greatest harmonicas around. Next to him I'd say there was Junior Wells. I worked with Walter a lot. The last time I worked with him was in 1967 in Europe. He passed away about a week after we came back from that tour."

—KOKO TAYLOR

T-BONE WALKER

"Mind you, to me the best blues artist was T-Bone Walker, one of the finest blues guitarists ever was, ever will be. And if you listen to other top guitarists of the country, you will hear some of T-Bone Walker in their guitar playing. Not B. B., but T-Bone Walker. B. B. set the stage with the type of guitar that he plays, and there are others who will copy him just as he copied T-Bone Walker."

—RUFUS THOMAS

"Everyone who's playing modern blues guitar owes a debt, directly or indirectly, to T-Bone Walker. Everybody who's playing the blues harmonica, owes a debt, directly or indirectly, to John Lee 'Sonny Boy' Williamson. Of course, Little Walter went on and made it, but Little Walter was influenced by Sonny. B. B. did just like Little Walter with the guitar. B. B. took the guitar further than T-Bone. So, B. B. is the most influential guitar player living. But he owes a debt to T-Bone."

—BILLY BOY ARNOLD

"I had so many idols. I'm a mixture of many, my style is. But I could never play like either of the people I wanted. I tried to play like T-Bone Walker. I tried to play like Charlie Christian. I tried to play like Lonnie Johnson. I tried to play like Django Reinhardt, Blind Lemon [Jefferson], and you mention it."

—B. B. KING

"I played with T-Bone. He was a helluva artist but he shouldn't have been credited with everything. There's guys out there who was as great as T-Bone. Muddy and them others, Sonny Boy and them. T-Bone had to take a little bit from them guys to get where he was."

—JIMMY MCCRACKLIN

B. B. KING

"B. B. King, man he's one of the greatest, in the blues field he started the whole world rockin'—me 'n' him—with the blues. He's a really loving person, great person, well liked by people, all good things about B. B. I've known him since he was a young guy back in Memphis. I met him in Atlanta in a club we both used to work at. Every time I see B. B. my eyes light up like a Christmas tree."

—JOHN LEE HOOKER

"I think B. B. King's place in the world of the blues is that, number one, he's unique in that his music is inclusive, which I think is very, very important. He includes people. He doesn't exclude people. B. B. King is a great guitar player, but he's not so great that a kid at home can't play along with a B. B. King record. It isn't like Django Reinhardt or Charlie Christian, where if you try to play along with them you don't get it, you just feel flustered.

"I always said that to me B. B. King is a gospel singer in a blues singer's body. Because he was such a sweet singer, and he still is a great singer. But in his prime it would floor you to hear him sing and to play guitar, because he always played what needed to be played, it was economical, and his singing was just what needed to be sung."

—JOE LOUIS WALKER

"I had one little something that I think made my style more than anything else. I can't hear lows. Like, you take the bass, the big bass and you hit the low note, I don't know what it is. I can't hear it. But if you put the trill on it, I can hear it, then I can recognize it. So on my guitar I always play with a lot of trill, because then I can recognize the sound."

—B. B. KING

"B. B. has a style of his own, like most blues guitarists. B. B. is not the best blues guitarist in the world. There's a whole lot of people can play blues as good as B. B. But B. B. was there first, and that's what makes the difference. You see, he set the stage for other guitarists and blues artists to follow."

—RUFUS THOMAS

"And I want to say this. This is my personal opinion. B. B. King is the greatest blues singer and the greatest guitar player that ever appeared on records. Ain't nobody, and nobody came before, beat him singing the blues. No one has did for the guitar what B. B. has done. Everybody playing the blues, white, black, everybody, are using B. B.'s licks. B. B. is the greatest blues singer of them all, bar none."

—BILLY BOY ARNOLD

He's unique in that his music is inclusive, which I think is very, very important. . . . With B. B. King, you get a hope that you one day can play like that. You may never get the feeling, but you think you can play like that, and that's inspiration.

—JOE LOUIS WALKER

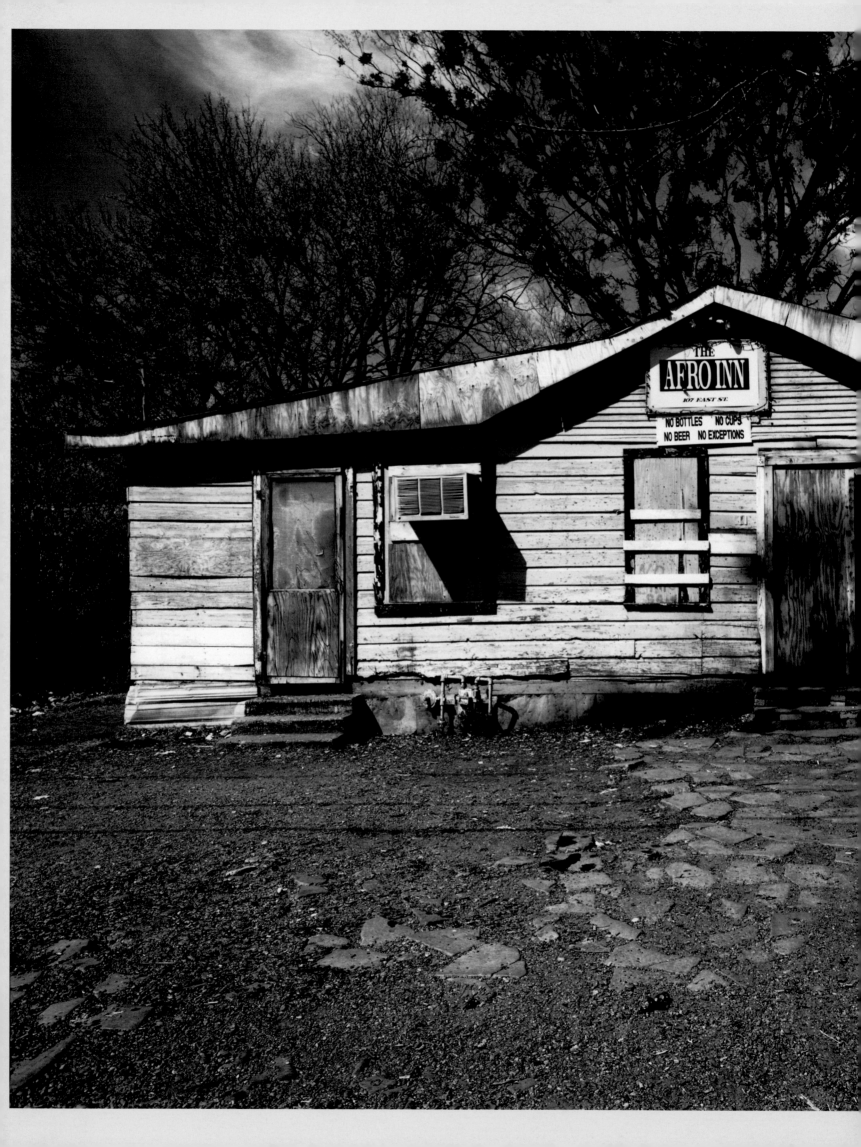

INFLUENCES

I don't care how traditional you are, I don't think any musician is going to do 'Hoochie Coochie Man' better than Muddy did it, I don't think anybody is going to do 'Dust My Broom' better than Elmore James do it. . . . I think that the people who brought it as far as they did, and didn't really share in the rewards of it, really are the true heroes of the music now.

—Joe Louis Walker

Afro Inn, East Street, Rolling Fork, Mississippi

P eople talk about how mean Howlin' Wolf was. That's a total lie. I didn't find Wolf to be mean. Wolf was a big pussycat. He could bark a lot but he wouldn't bite. I learned a lot from that guy. I mean positive things, not negative things.

—SAM LAY

"Listen to the piano players of the 1920s. They were playing boogie-woogie. They was playing Jimmy Reed. Boogie-woogie ain't nothin' but Jimmy Reed. Jimmy Reed plays it slow. Listen to Jimmy Reed and listen to Chuck Berry. Chuck Berry's playing Jimmy Reed up-tempo, right? That's the basis of blues, boogie-woogie. Boogie-woogie in the twenties is rock and roll. Rock and roll is just boogie-woogie played up-tempo, faster: 'Tommy Dorsey's Boogie-Woogie,' you heard that? That's 'Pine-top's Boogie-Woogie.' That was based on Pinetop [Smith]. Because if you look on Tommy Dorsey's record, you'll see 'Tommy Dorsey Boogie-Woogie,' with Smith as the writer. Because they took that from Pinetop. Jimmy Reed. That's all it is! The piano became obsolete, and the guitar played boogie-woogies in the fifties. The guitar became the main instrument. Chuck Berry, Jimmy Reed, and them based it from the old piano boogie-woogies."

—BILLY BOY ARNOLD

"Elvis, Jerry Lee Lewis, Carl Perkins, three of the so-called rock and rollers, direct copies . . . and especially

Jerry Lee Lewis, a direct copy of Little Richard. And if you listen to Little Richard, you'll see that Jerry Lee Lewis copied from Little Richard. Good! That's all right. Music is supposed to be widespread. So you don't steal. You only copy. You put something on top of something that's already there. So that would be my version of blues, gospel, rhythm and blues, and then rock and roll. Rock and roll is the white man's difference of rhythm and blues. Same thing, but a bit different. So all of it is the same. But the blues, the basics, is the foundation of it all."

—RUFUS THOMAS

"I heard what I heard and I knowed what I knowed from listening to the radio. I never thought that I'd meet any of those people. Howlin' Wolf and Muddy Waters was my biggest influences and idols. When I got to Chicago, those was some of the first musicians that I met when I got here. Hey! It was just outta sight. I can't explain it because it was so unexpected and unique to meet them. I never thought I'd meet those people. I met Jimmy Reed and all these people. . . . It was awesome."

—KOKO TAYLOR

"Yeah, I used to go see B. B. King, I used to go see Bobby 'Blue' Bland, Junior Parker. All of them were in the South. And B. B. used to come on and sing, 'Pepsi-Cola sure is good, you can get in anywhere in your neighbor-hood.' That was way back."

—LITTLE MACK SIMMONS

"I think that I really wanted to be a gospel singer. That's what I started out to be. I used to stand on the street corners of my little hometown of Indianola, Mississippi, sit and play, and people would request songs—and most people that requested gospel songs never tipped! But the people that would request blues songs would always give you a tip, and praise you, pat you on the shoulders and say, 'Boy, keep it up; you're going to be good,' when the spiritual people did not. So that motivated my wanting to play."

—B. B. KING

"I remember when there was no Muddy Waters, Howlin' Wolf, or nobody. In 1948, there was Memphis Slim, Big Bill Broonzy, Memphis Minnie, Arthur 'Big Boy' Crudup, Louis Jordan, Charles Brown, T-Bone Walker—all these people was on records. Muddy had just made this funny-sounding record [SINGS THAT SOUND]. I thought it was Hawaiian music! I had never heard nothin' like that before. It sounded so different from what was happening, from Big Bill Broonzy, Tampa Red, and all those guys. Muddy had just come on the scene, and he wasn't popular at all; he wasn't a major artist then."

—BILLY BOY ARNOLD

"People talk about how mean Howlin' Wolf was. That's a total lie. I didn't find Wolf to be mean. Wolf was a big pussycat. He could bark a lot but he wouldn't bite. I learned a lot from that guy. I mean positive things, not negative things."

—SAM LAY

"Lonnie [Johnson] was sort of a jazz guitar player, too. He played with Louis Armstrong and people like that in his early career in the twenties. [He recorded with Ellington.] He was an advanced guitarist. He knew a lot of chords. He wasn't just a straight-out blues guitarist. He was a lead guitarist, played beautiful chords, and he had a beautiful style of his own."

—BILLY BOY ARNOLD

"Sonny Boy II loved W. C. Handy. I know that. He thought the world of Handy."

—SONNY PAYNE

"Willie Dixon, of course, he's an old legend. But you know, he produced Muddy mostly all his young career. So Willie had a lot to do with it, but as far as actually making it happen you've got to give it to Muddy and Jimmy Rogers."

—BIG DADDY KINSEY

"Willy Dixon wrote the 'Wang Dang Doodle' for me. When they told me it had sold a million copies, I couldn't believe it! I thought they was talking about Nat King Cole or somebody else. I was fortunate enough to do that, and I've been trying to catch a fish that big ever since."

—KOKO TAYLOR

"I met Son House, got to hang out with him and guys like Skip James, Mississippi Fred McDowell, Arthur 'Big Boy' Crudup, Robert Pete Williams, and others. The operative word with a lot of these guys is 'Southern.' They would come up North to do all those blues festivals organized by folk—crazed, mostly white, middle-class kids who'd fallen in love with the blues."

—BONNIE RAITT

"I got hooked on the blues when I listened to Lightnin' Hopkins and John Lee Hooker and Muddy Waters. But when I heard Lightnin', I think Lightnin' Hopkins was the first blues person on a record that I heard, and it did something to me. I wanted to be him."

—LONNIE BROOKS

You know, Son [House] was the cat, in my opinion. He was the most authentic, scary, deepest cat I've ever heard play the blues. John Lee and him are in a field that's so stark, lonely, in the dark night of the soul of blues.

—BONNIE RAITT

Okay, there's only three original blues singers out of them all—totally original. Robert Johnson, John Lee "Sonny Boy" Williamson, and T-Bone Walker. Now try to match that. Those are the three guys who had unique styles, didn't come from nobody else.

—BILLY BOY ARNOLD

"Well, John Lee Hooker, yeah . . . he did a lot of other people's songs, but he was totally original. Yeah, he's got his own sound. When I first heard John Lee, I loved John Lee Hooker's music, because he plays the type of music that I felt in my heart. I started buying his first records when they came out. 'Hobo Blues' and 'I'm in the Mood.' I used to have a girlfriend, and they had 'Hobo Blues,' and I used to have her play it for me all the time when I was fifteen years old. See, I love this type of music. He was totally original."

—BILLY BOY ARNOLD

"Sir John Lee Hooker! We go back a hundred years. He's one of my main mans, you know. A great guy and a great entertainer. Never rhymes nothin', but everything he does sounds good and it fits him. He's a funny guy. I love him. Oh, man! I'll tell you one thing that he said that I'll never forget. This was some years back, down in Mississippi doing a summer festival. John Lee is known to date . . . well, we going to skip that! I'll put it this way, we're used to him to be likin' young womens. The color I won't men-

tion. So we was out in Mississippi and he was by himself. Everybody was teasing him for being by himself. They was saying, 'Hey, man! You by yourself today! Where's them young womens? Where's all the pretty young womens?' He said, 'Well, I knows times have changed but they ain't changed that much! They'll never get to hang me down here!' Back when he was young, they'd hang black mens for just looking at that kind of womens!"

—KOKO TAYLOR

"I used to work for Lowell Fulson. He's like my brother. Ray Charles played the piano for him. I'd drive the van and play and sing on some of his shows. Once, Lowell got drunk, didn't pay nobody, and took off! Ray and I was stranded in some little old spot about thirty miles from Houston. He got tanked up and just took off! Me and Ray didn't have no way to get to the hotel. You setting up there with a blind guy and another guy who ain't blind but who don't know where he going and you in trouble, man!"

—JIMMY MCCRACKLIN

"Dick Waterman and I were driving to a blues festival once in 1968 or 1969, with Son House in the back of the car sleeping—Dick had been one of the people who'd found Son in Rochester in 1964, and who managed him and Skip James, Mississippi Fred McDowell, John Hurt, Arthur Crudup, among others. There's a record of his called 'Clarksdale Moan' that no one had ever been able to find a recording of. They knew the song existed, but no one knew the words, including Son, who had forgotten them. Son's sleeping in the back when all of a sudden he woke up singing something. Dick turns to me and says, 'That's the song!' We didn't have a tape recorder, didn't have anything to write with, then he fell back asleep and when he woke up, he couldn't remember the song again."

—BONNIE RAITT

"And the main thing about it is, I don't care how traditional you are, I don't think any musician is going to do

'Hoochie Coochie Man' better than Muddy did it. I don't think anybody is going to do 'Dust My Broom' better than Elmore James do it. So in a way, it's great to have fun in a bar playing that, but I don't think an individual can make a career off of that, because it's been done, and it's been done by the best. So I think that the people who originated it and brought it as far as they did, and didn't really share in the rewards of it, really are the true heroes of the music now. I think a lot of people now, including myself, are reaping the reward of a lot of pain and suffering that those gentlemen did."

—Joe Louis Walker

"The blues, man, I went through hell to learn to play it, and I wanted to play it so bad. I used to go out at least seven nights a week, man, and listen to blues when I'd come to Chicago. That's why I moved to Chicago. I went out and I listened to Muddy Waters, I listened to Howlin' Wolf, Buddy Guy, Junior Wells, Otis Rush. And I still . . . you know, I couldn't get it.

"This happened one night, I think it was a Monday night. I went out . . . it was not too far from where I was living. Magic Sam. He was a real friendly guy. Now, Otis Rush was probably the best-sounding guitar, I thought, but he was off to himself, he didn't talk too much. Just that type cat. But Magic Sam, yeah, he'd talk. 'Let's have a drink.' So I'd buy him drinks, Magic Sam. And one night, man, some little girl made him mad, man, he just took a bottle and drank it right on the bandstand, turned it up, and started pulling on them strings, man. I said, 'Whoa!' I looked at him, and he was just biting off. I said, 'You got to get drunk, you got to get mad—it's got to come from here.' So I left there. . . . Just as soon as he got through with the song, I went straight home, and I got down in the basement, man, and got that son-of-a-gun. I was just humming what he was doing, remembered where he put his fingers and how he did it. And I'd say within a month I was playing blues. That's how I got it, from him."

—Lonnie Brooks

"Okay, there's only three original blues singers out of them all—totally original. Robert Johnson, John Lee 'Sonny Boy' Williamson, and T-Bone Walker. Now try to match that. Those are the three guys who had unique styles, didn't come from nobody else. You can't find nobody on record that T-Bone came from. What I'm talking about is, there's three originals of all the blues singers, and you can derive where the styles of the real popular blues singers came from. It's like everybody who play guitar, play guitar like B. B. King. Before B. B. King appeared, everybody was playing like T-Bone Walker."

—Billy Boy Arnold

"I used to listen to Bessie Smith, Memphis Minnie, Big Mamma Thornton, and Ma Rainey—all of them womens I used to listen to on WPIA down in Memphis. I remember one song, 'Give Me a Pig Foot and a Bottle of Gin,' by Bessie Smith. I remember a song Memphis Minnie recorded when I was a little teenager called 'Me and My Chauffeur Blues.' On the other side of that tune was one called 'Black-White Blues.' That song stuck with me and was one of the reasons that drove my attention to the blues when I wasn't nothin' but a kid. I used to listen to all of those womens and I thought they were so great and so inspirational. That stuck with me all the way through my career. They showed me there was a beautiful way in life through music."

—Koko Taylor

"I first heard country blues when I was fourteen years old, on an album called *Blues at Newport '63* on Vanguard, with John Lee Hooker, Dave van Ronk, John Hammond, Brownie McGhee and Sonny Terry, Mississippi John Hurt, and Reverend Gary Davis. I fell in love with it. I'd never heard anything like it in my life. I taught myself to play every song on that record."

—Bonnie Raitt

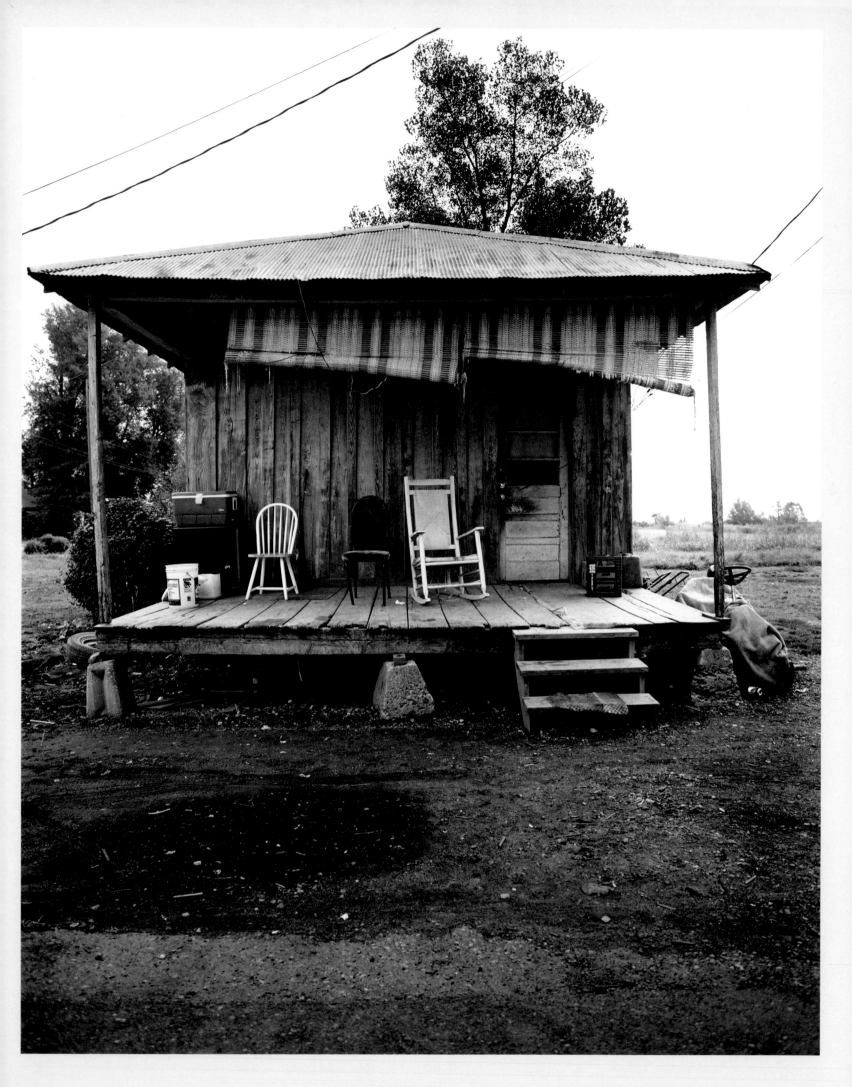

Robinsonville, Mississippi

BLACK AND BLUE

To me there is no such thing as black music or white music. If you put the notes on the paper, what do you get out of a musical note? You get black and you get white. So together, black and white together make the greatest music that the world, that the whole world has ever known—and that's blues. Blues was born black, but not now. Blues belong to the world! Blues music is a part of everyone now. It's a part of your soul. When you learn and find out what the music is all about, then it's one of those kind of things that dig deep down within you if you've got anything at all. What we call blues are the roots, it's the foundation of all the rest of the music.

—Rufus Thomas

They wanted to ask me first, what did I think of playing the blues? Did I think that was serving the Devil or not? I let them know, 'No, this is a gift God give me, and God want people to enjoy theirself. Ain't nobody sinning when they go out and drink and enjoy blues.'

—LITTLE MACK SIMMONS

"I never had it in my mind that this would happen like this for me. I was in Chicago working in the North Shore working for rich white people in their homes, scrubbing floors, taking care of the kids, washing and ironing the clothes, but that was good because it was a job, and honestly, anything you can do to make an honest dollar and live out of it is good."

—KOKO TAYLOR

"I'm an ordained minister, I've been a preacher, I remodeled a church, I put $18,500 in my pastor's church, and I know this is my gift God gave me. They wanted to ask me first, what did I think of playing the blues? Did I think that was serving the Devil or not? I let them know, 'No, this is a gift God give me, and God want people to enjoy theirself. Ain't nobody sinning when they go out and drink and enjoy blues.' What's wrong is when people bother people, fighting in the club. All these places I play, I don't see no fights no more. When I played in the col-

ored clubs and things, people be fighting and sometimes shooting. Since I've been playing these white clubs— I'm just speaking the truth—I ain't never seen nobody fight, everybody drinking."

—LITTLE MACK SIMMONS

"We was doing a tour with B. B. King, on a tour in Europe, and B. B. King was doing an interview, and he was saying in the big concerts at the the Fillmore West or House of Blues or whatever, you'd have two thousand whites and eight or nine blacks. But now it's changing. You've got a thousand whites and you might have a hundred blacks now."

—JIMMY DAWKINS

"Blues was born black, because white folk didn't want to partake of the greatest culture of America. And then suddenly, a white boy came along, singing what the black man had been singing all the time. Elvis Presley came along and started to sing the blues. Sam Phillips of Sun Records was looking for a white boy could sing black. And it's kind of strange, and it makes you think that you can't do anything on your own. You've got to be a copy of something else. You don't want to *be* black, but you want to sing like a black man. You want to dip into the culture, but you don't want to be black. You want to reach in and get something out of it that you can use. There was Elvis, who was a copy of what we call black man's music."

—RUFUS THOMAS

"The way Sam Phillips put it, he was looking for a 'white nigger.' That's the word he used. And Elvis was it."

—JIMMY DAWKINS

"They's let Elvis in a club to play 'The Walk,' and they wouldn't even let me in the club unless I came in the back door. I wasn't shit! And it was my song and I was wanting to perform it but couldn't at that time. I live on them royalties man, I don't have no day job or nothing!"

—JIMMY McCRACKLIN

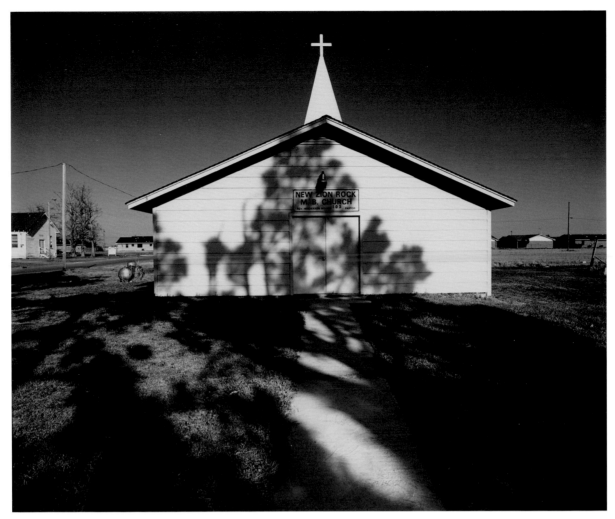

Zion Rock MB Church, Quiver Street, Sunflower, Mississippi

"I was on a tour with Fats Domino and Johnny 'Guitar' Watson in 1957. We started in New Orleans, and was going all through Texas, Mississippi, Alabama, and everywhere. And we were playing for a mixed audience. Because of Fats Domino, we was playing big auditoriums. The white people wanted to see Fats Domino, and they wasn't going to stand for that segregation. See, in the '50s, in '55, when Jimmy Reed, Etta James, and all of them used to go down on those package tours, the whites would have to be up in the balcony, while the blacks was downstairs dancing with the band. But the people stopped Jim Crow at theaters and things. The audience did that on their own. They would come and break down the barriers. The white cops were trying to hold the white kids back from the blacks, and they broke the barriers down, started dancing with the blacks, and they started integrating. The music did that.

"Fats Domino started it. He was the first rock-and-roll guy. And everybody was buying his music. Whites liked his music as well as the blacks. And he was playing integrated clubs by the early fifties. I went on a tour with him, we were playing Texas and everywhere, and there were as many whites in the audience as there was blacks. Then Bo Diddley came along, then Chuck Berry, then Little Richard, and that was it. That was the beginning of rock and roll."

—BILLY BOY ARNOLD

"After Paul Butterfield got started here, you could put blues in places where they didn't have blues music. You don't hear nobody giving him credit for that, but I was there. Paul was white. But it didn't just open it up for white musicians. It opened it up for all the musicians who could play blues. Butterfield opened a whole lot of doors. Doors to the white audiences. Without a doubt. If anybody tell you any different, tell them Sam Lay say you're a liar. Give them my number, tell them to call me."

—SAM LAY

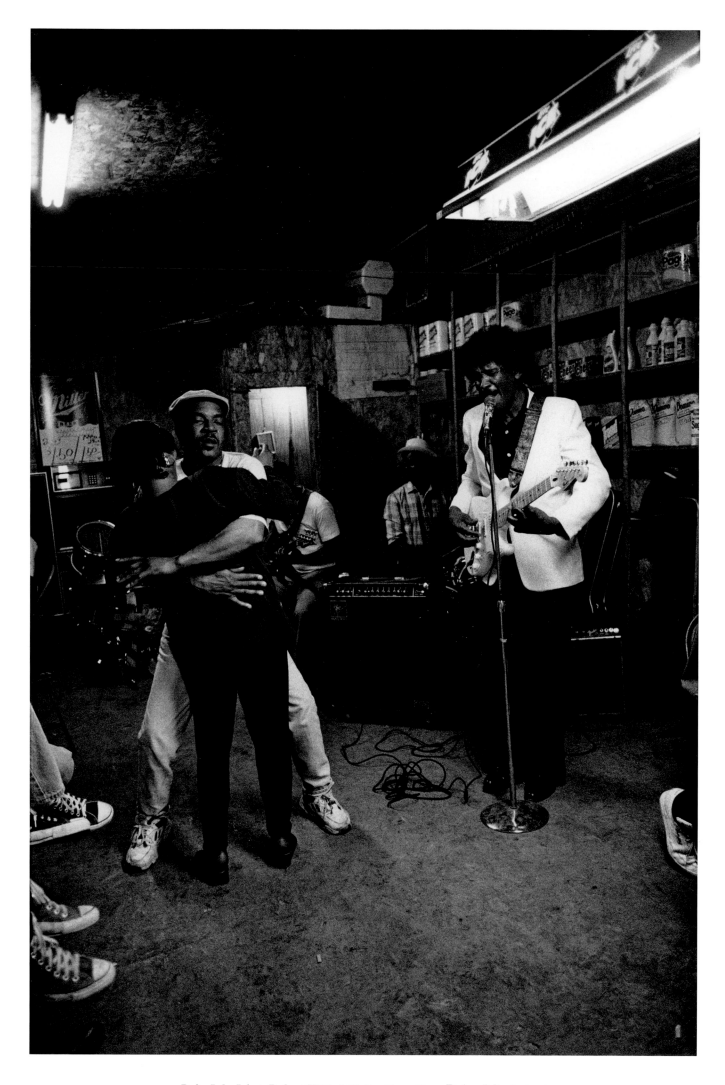

Bobo Juke Joint, Robert "Bilbo" Walker/Sam Carr, Bobo, Mississippi

"Back in the forties and fifties, the white wouldn't listen to the blues. Certain radio stations would play them and certain wouldn't. Now everybody plays the blues. They called it black folk's music. They ain't no such thing as black folk's music. Now it's everybody's music. Back then the whites was listening to hillbilly and cowboy stuff! It took them some time to catch on! Let's face facts: they had no taste for the blues, the blues didn't tell them anything. In the black churches, they shout and carry on from their feelings. The whites didn't do it that way. They sat there and read from the book! He's up there just talking! Time brings about a change, and the change is here now. More white kids playing the blues than black kids."

—Jimmy McCracklin

"See, when guys were making the records in the fifties and the sixties, they were singing songs that related to black life. The white guys can play the blues, but they can't write a song relating to black life because they haven't lived the black life. The songs are written about black experience. 'My Heart Beat Like a Hammer' or 'Three o'clock in the Morning,' these are all black people's songs. They wrote these songs. These were songs that were original. A lot of the younger blacks, really young blacks, don't even know that blacks created the blues. When they hear blues, they see a white band on TV playing blues, and they think white people invented blues."

—Billy Boy Arnold

"Johnny Winter is a blues man, without a doubt. There's two white musicians who I think is two of the greatest. If you want to separate and say black and white blues musicians, there's Johnny Winter and there's John Hammond. If I had to have a choice of two or one, it would be one of the two unless I could get both of them."

—Sam Lay

"All I mostly play for now is white people. I don't play in my own people's clubs. They want to hear rap, and they want to hear cussing and stuff. I don't understand it.

When I played in the colored clubs and things, people be fighting and sometimes shooting. Since I've been playing these white clubs, I don't see no fights no more."

—Little Mack Simmons

"I've found out that blues in particular, it doesn't know a political party, it doesn't know a race, it doesn't know a gender. Now, what a person does when they learn these chords and when they learn these different songs is something different altogether. If it moves a lot of people, then I think that's the criteria. I don't think it has so much to do with what color the person is."

—Joe Louis Walker

"You know there's that dark side, the loneliest forlorn rebuke, scorn. There are all flavors of blues that cover all kinds of different feelings, but the real Delta blues of Mississippi Fred [McDowell], Skip [James], and Robert Pete [Williams] are so dark, so lonely. They gave voice to that part of me that was in pain, even as a teenager. That's some of the hardest time of your life—your first love, unrequited love, hating the way that you look, you're not good enough. I learned about men and women. I got to look through a window on the world through Sippie Wallace and all these people. It was incredible to be a young white girl and get to move in that world. When people ask me why did I leave college, wouldn't you?"

—Bonnie Raitt

"It's not only the black man. Everybody has the blues at one time or another. I don't care if you're white, black, or what. This young guy that became the King, they gave him credit for the rock and roll, Elvis sure had them. But he might not realize it. But he had the blues. Because everything that made him popular was the blues."

—Big Daddy Kinsey

"The biggest misconception about blues is that it's easy. It's the hardest music in the world to play because it's all feel. It's not notes. You can go to the guitar institute and learn

It's not who you are or what you do, it's this: If you respect yourself and you respect other people, they'll give you respect. It's how you carry yourself. It ain't got a damn thing to do with black and white or nothing like that. It's just common sense, that's all.

—JIMMY MCCRACKLIN

how to play notes. You can play fusion, you can play jazz, you can read it off the book. You can play in an orchestra with Doc Severinson. You can't do that with blues."

—JOE LOUIS WALKER

"You know, there's nothing new about the fact that there are less womens playing the blues than mens. This is a man's world. The blues world is a man's world. They just allowed us a little corner to come into. They let us in there. They feel that a woman's place is in the home. Where the mens could be gone, up and down the road touring two or three months at a time away from home, the womens got to be at home because they're wives, mothers with small children, mothers birthing children. Womens couldn't compete with the mens out on the road. Even if the mens aren't touring, the womens can't hang in the streets like the mens do. I'd like to see more womens out here doin' it, but it just ain't happening."

—KOKO TAYLOR

"Rap is a new creative art that came out of the black experience."

—BILLY BOY ARNOLD

"You don't hear the disco much now. All right, they got rap now. That rap is gonna go, too. But really, rap stands so long because all the young people can do it together. All them doing the same thing together. That's the reason they like it. You take rap, there's no feeling to it. What they dance by is the beat. You don't feel it. Just BOOMP-BOOMP-BOOMP, and they're doing this. There's no feeling to it. They have a lot of fun, they're doing it together. You see? But it ain't nothin'."

—HONEYBOY EDWARDS

"Some people feel like we—the mainstay blues players like myself and Mr. Arnold here, and Otis Rush—people feel like we're really the traitors. They say, 'Well, you know how they treated you, and you're still singing that old downtrodden stuff.'"

—JIMMY DAWKINS

"My blues is not designed to make people feel sad. My music is designed to make people get up, pep up, look up and enjoy the music that I'm performing. Make them feel good about themselves! Have a good time! If it ain't but one night where they can listen to me sing."

—KOKO TAYLOR

"I go overseas, that's the only time they treat me . . . they treat me just like a king, I'm telling you. A round-trip ticket, two meals a day, and the best of hotels. They don't put you in no hotel like the black people put you in. They put you in one where somebody brings food to your room. These people take you around to meet people, and they treat you good. A thousand dollars a week. I was over there for a month. I came home with $4,000."

—LITTLE MACK SIMMONS

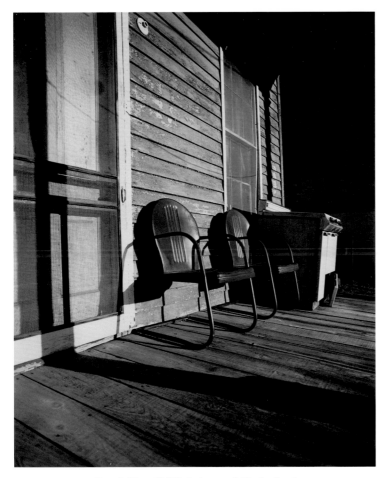

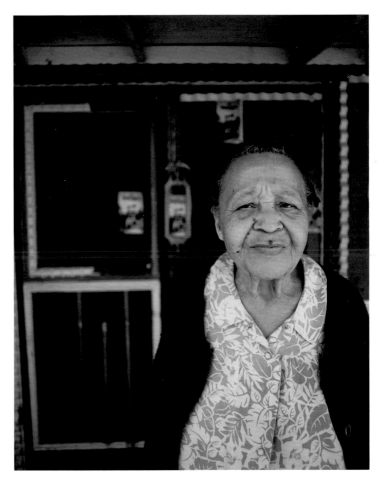

Porch Detail, Vicksburg, Mississippi

Margaret Dennis, Margaret's Grocery,
Highway 61, Vicksburg, Mississippi

"We came to Chicago, and you're homesick for Arkansas and your family. Mostly everybody you meet is from somewhere else in the South. You meet a girl, she's from Alabama, you're from Jackson, Tennessee, another guy's from Tupelo, Mississippi. So there's a common bond there, and you're home away from home. That's what made Chicago such a melting pot for the blacks. And when you heard them blues, that was your music in that day. See, in the twenties when they made blues, they made it for black consumption. They didn't figure anyone else wanted to hear it. They called it 'race records.' So it was made for black audiences. And guys figured, 'We can get some money making records for black people to hear their own music'—and they started making money at that. And it was the music of the day for the black people. When they came to Chicago and everything, and they're sitting around there in the clubs, and Muddy Waters and Elmore James, they're playing their type of music. It was their home away from home, see? Then, when the experiences started changing, and when blacks hear something

for so long, they don't want to hear it. Like, they don't want to wear a dress that came out twenty years ago today. That's the way they look at music. When they get through with something, move on. You know what I mean? See, they weren't looking at music for the artistic part. When a white crowd comes out to hear the blues now, they're coming out to hear the artistic form of the blues. But when blacks was listening to the blues, they wasn't listening to artistic. They was listening to it because it made them feel experiences in their life."

—BILLY BOY ARNOLD

"To me there is no such thing as black music or white music. If you put the notes on the paper, what do you get out of a musical note? You get black and you get white. So together, black and white together make the greatest music that the world, that the whole world has ever known—and that's blues. Blues was born black, but not now. Blues belong to the world! Blues music is a part of everyone now. It's a part of your soul. When you learn

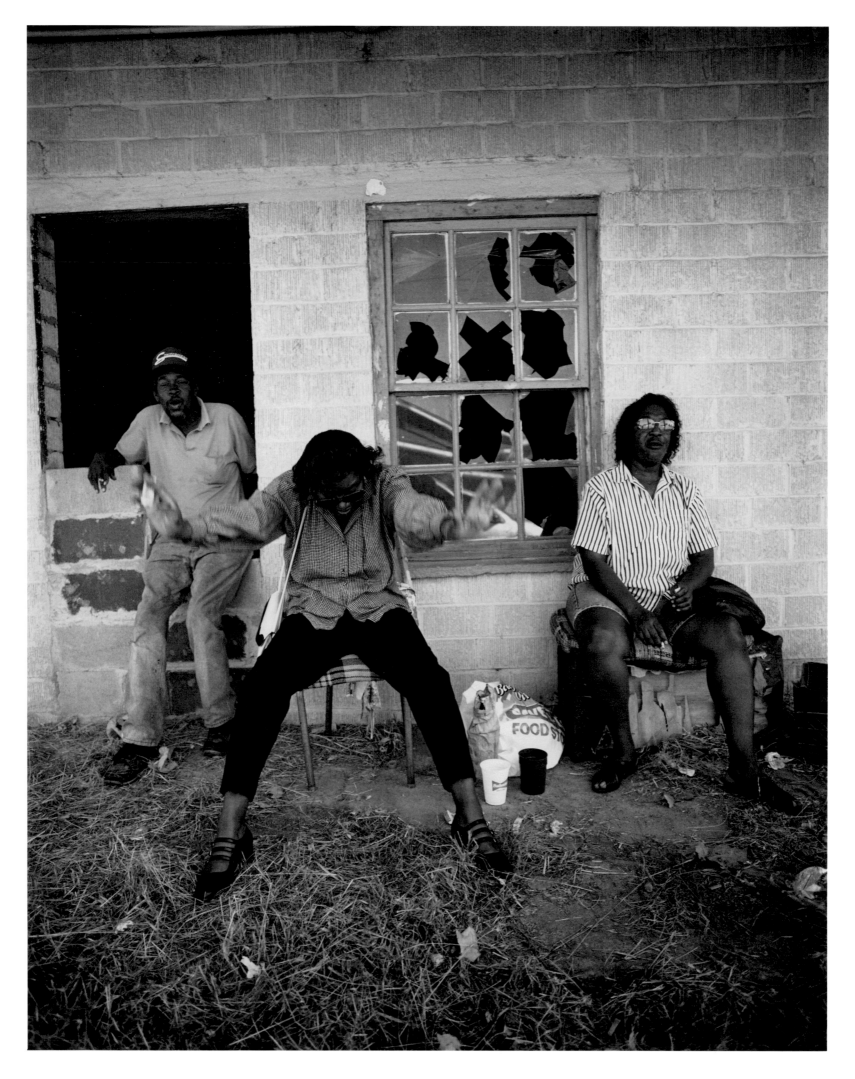

Walnut Street, Helena, Arkansas

and find out what the music is all about, then it's one of those kind of things that dig deep down within you if you've got anything at all. What we call blues are the roots, it's the foundation of all the rest of the music. With the exception of gospel. Gospel and blues runs parallel. But on top of the blues. You find out that when you do the blues, and it's a slow, melodic kind of music, that when you play it like you hear the bass line go DUM-DOOM, DUM-DOOM, DUM-DOOM. Now, just bass alone can give you a feel like you never had before. Then you put the piano on top of that, and then you put drums behind that, then you put a guitar with that, and you've got rhythm. And that's the slow, melodic sound of the blues.

"And then, rhythm and blues. You get tempo, which makes it a really rhythmic up-tempo kind of thing. It's the same thing, now, DUM, DUM-DOOM, DUM-DOOM, DUM-DOOM, same notes now [SINGS THAT AT BRIGHTER TEMPO]—now you've got rhythm and blues. You know, there's nothing new under the sun. Everything comes from something else, somewhere or another. Then comes in what you call rock and roll right on top of rhythm and blues. Same thing. Same basic twelve-bar blues. But it's the white man's version, his version of how he wants to play it. The basics are there, but he has something else on top of it. He didn't create rock and roll. The white man did not create rock and roll. It was there all of the time. Just like Columbus didn't discover America. When he got here, *somebody was already here*."

—RUFUS THOMAS

"Older black people like blues today. But they don't support it. They work at the Post Office or retire, and they don't come out to clubs like they did when they was younger."

—BILLY BOY ARNOLD

"The old black folks, now, they love my playing."

—LITTLE MACK SIMMONS

"One of the problem with the release of all these CDs now is that the original record deals these older artists had didn't allow them a royalty rate that would allow them to share in the profits. They'd be paid a few hundred dollars for the whole album, then have to pay all the costs of recording out of maybe one or two percent. The record companies today are buying them at no cost because the masters already exist. It's a nightmare. CDs and bootlegs are great for the blues fan, but what about the artists? It's like slavery twice, in my opinion."

—BONNIE RAITT

"As far as the musicians that have come and gone . . . here's a quote: Why in the hell did they wait until they get so old to get recognition of any kind whatsoever? I've seen heartache, disappointment, people wanting to commit suicide because thought they had it right in the palm of his hand and they didn't. What happens when they die? Greed. People trying to make money off of him after he's in the grave. Why in the hell couldn't they do it while he was alive? There's only about a half dozen that are alive today that are finally recognized. There's B. B., you got John Lee Hooker, Sam Carr, Frank Frost. He's not as old as we are but he's getting there fast! There's a few out in California who aren't African-American, they're white. Fred McDowell was unknown until five years ago, but they waited until he was gone and now they make a whole lotta money off of him. They know who they are and what I'm talking about. One of them from a known label came to the station here one day and took an old album of Sonny Boy's and copied it. He ain't paid nobody a dime. He did the same when Fred McDowell died. He's a thief. There's lots of them out there, just waitin' for them to die."

—SONNY PAYNE

PORTRAITS II

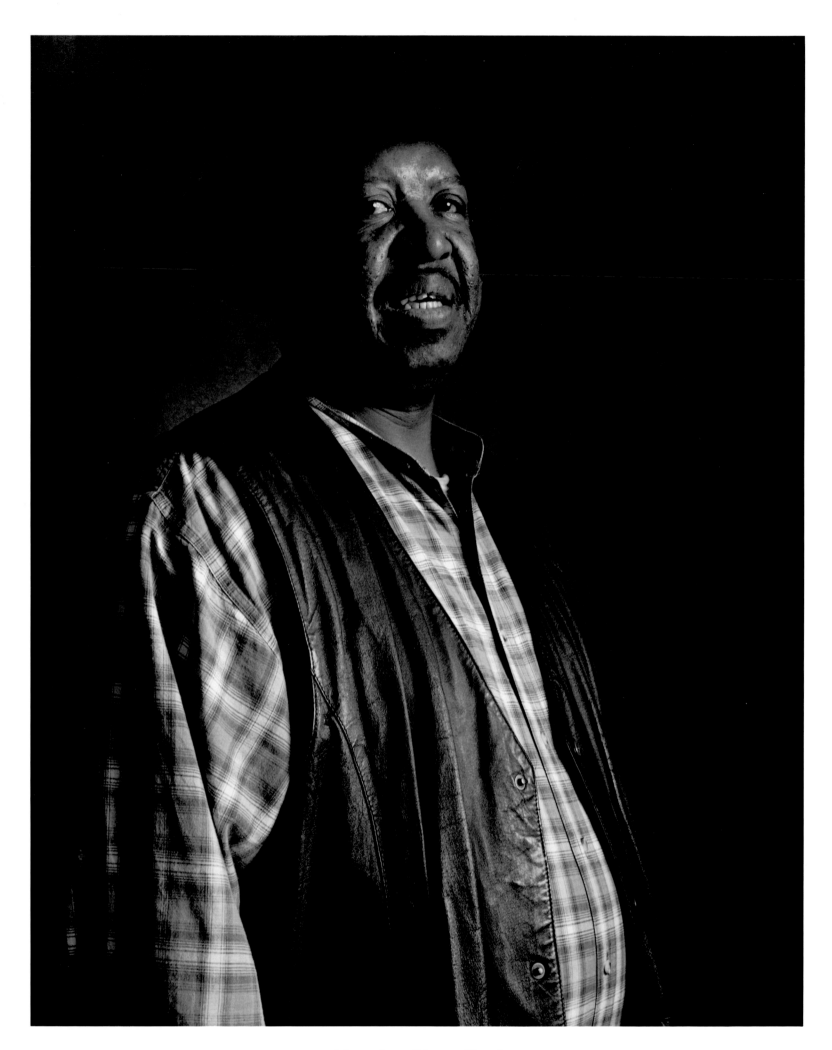

MAGIC SLIM (MORRIS HOLT)
Grenada, Mississippi

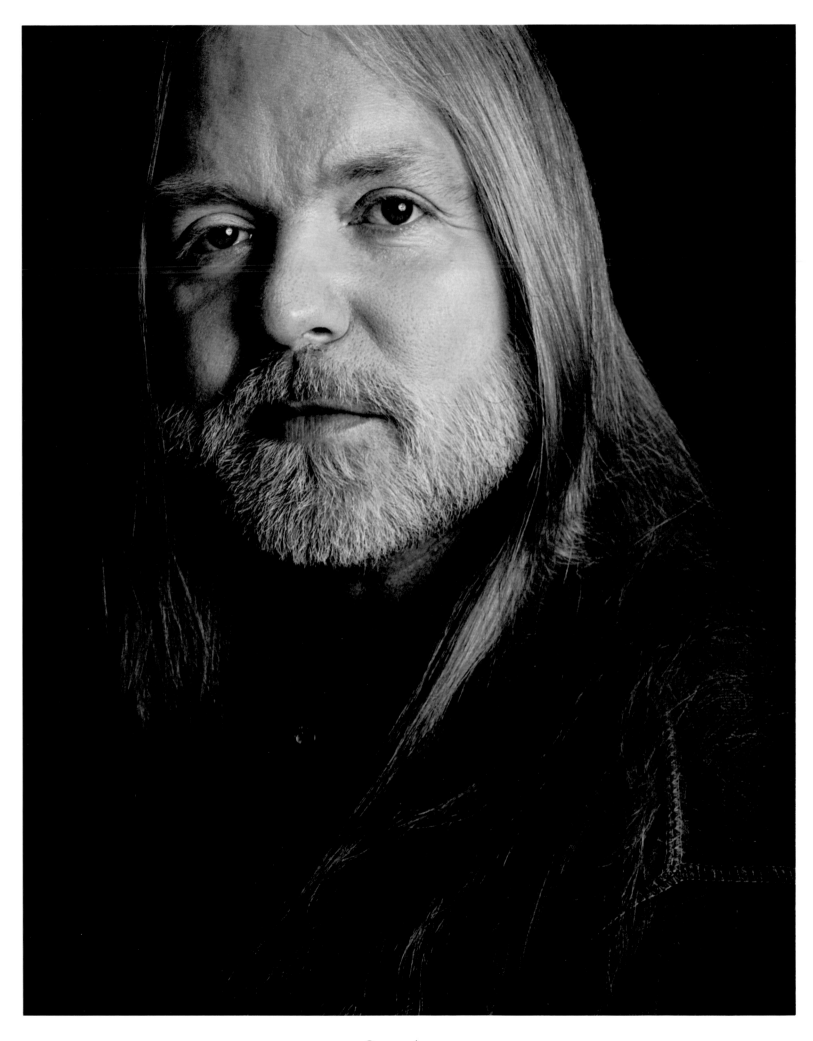

GREGG ALLMAN
Nashville, Tennessee

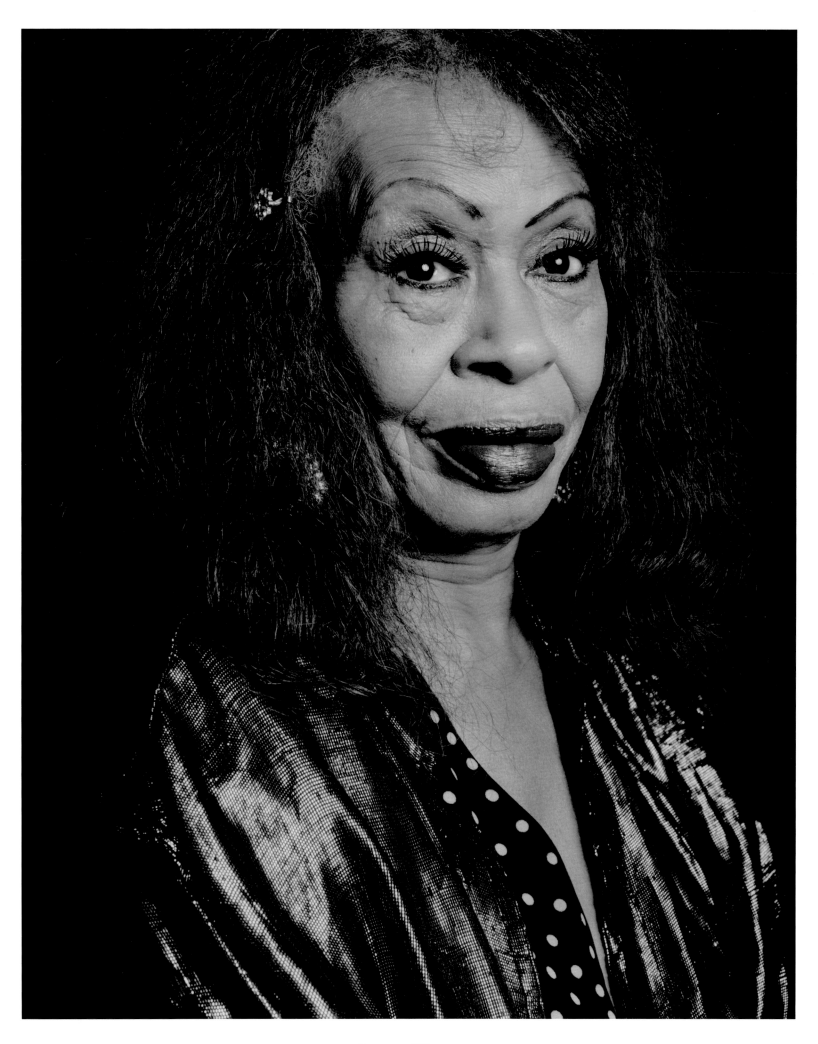

LAVELLE WHITE
Amite, Louisiana

116

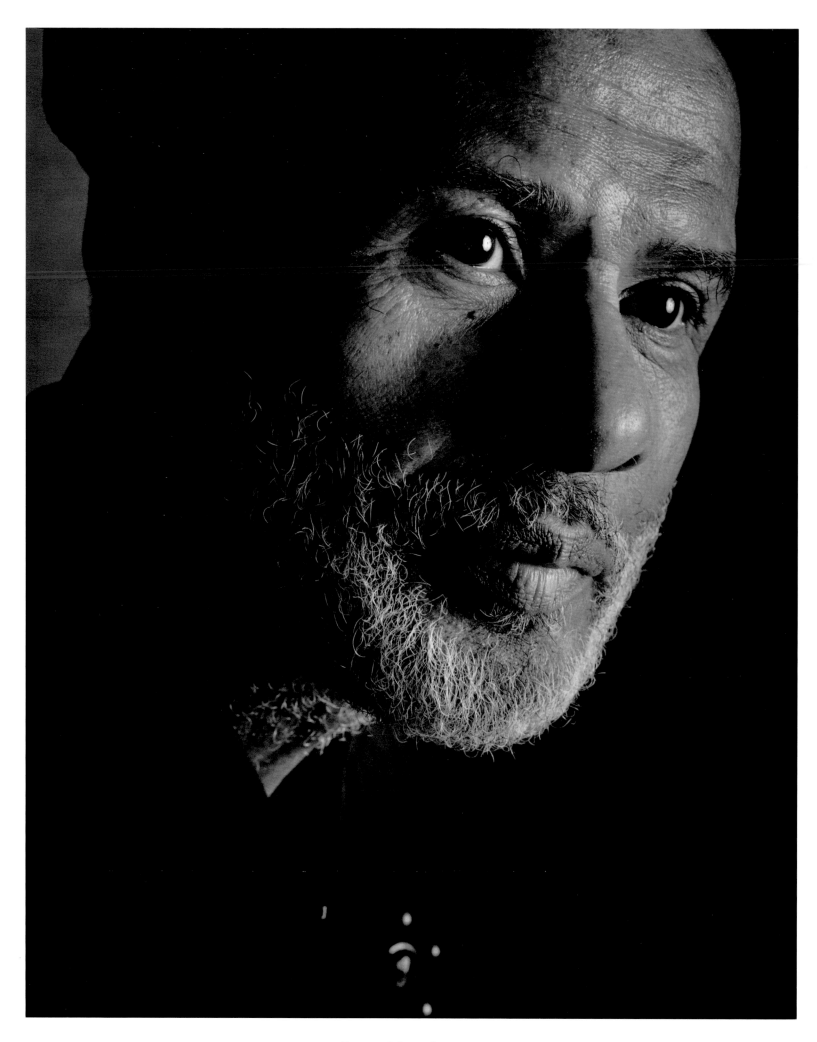

LITTLE MACK SIMMONS
Twist, Arkansas

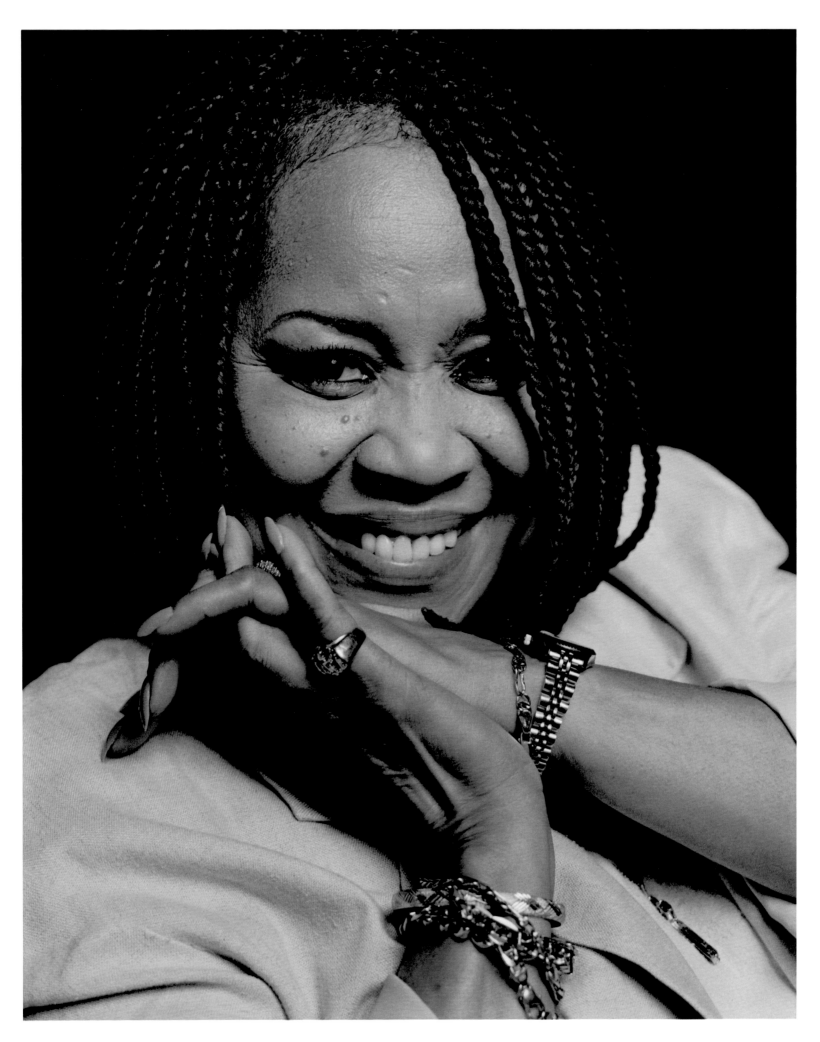

MAVIS STAPLES
Chicago, Illinois

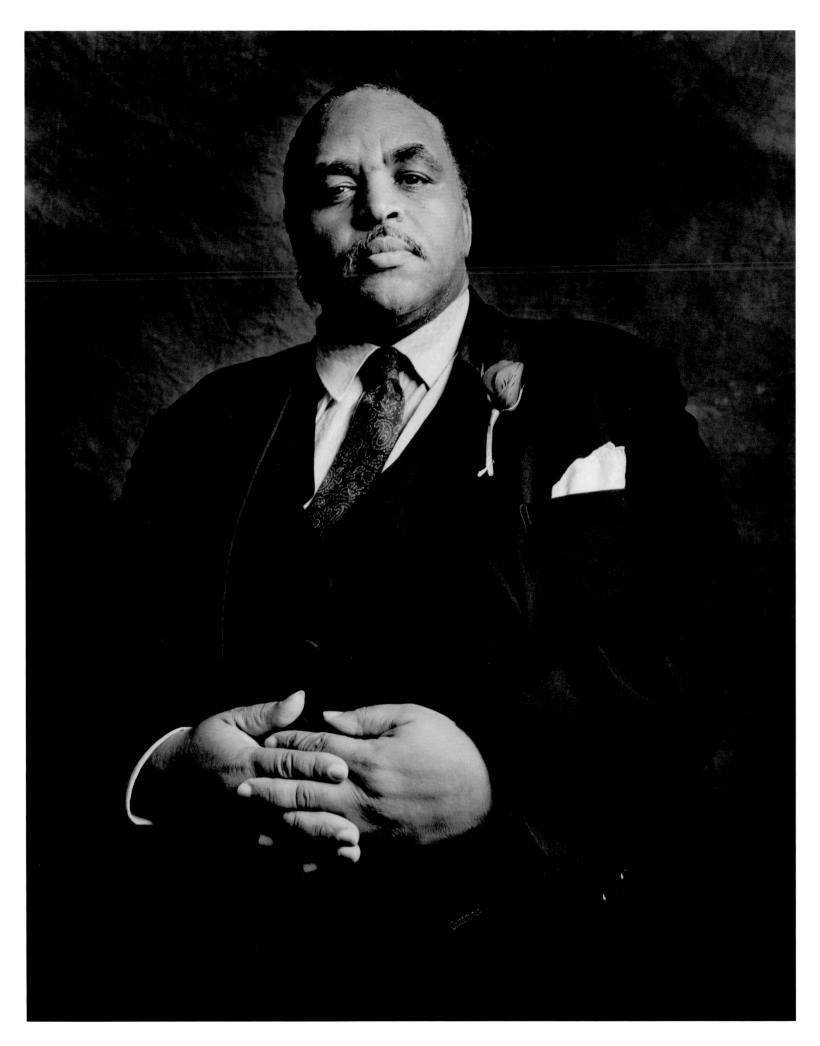

SOLOMON BURKE
Philadelphia, Pennsylvania

119

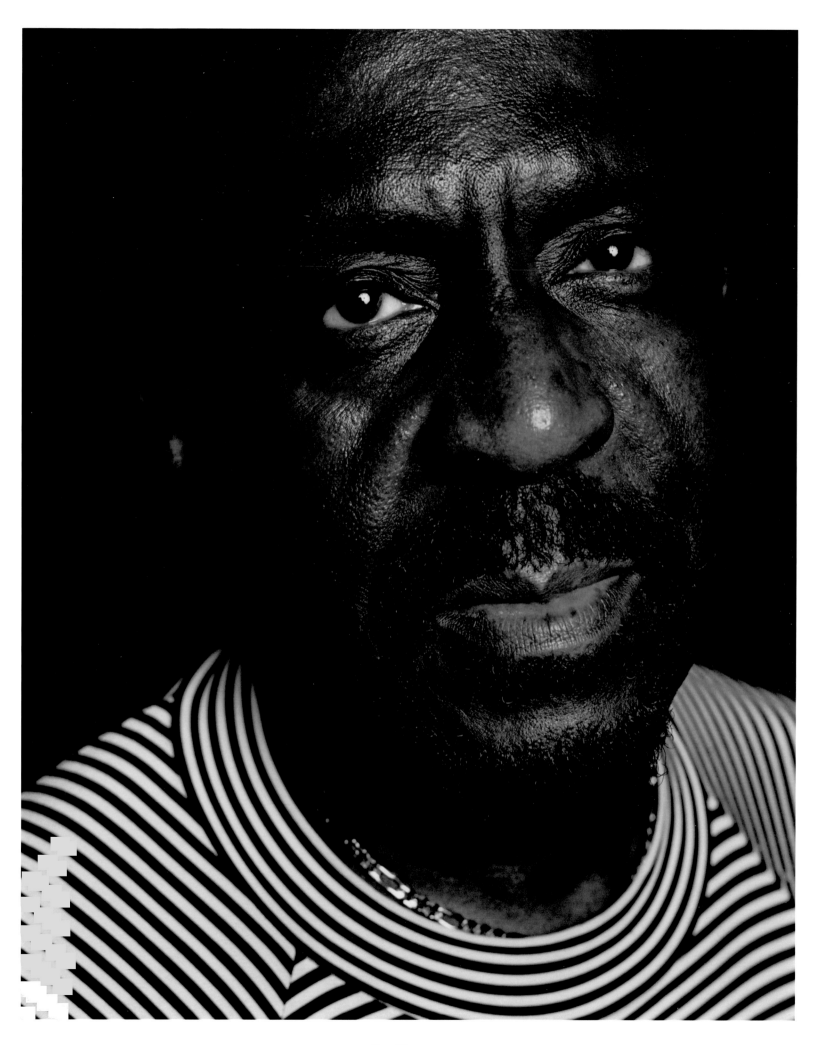

IKE TURNER
Clarksdale, Mississippi

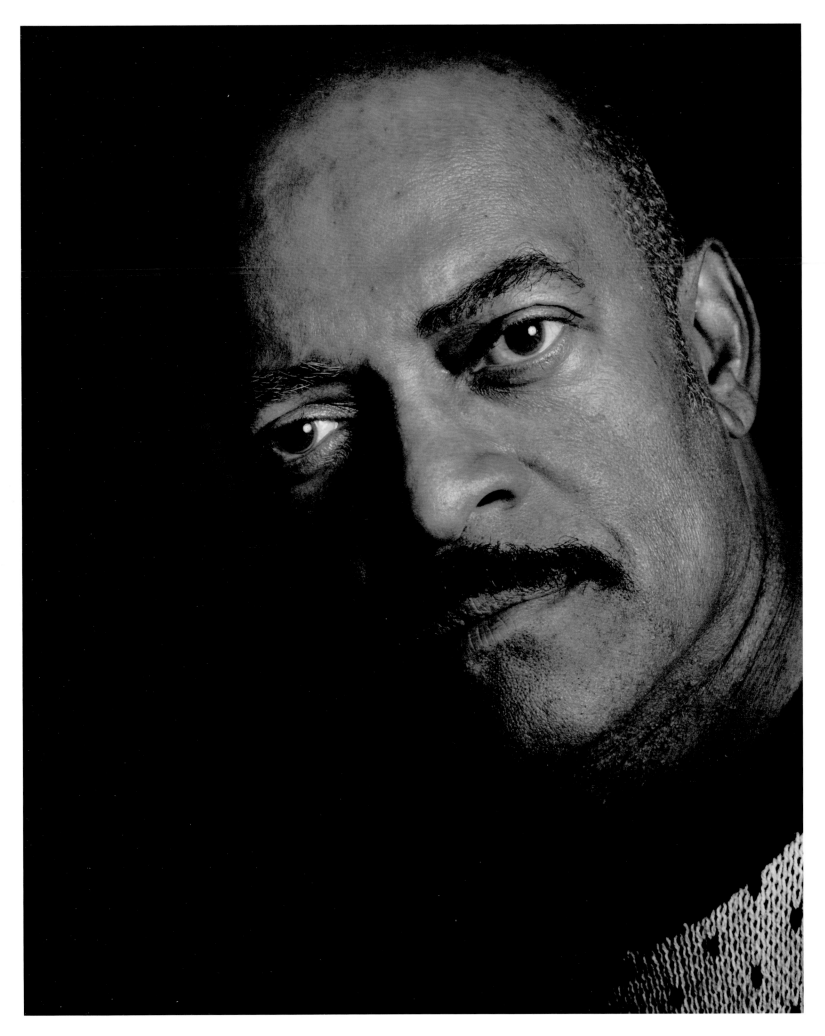

JIMMY DAWKINS
Tchula, Mississippi

121

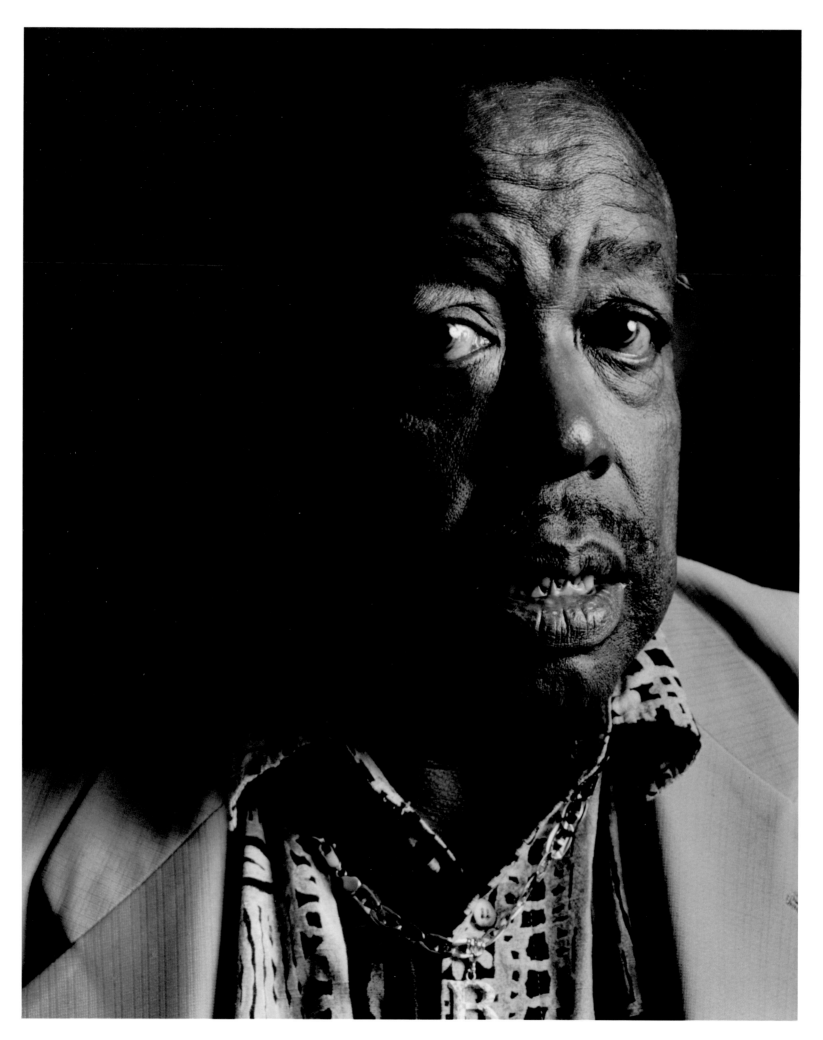

CAREY BELL (CAREY BELL HARRINGTON)
Macon, Mississippi

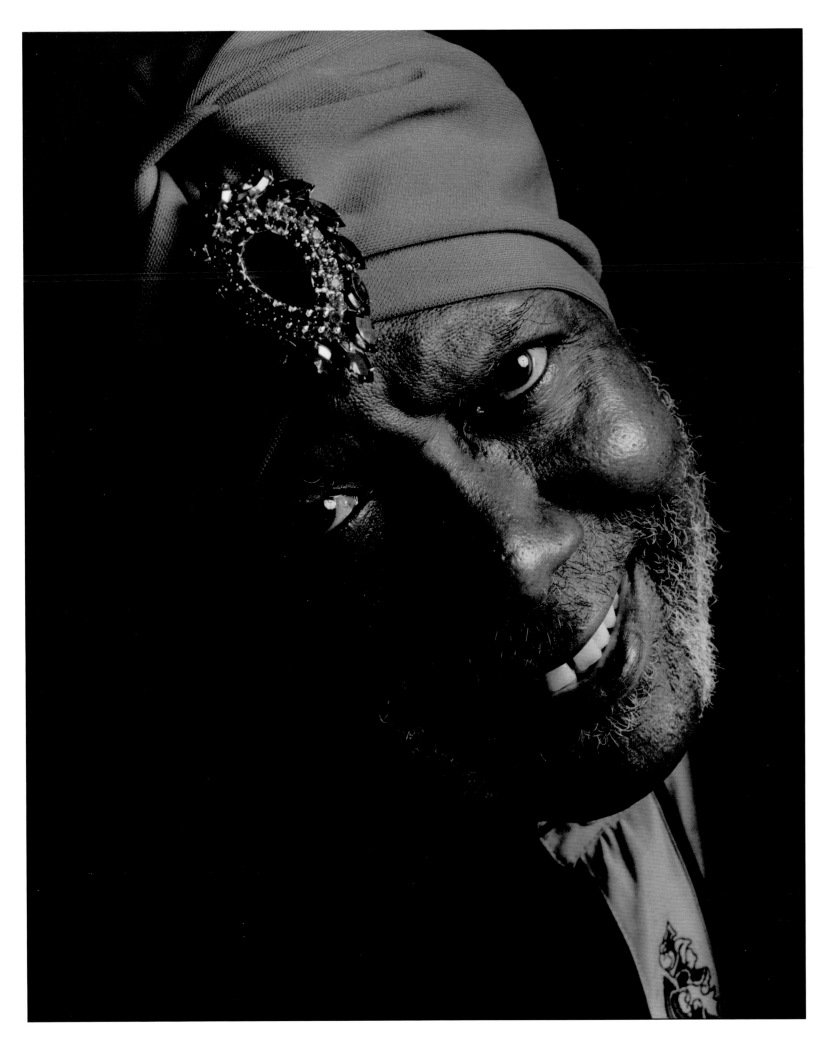

SONNY RHODES (CLARENCE SMITH)
Smithville, Texas

The blues is the blues. You see an old cat down on his luck and everything and he's got the hard-luck blues. A lot of people got the blues and don't know it. People never stop and think about what it means.

—JAY McSHANN

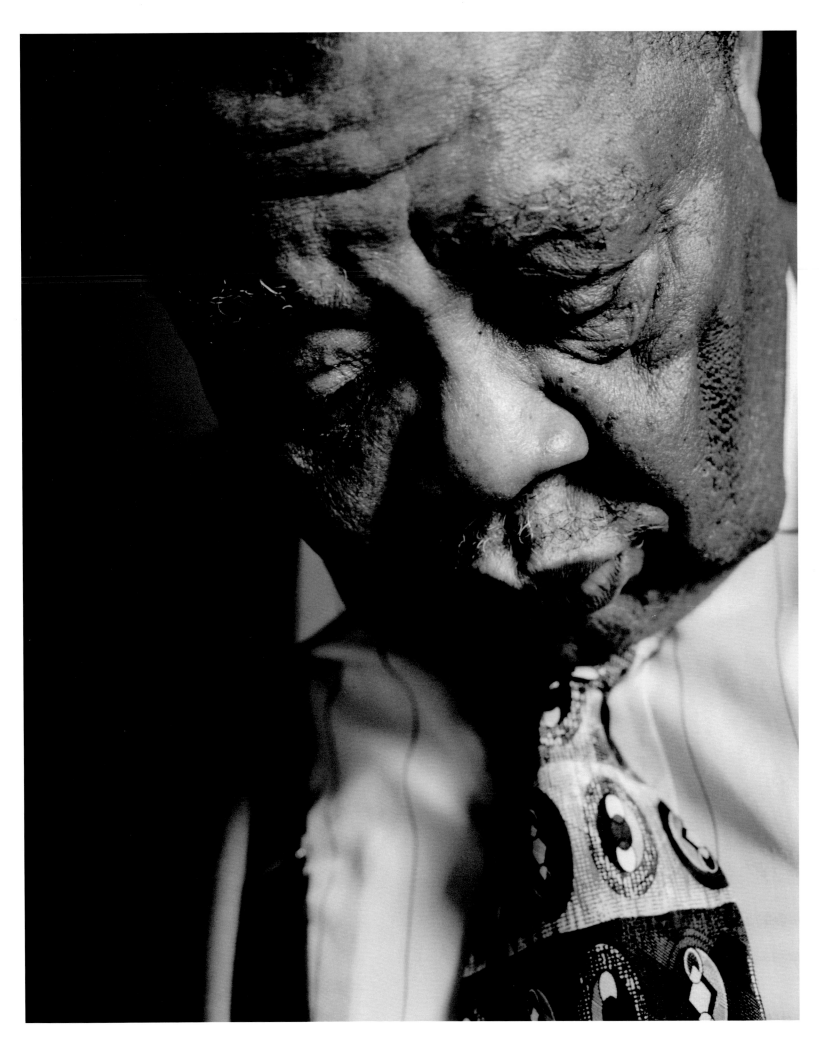

JAY McSHANN (JAMES McSHANN)
Muskogee, Oklahoma

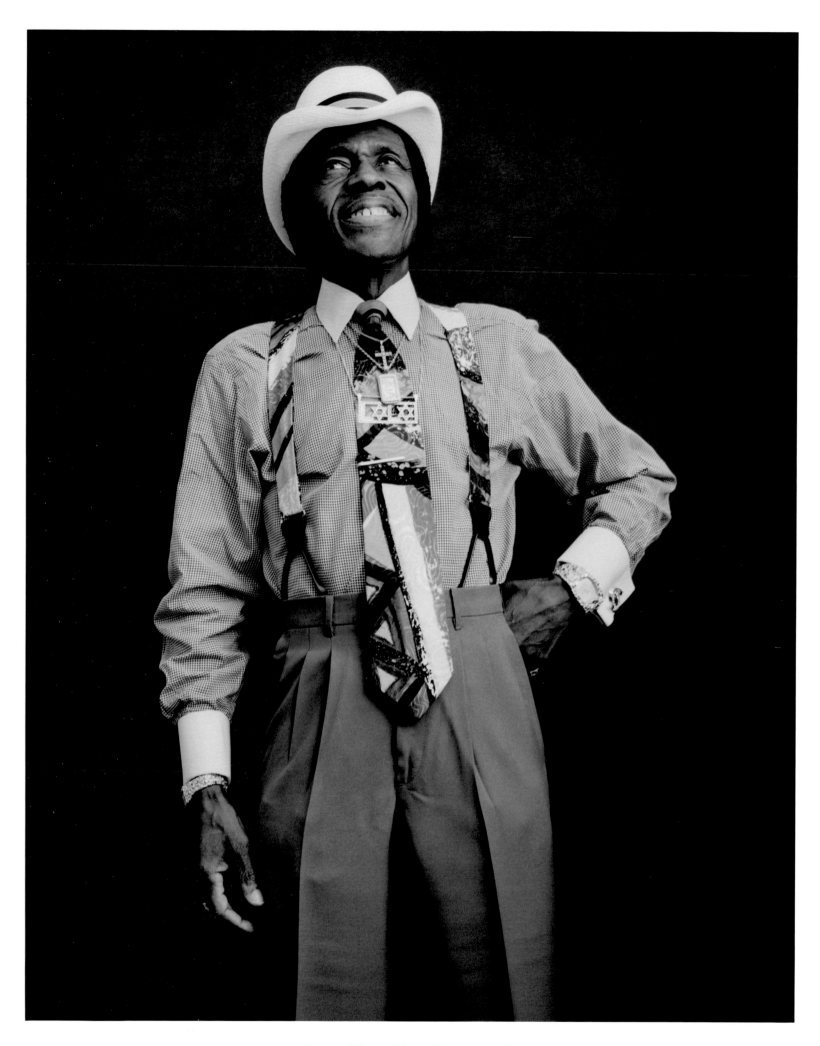

JUNIOR WELLS (AMOS BLAKEMORE)
Memphis, Tennessee

126

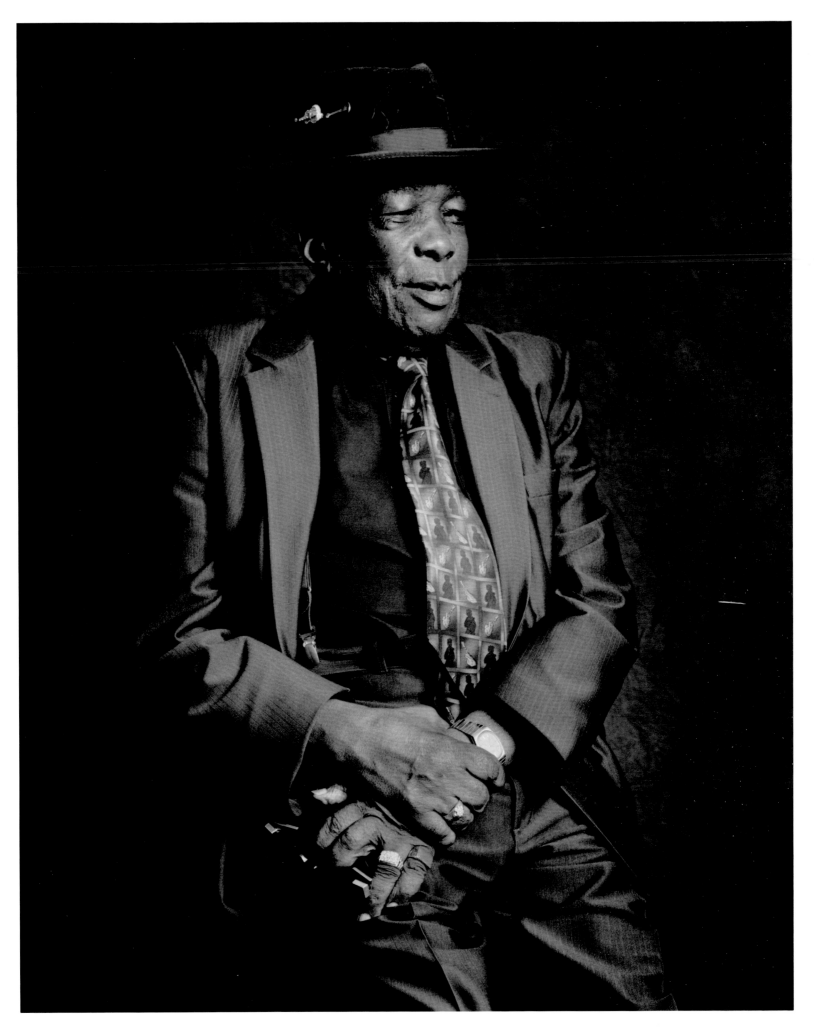

JOHN LEE HOOKER
Vance, Mississippi

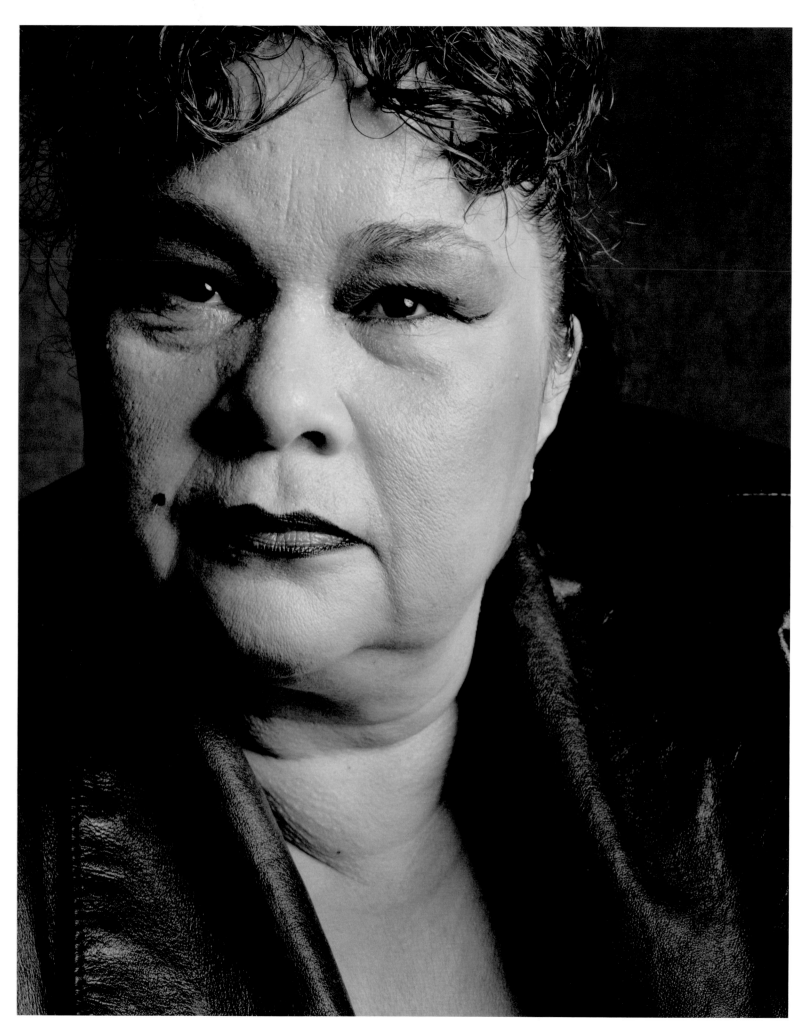

ETTA JAMES (JAMESETTA HAWKINS)
Los Angeles, California

128

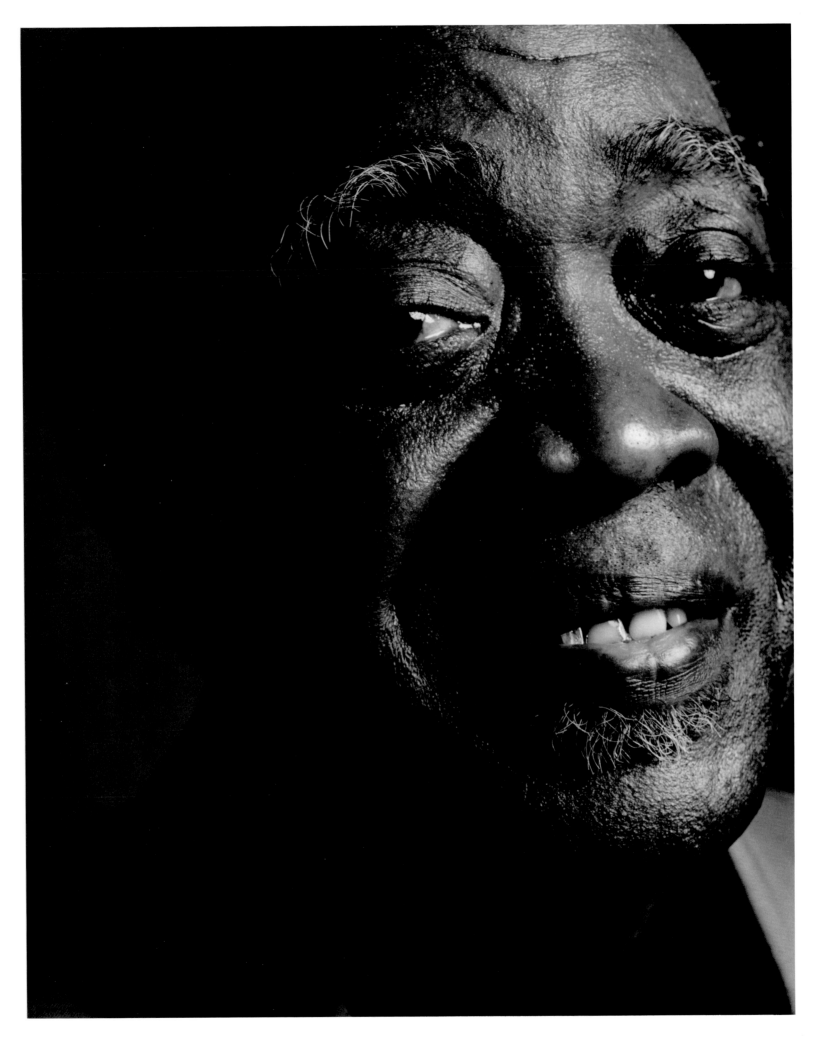

JOE "GUITAR" HUGHES
Houston, Texas

129

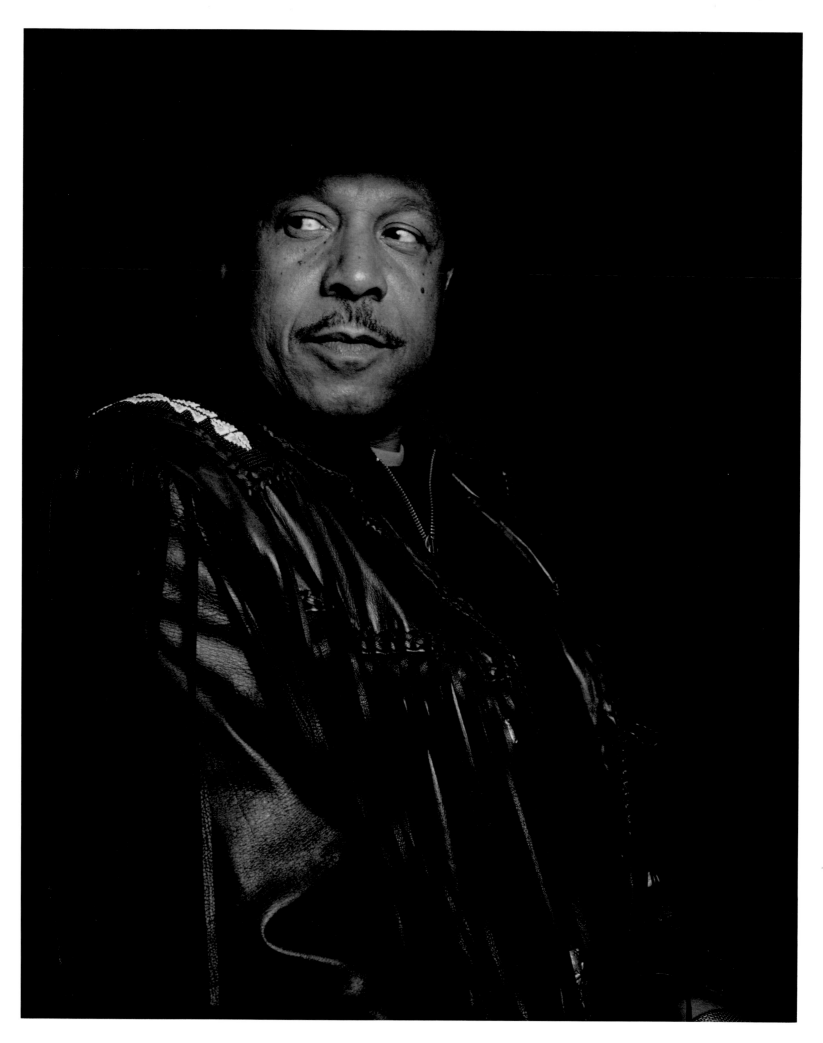

LONNIE BROOKS (LEE BAKER, JR.)
Dubuisson, Louisiana

130

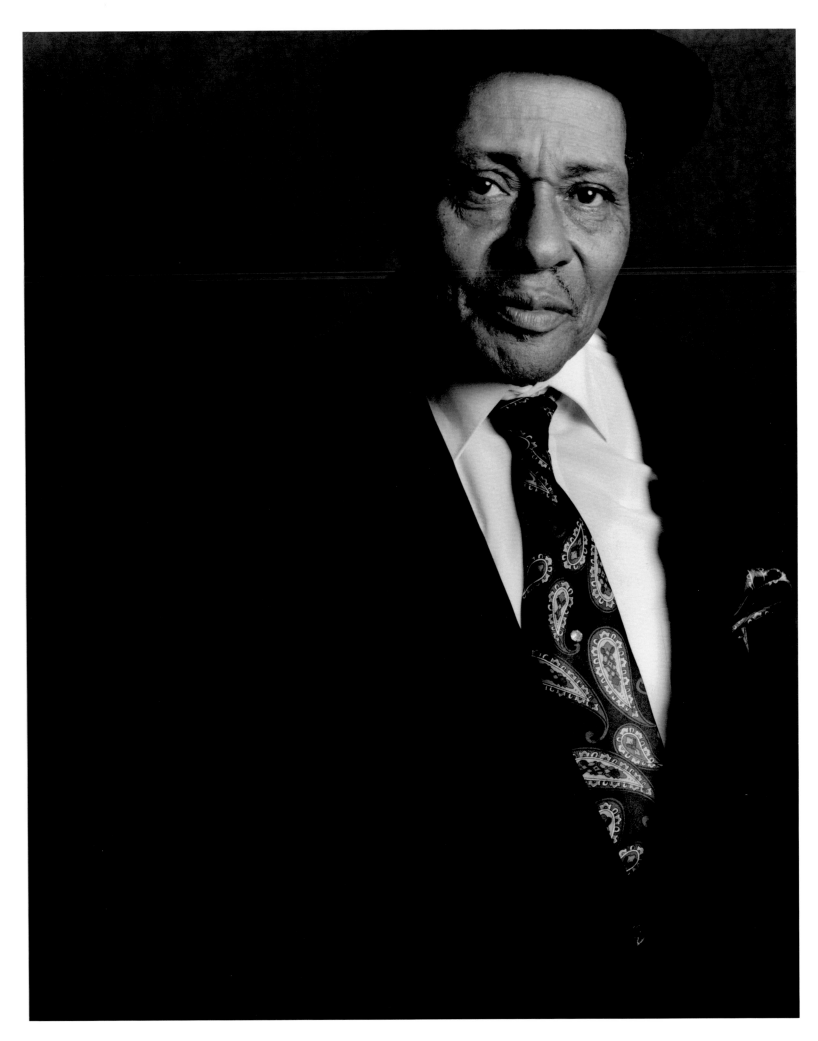

LITTLE SAMMY DAVIS
Wynona, Mississippi

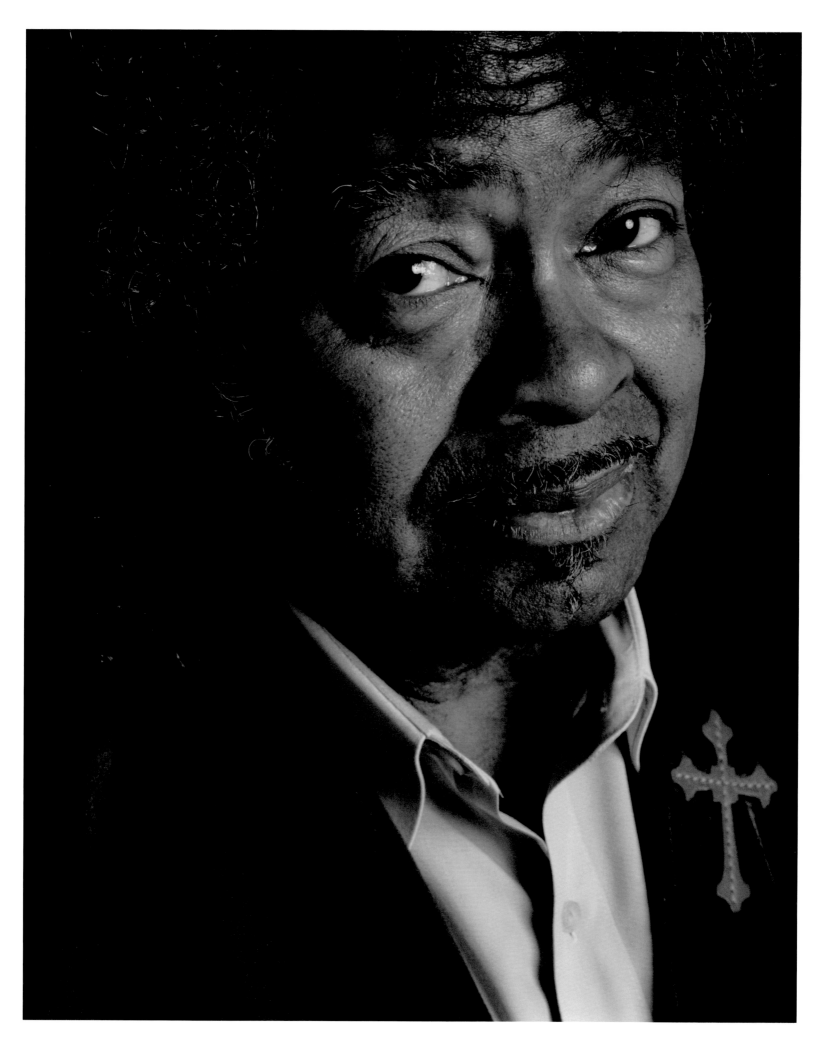

GUITAR SHORTY (DAVID KEARNEY)
Houston, Texas

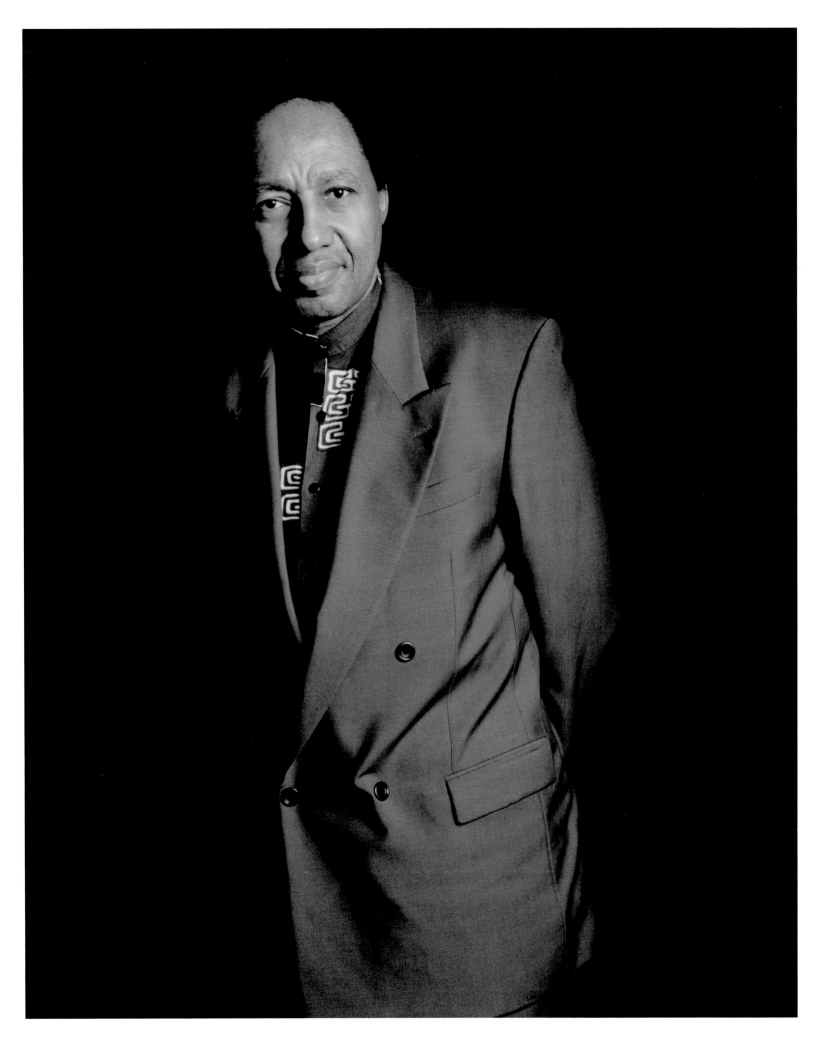

BILLY BOY ARNOLD (WILLIAM ARNOLD)
Chicago, Illinois

133

Blues ain't gonna leave. I can tell you that now. . . . We got quite a few young guys around here playing good blues— *good* blues. It ain't gonna never go nowhere. I don't believe that. It's always going to be the blues. Because it's been around too long.

—HONEYBOY EDWARDS

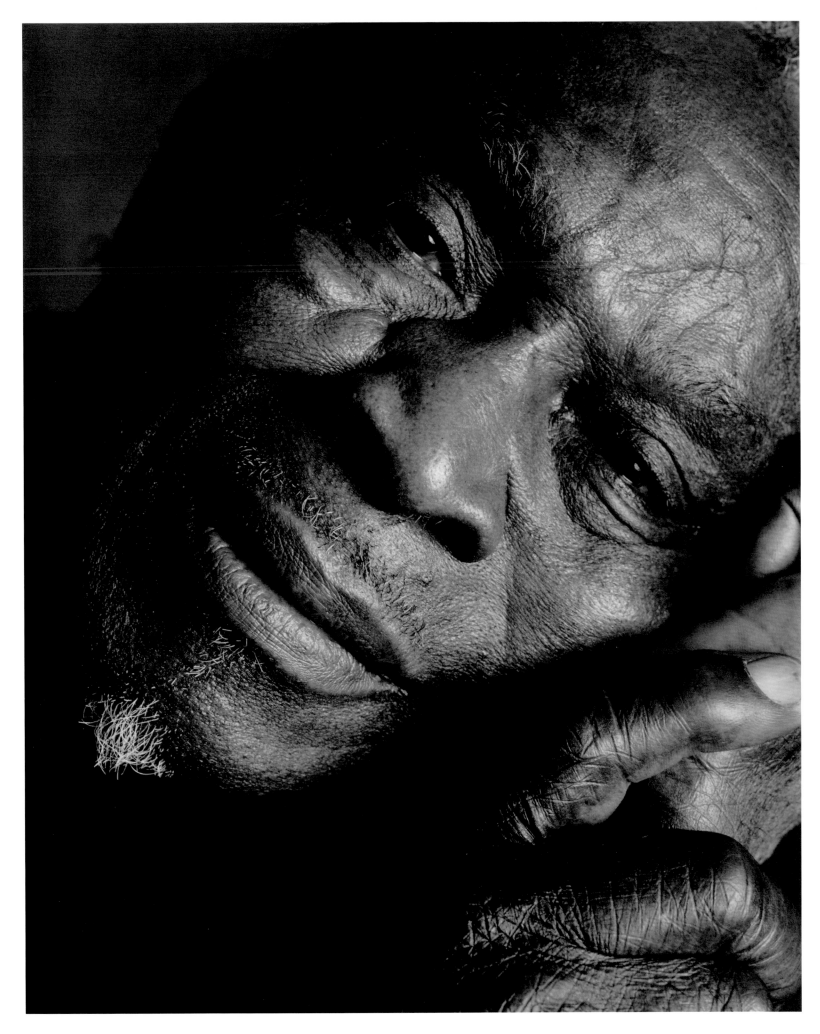

HONEYBOY EDWARDS (DAVID EDWARDS)
Shaw, Mississippi

135

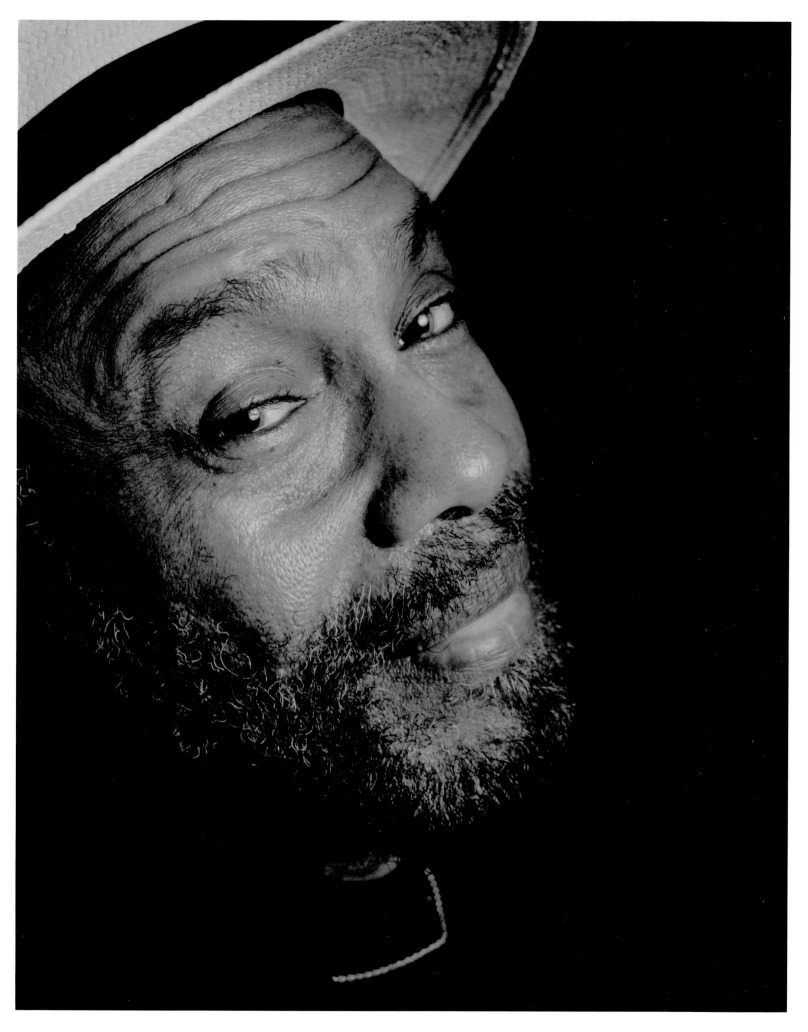

LESTER DAVENPORT
Tchula, Mississippi

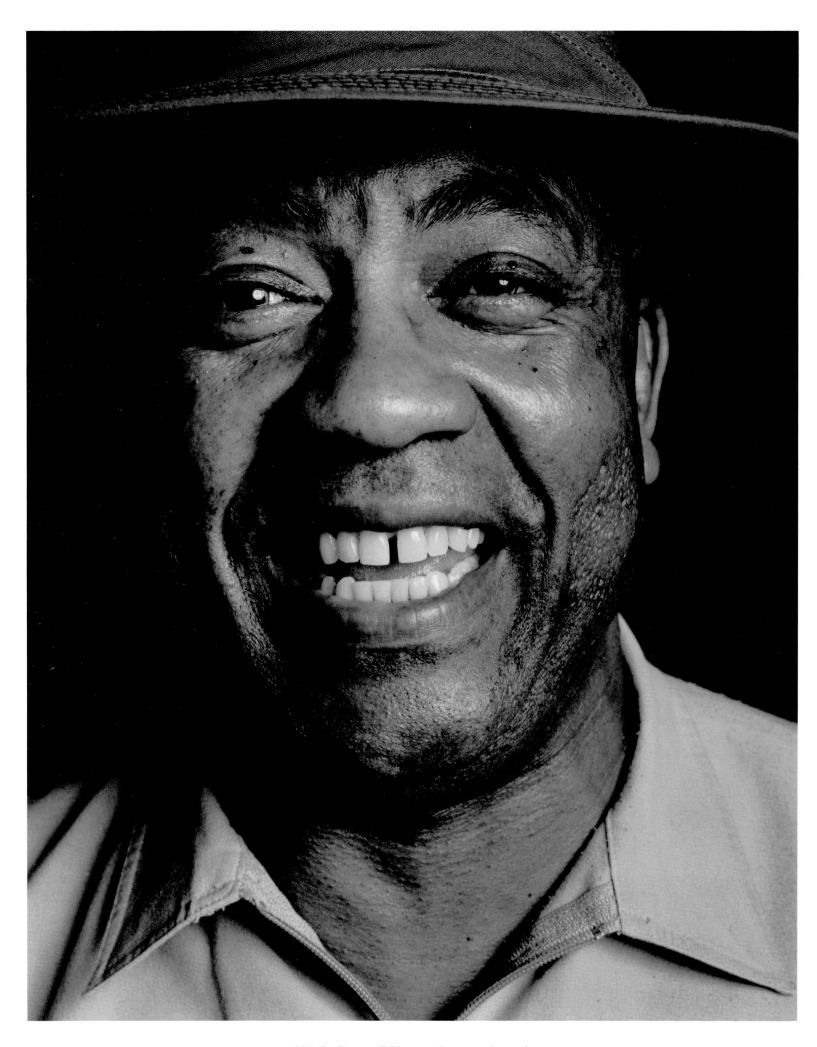

W. C. CLARK (WESLEY CURLEY CLARK)
Austin, Texas

137

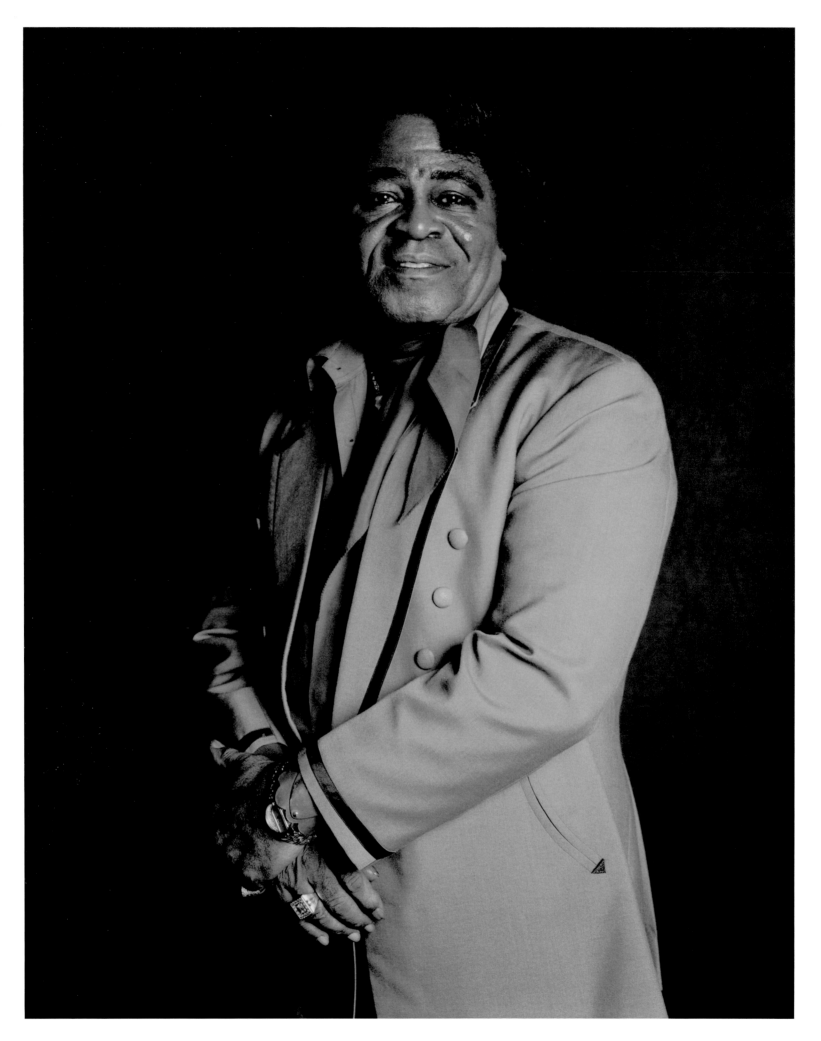

JAMES BROWN
Barnwell, South Carolina

138

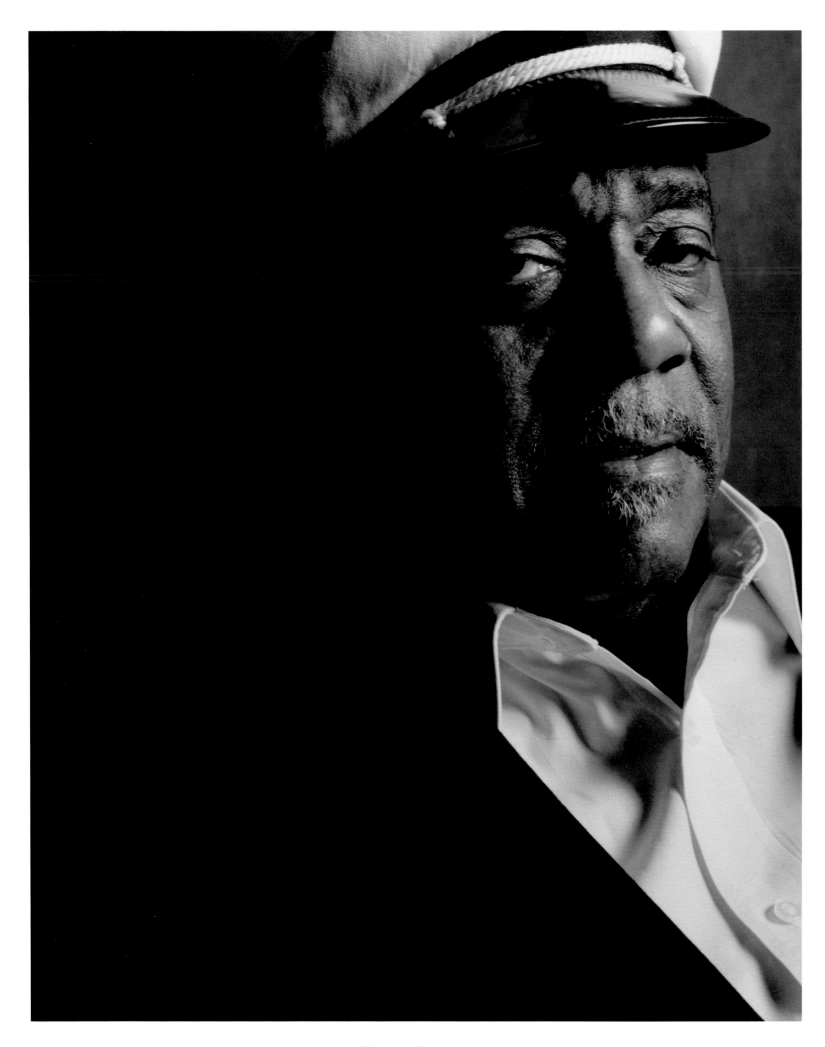

JOHNNIE JOHNSON
Fairmont, West Virginia

139

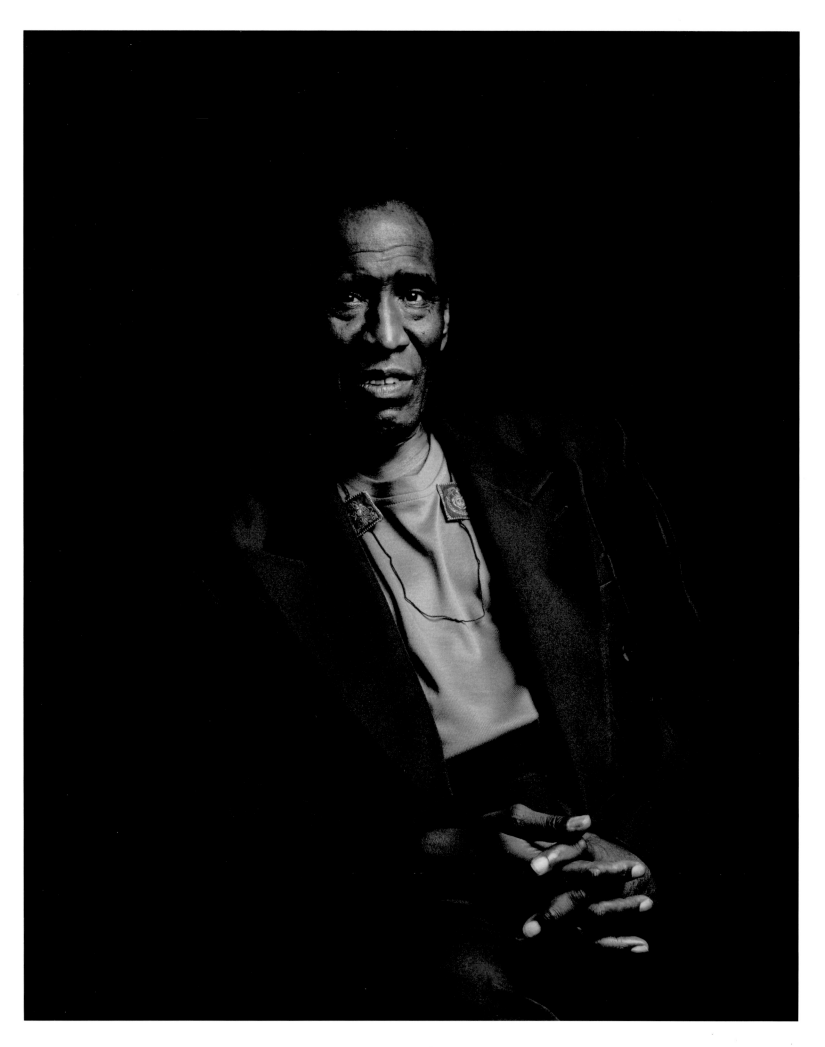

JOHNNY CLYDE COPELAND
Haynesville, Louisiana

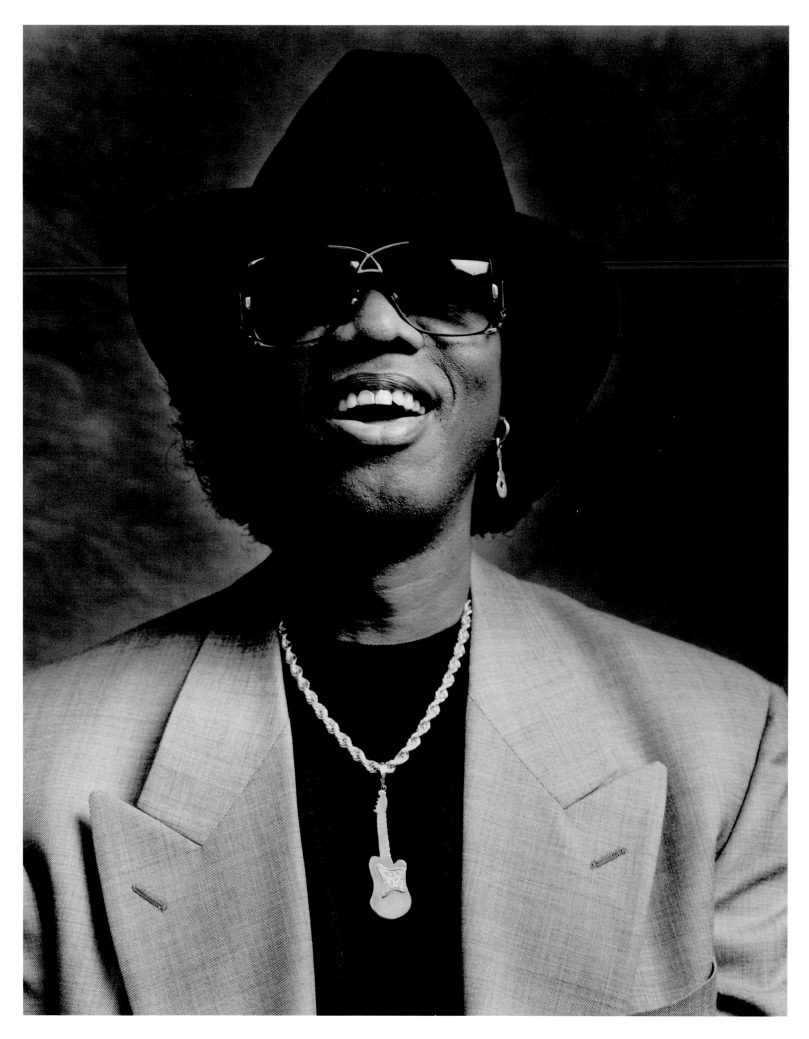

JOHNNY "GUITAR" WATSON
Houston, Texas

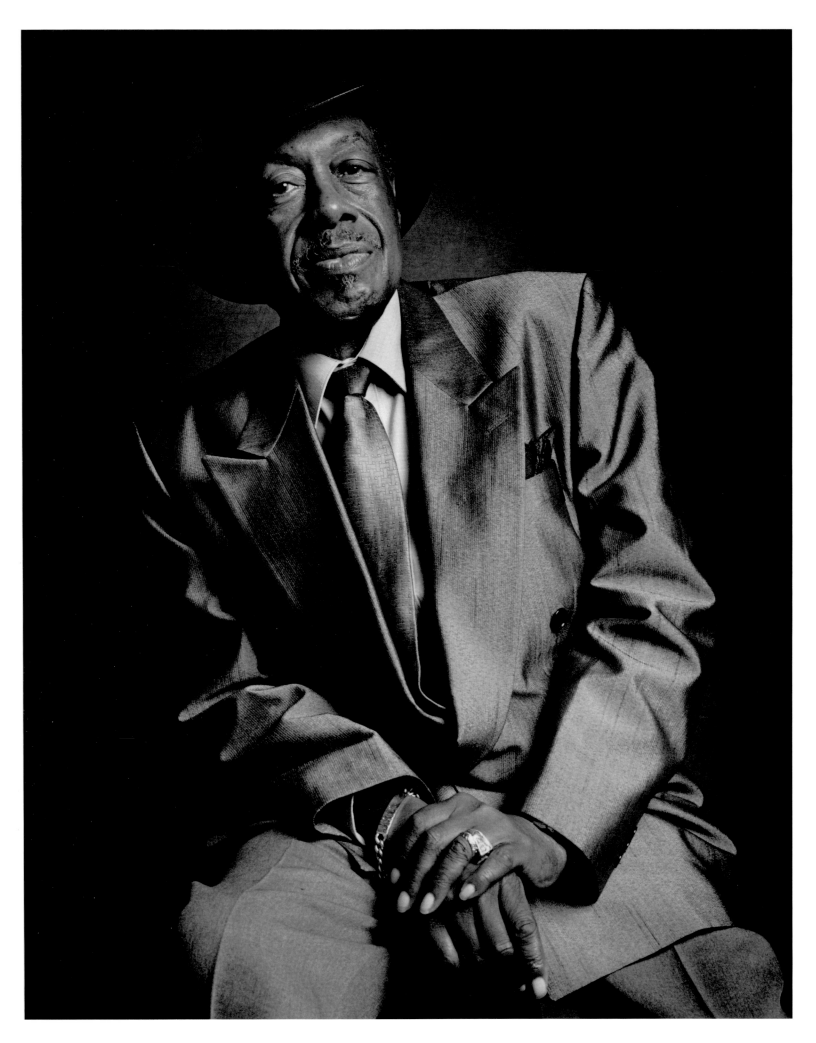

JIMMY ROGERS (JAMES LANE)
Atlanta, Georgia

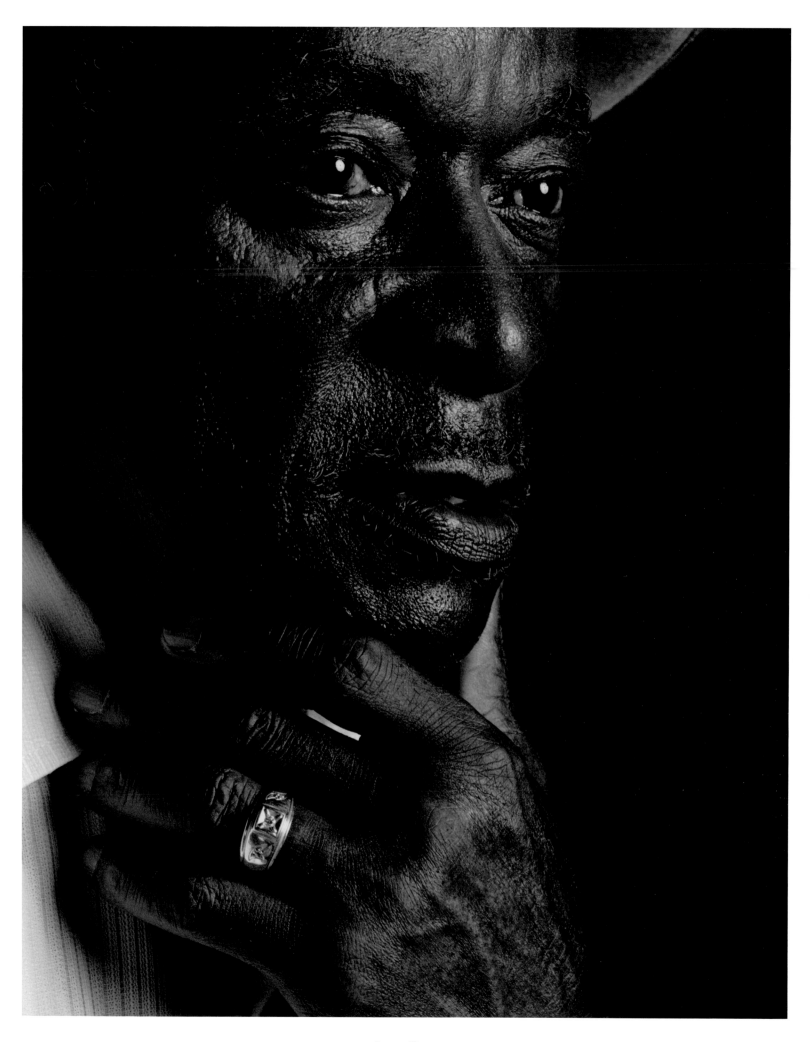

JOHN BRIM
Hopkinsville, Kentucky

143

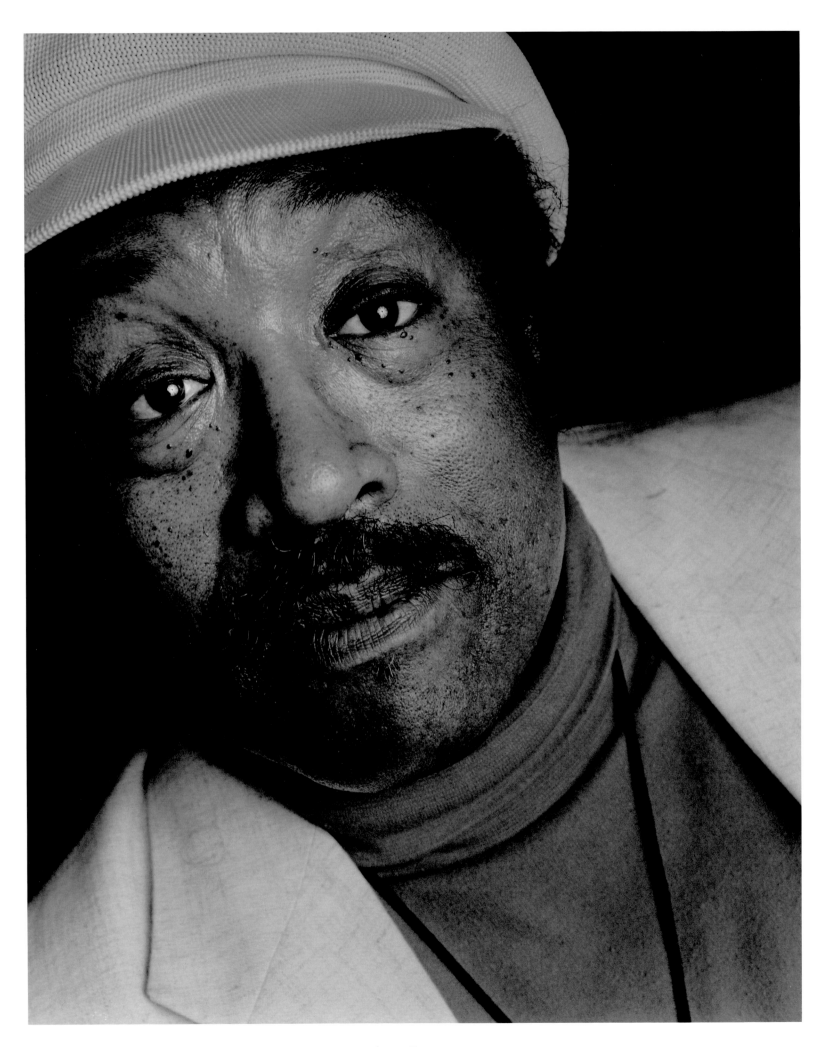

ARON BURTON
Senatobia, Mississippi

144

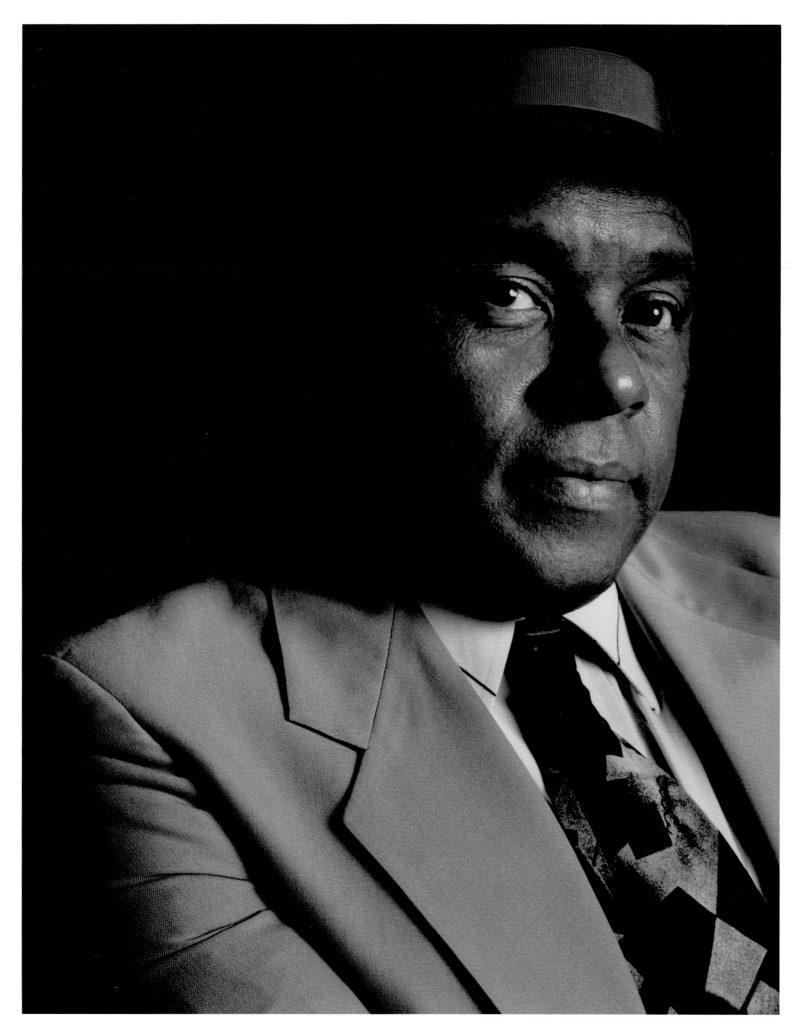

ROY GAINES
Waskom, Texas

145

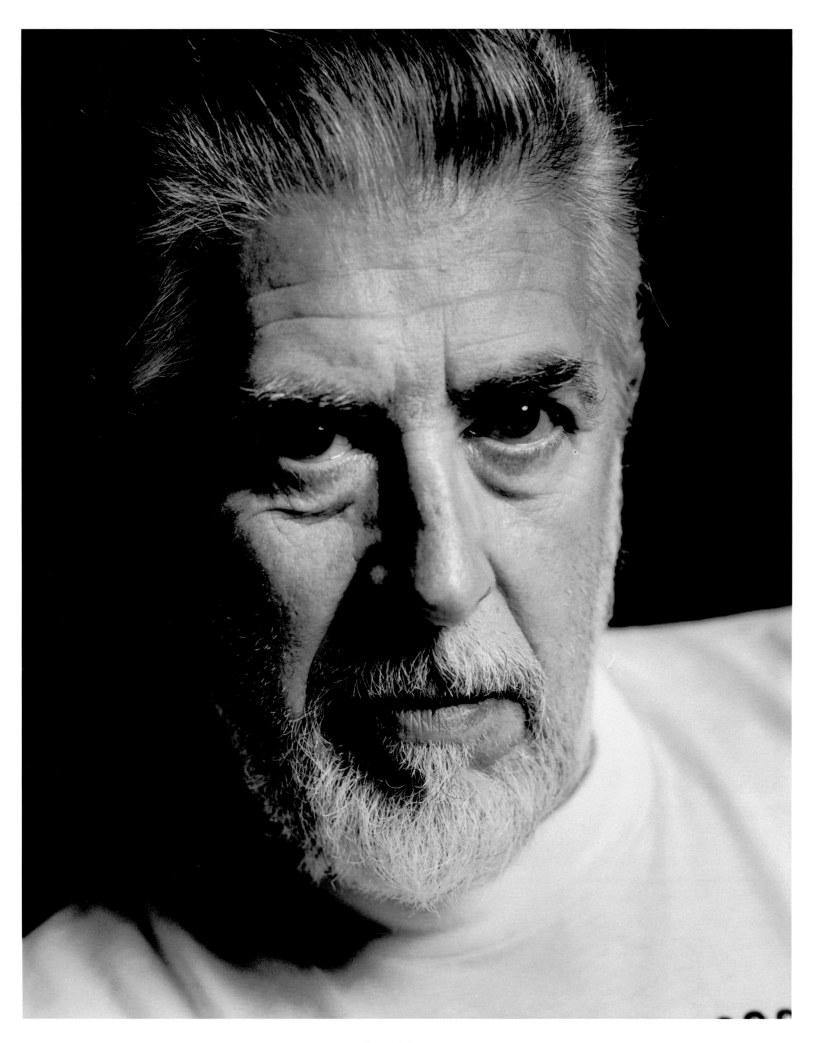

JOHN MAYALL
Manchester, England

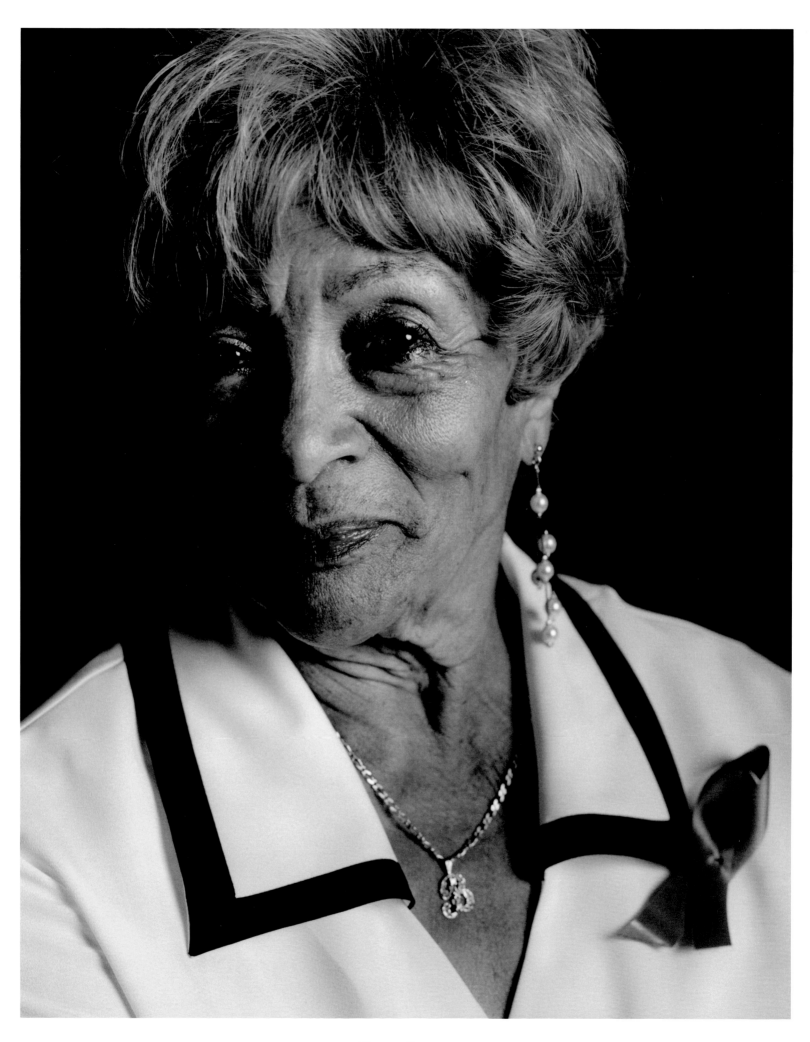

HADDA BROOKS
Boyle Heights, California

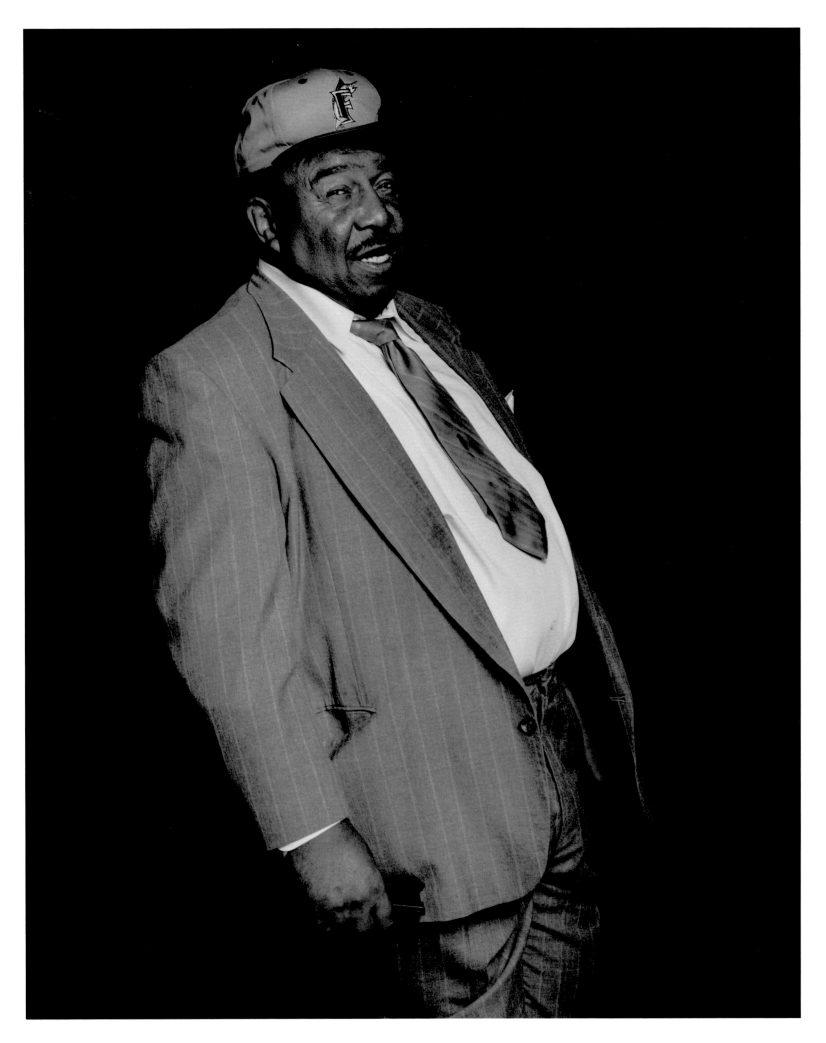

FLOYD DIXON
Marshall, Texas

148

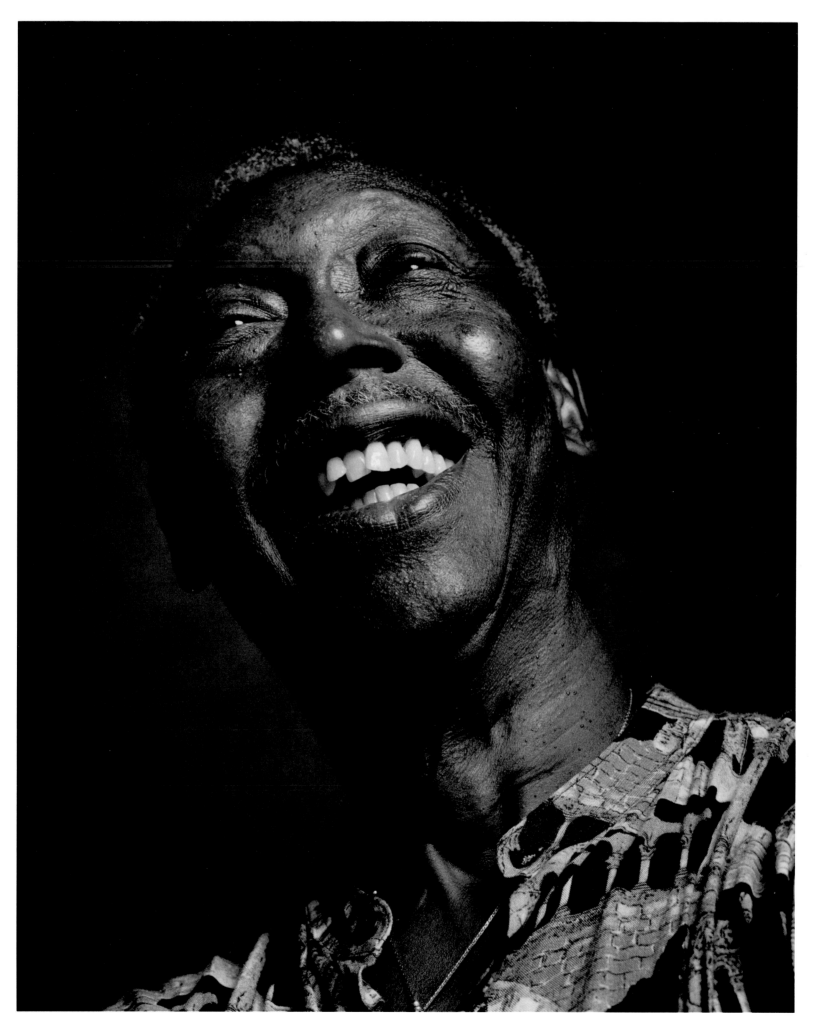

"TEXAS" JOHNNY BROWN
Ackerman, Mississippi

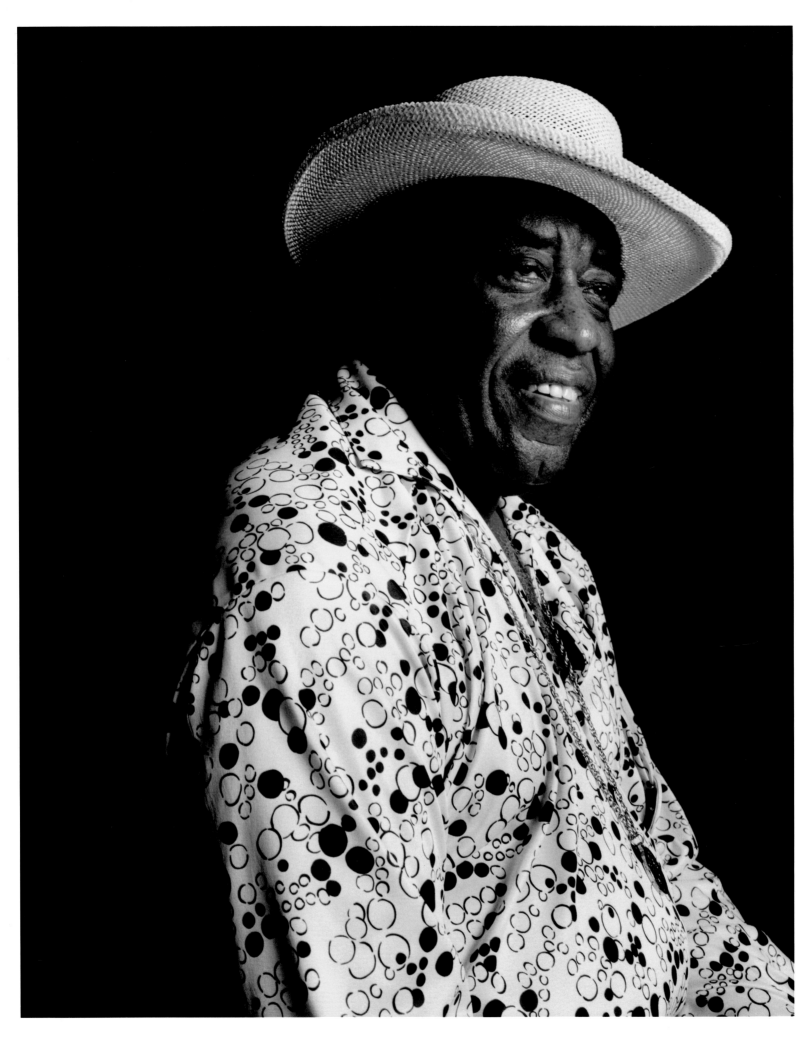

LONG JOHN HUNTER
Shreveport, Louisiana

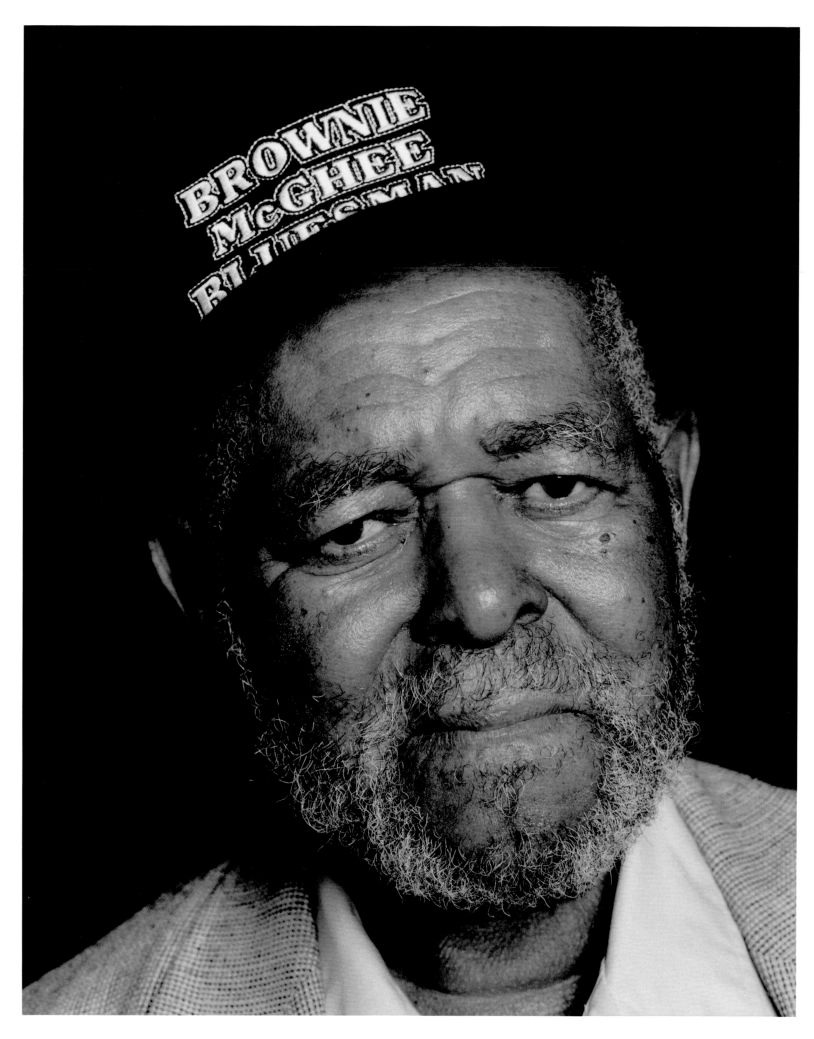

BROWNIE McGHEE (WALTER McGHEE)
Knoxville, Tennessee
151

Well, you see, the way the blues is, somebody worried about something, they got the blues if they can't sing them. If your old lady done quit you, you got the blues if you can't sing 'em. If you can sing 'em, you can get them off your mind, practically. That's what the blues is all about.

—PINETOP PERKINS

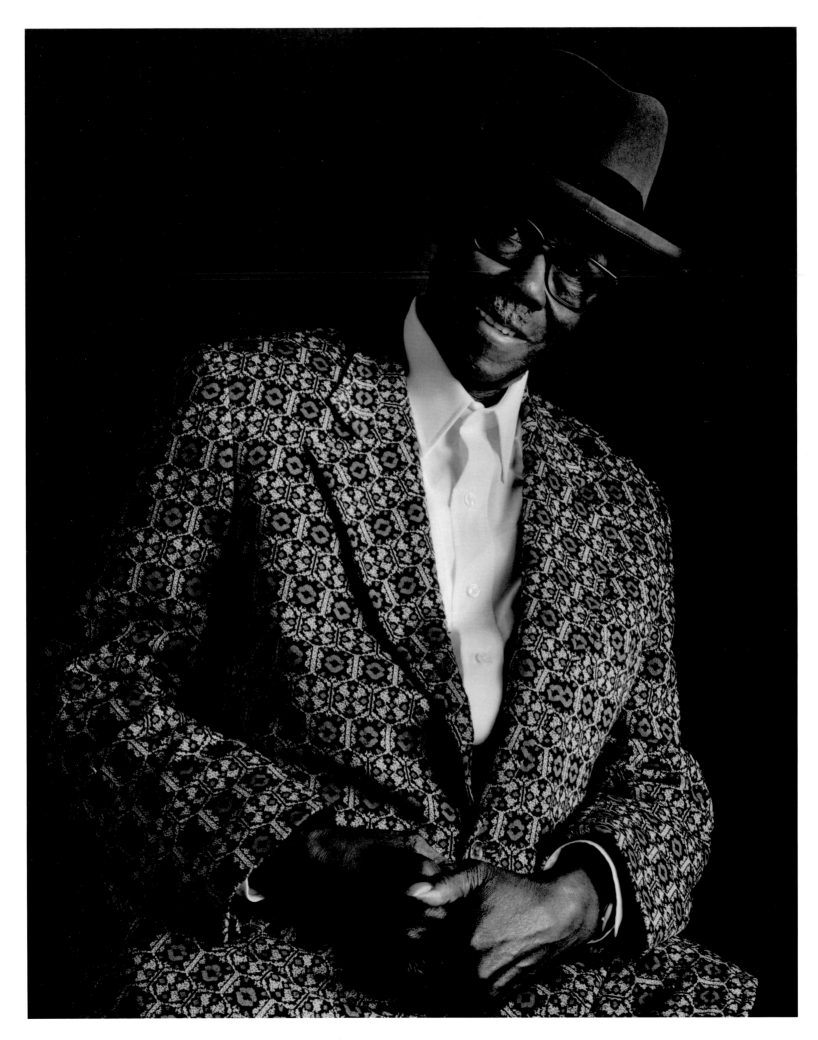

PINETOP PERKINS (JOE WILLIE PERKINS)
Belzoni, Mississippi

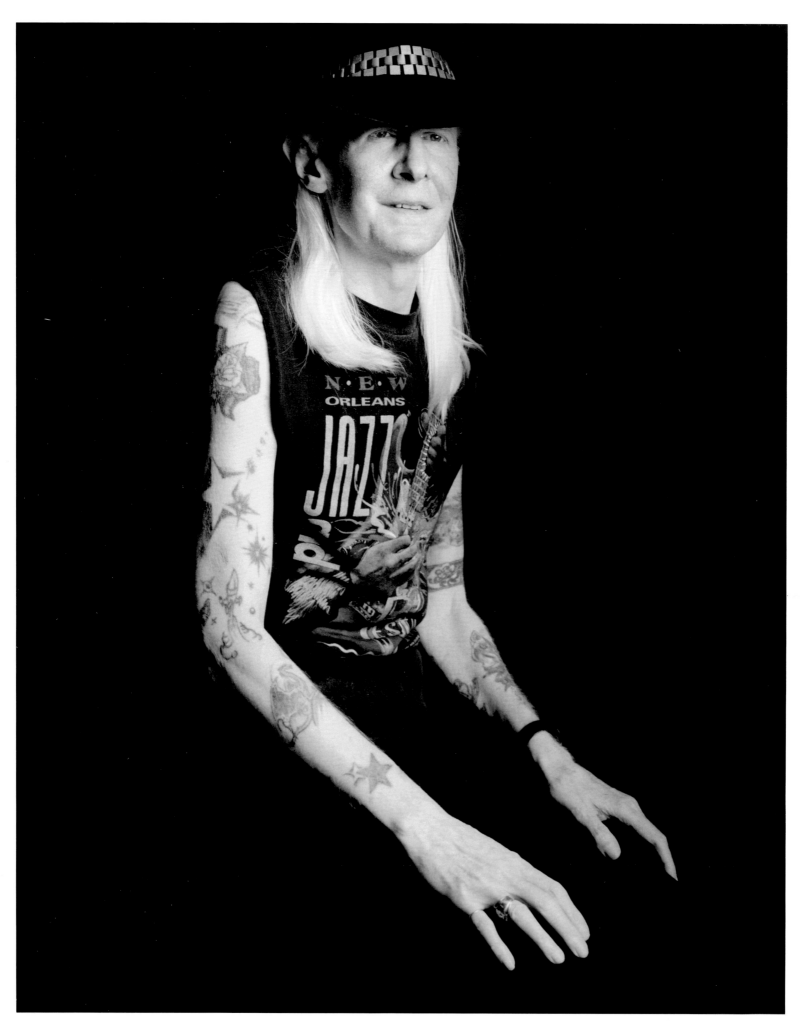

JOHNNY WINTER (JOHN DAWSON WINTER III)
Beaumont, Texas

154

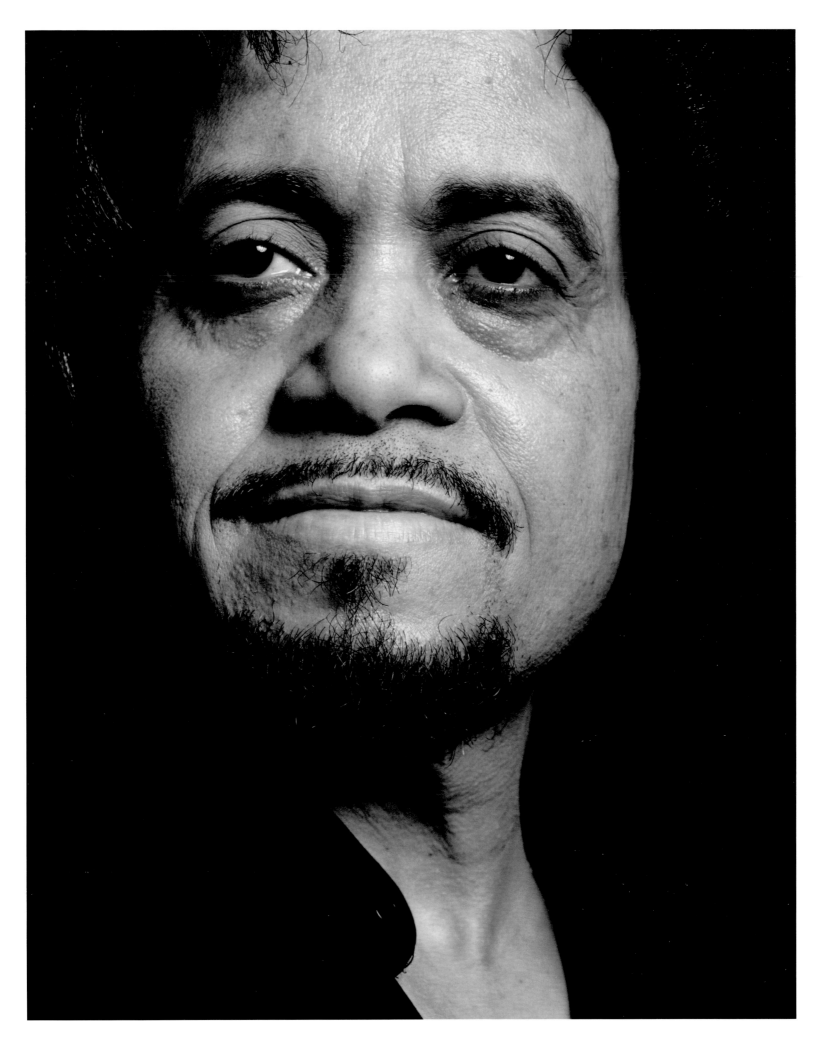

BOBBY PARKER
Lafayette, Louisiana

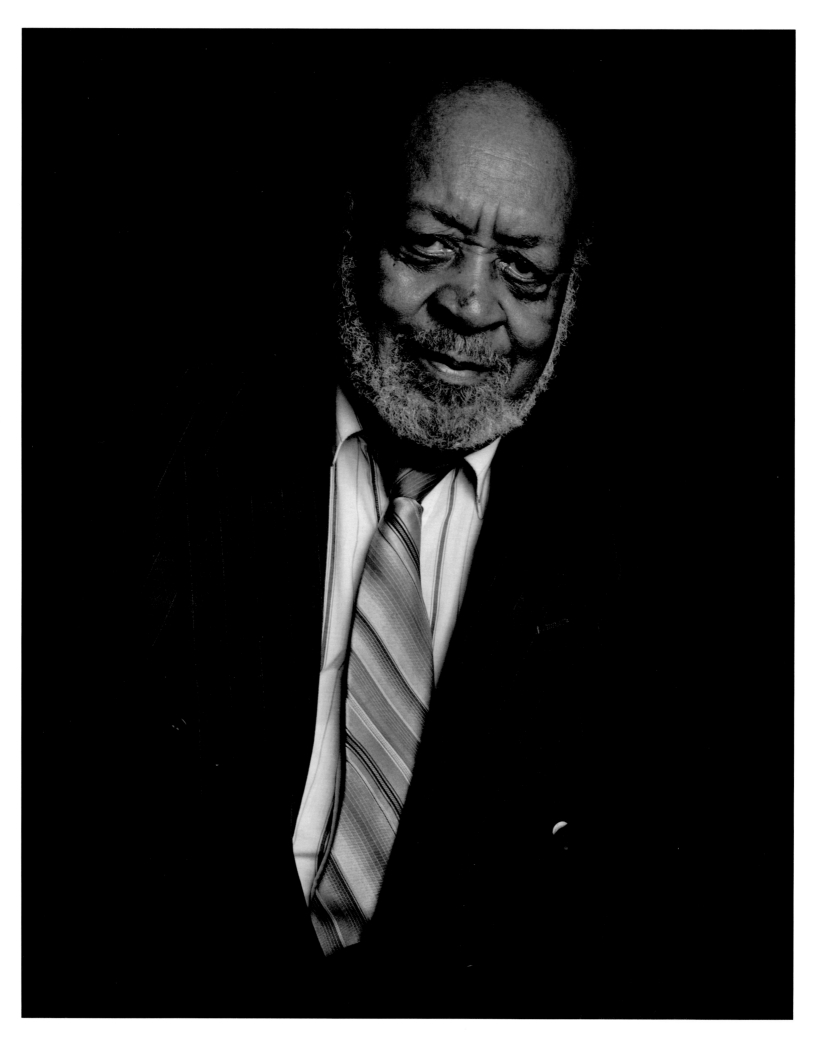

ROBERT JR. LOCKWOOD
Marvel, Arkansas

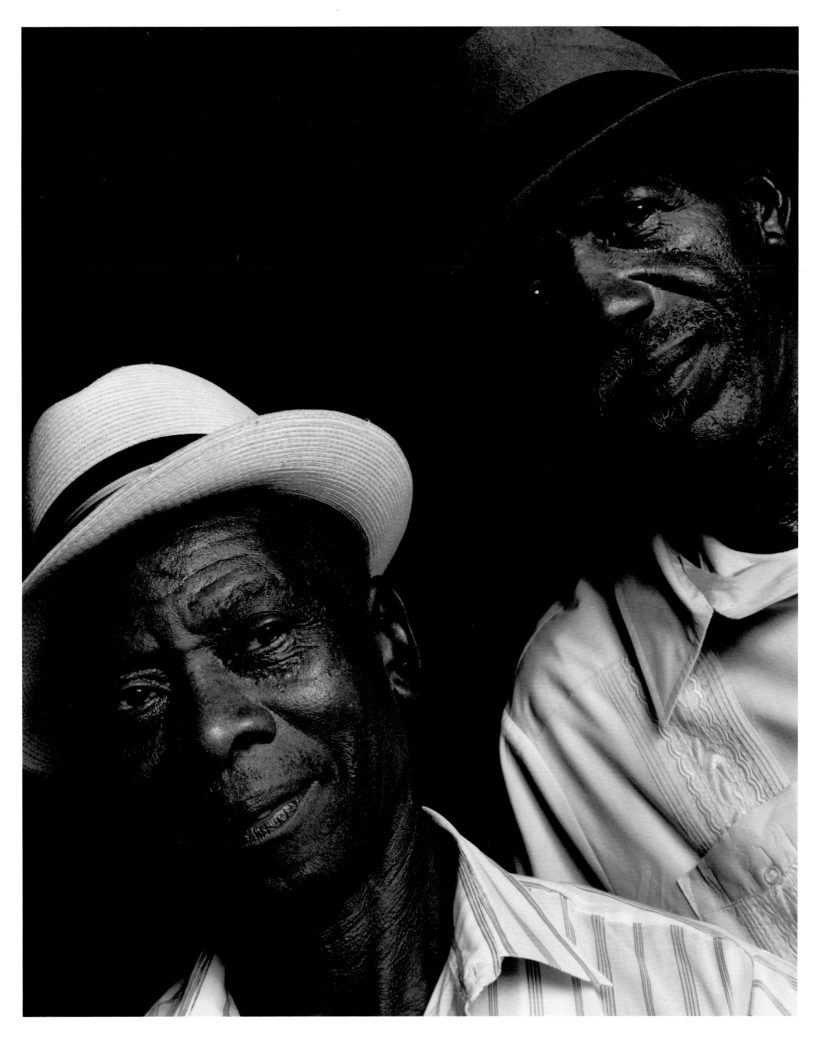

SAM CARR / FRANK FROST
Friar's Point, Mississippi / Augusta, Arkansas

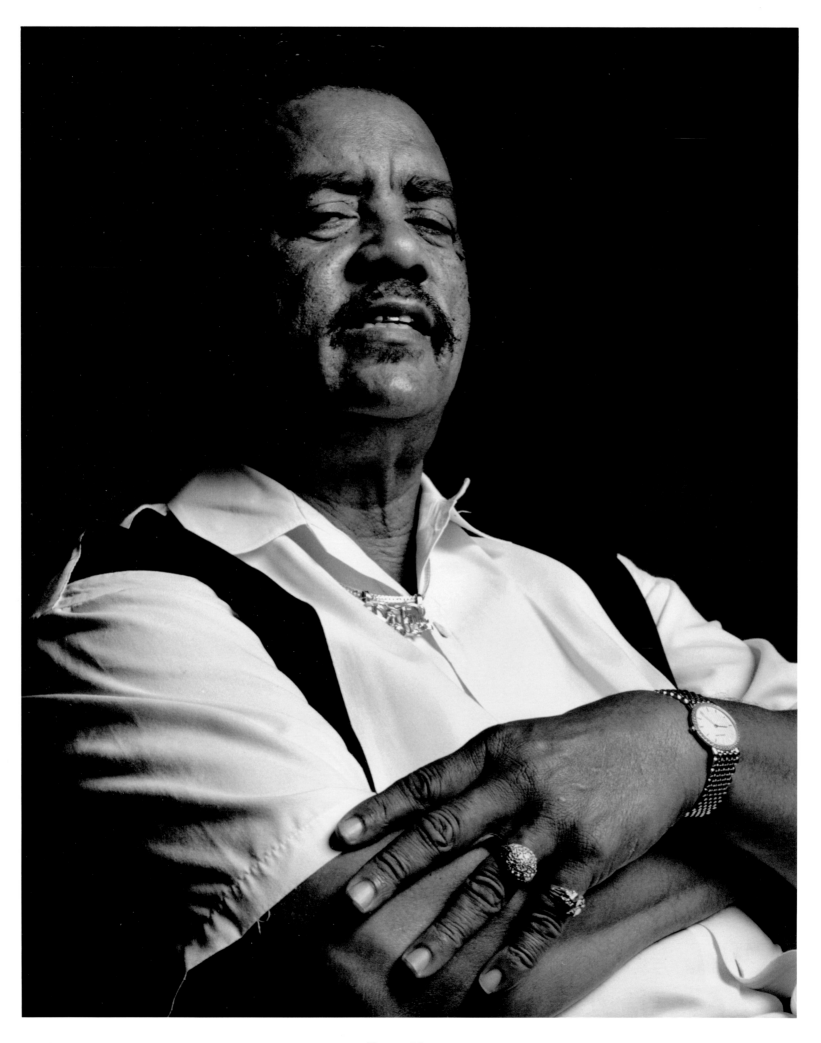

RAFUL NEAL
Baton Rouge, Louisiana

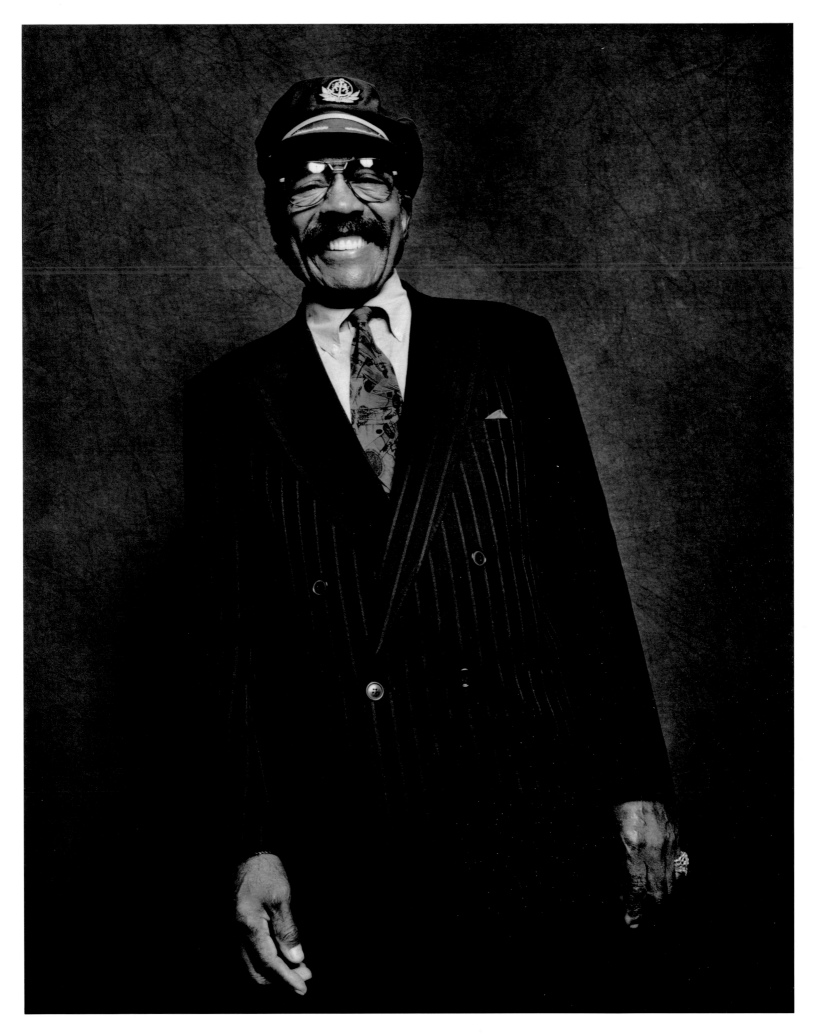

JIMMY WITHERSPOON
Gurdon, Arkansas

159

THE FUTURE

"The blues has changed just like a 1938 Buick automobile and a 1998 Buick automobile. The kids were brought up in a different environment since World War II. Times have changed. They got their freedom and wanted to play the music they liked. They didn't like the traditional music and so they started playing contemporary music. Now you can't tell the difference between the contemporary music and the blues! Hell, everybody loves it. They don't know what they're hearing but they love it! This is a different era, a different year, times have changed, so has the music. The people will stay with the current music as long as they like it, and then they'll go back to traditional music, jazz, Dixieland, and blues. The young people are getting older and as they age, they'll hear someone play something different and they'll check it out and come to like it."

—SONNY PAYNE

"Nowadays, the future of blues, the future of rhythm and blues is just like the future of rock and roll. All of it is going to be here now. It seemed like at one time that we were going to lose it. But it's got something now. It's got roots down there now that are spreading everywhere. More white groups are playing the blues now than ever before in the history of the culture. It's the music first that was here, that's been here, and it's going to be here now until the end of time. Nothing, but nothing can kill the blues. The blues is here to stay."

—RUFUS THOMAS

"Blues ain't gonna leave. I can tell you that now. We got a lot of young boys try to play the blues. They say, 'I can play the blues.' They can't play no blues. And then they got a few who can play the blues. You take Carey Bell's son, Lurrie Bell, he's a pretty good blues player. He is about thirty. Billy Branch is a good blues player. He ain't quite forty yet. We got quite a few young guys around here playing good blues—good blues. It ain't gonna never go nowhere. I don't believe that. It's always going to be the blues. Because it's been around too long."

—HONEYBOY EDWARDS

"I believe that blues music, the way we play it, could be played anywhere. It's just a matter of being able to get people to know about it. It was like, we wasn't trying to say, B. B. King and blues versus rock and roll, but let's be a part of it. Let us be a part of it with what we've got. . . . We thought it was good. And we come to find out a lot of other people think it's good, too."

—B. B. KING

"As for the future of the blues, it's not going to go away because it will climb all the way to the top and take its rightful place in our history books for future generations to learn from. Take it from an old man who knows."

—SONNY PAYNE

"The blues will live forever. As long as I'm around I intend to help keep it alive. I see the blues going all the way to the sky. If it lands somewhere in the clouds, I'll be right there singing the blues."

—KOKO TAYLOR

"The blues will forever be here. Just like gospel. You can't get rid of something that is true."

—JIMMY MCCRACKLIN

"The future for the blues looks good. I think to a degree, as time changes, the music changes. That is a sort of push-and-pull within the blues community, because a lot of people want things to stay the same. They want the same beats, the same rhythms, and you get younger musicians who want to expand on it and find their own style. So just like Muddy Waters did when he started playing electric, people thought he should have kept it acoustic. When he started making songs with bridges in them, like 'I Just Want to Make Love to You,' songs with different changes, people started to just want to hear the twelve-bar blues. So it's got to progress. It's going to progress no matter what anybody says."

—JOE LOUIS WALKER

JIMMY THACKERY
Pittsburgh, Pennsylvania

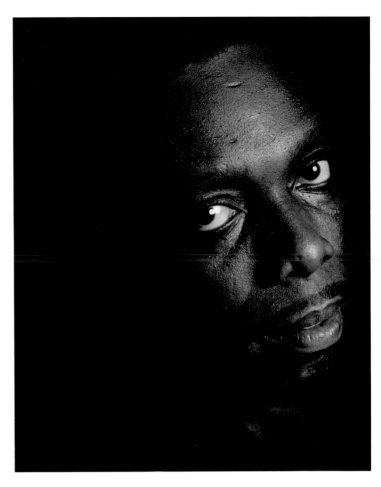

LUCKY PETERSON (JUDGE KENNETH PETERSON)
Buffalo, New York

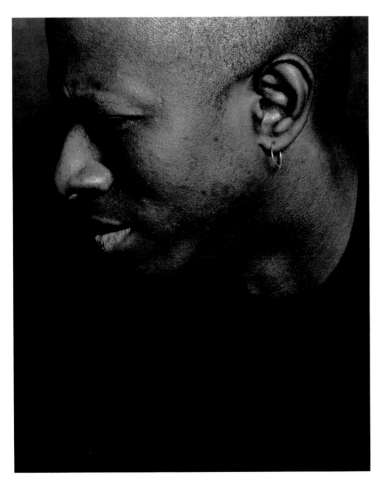

KEB' MO' (KEVIN MOORE)
Los Angeles, California

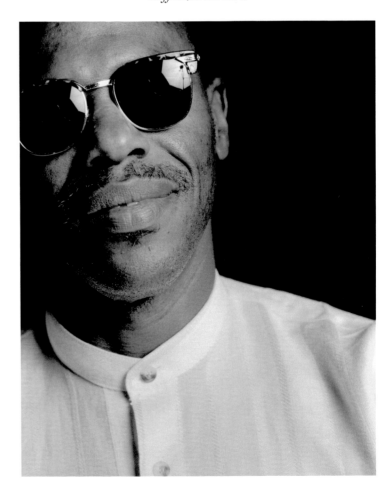

JOE LOUIS WALKER
San Francisco, California

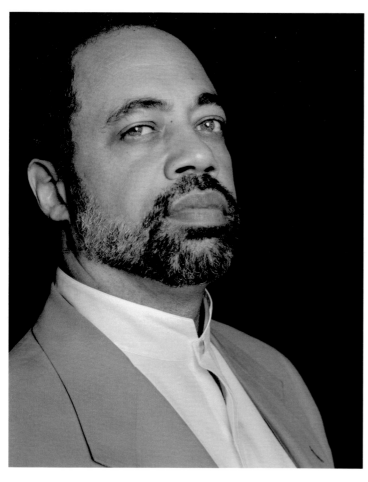

BILLY BRANCH (JAMES EARL BRANCH)
Great Lakes, Illinois

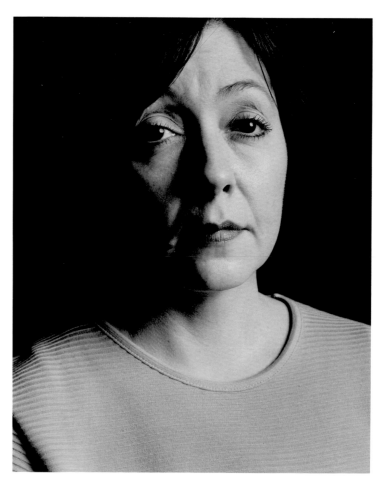

LOU ANN BARTON
Fort Worth, Texas

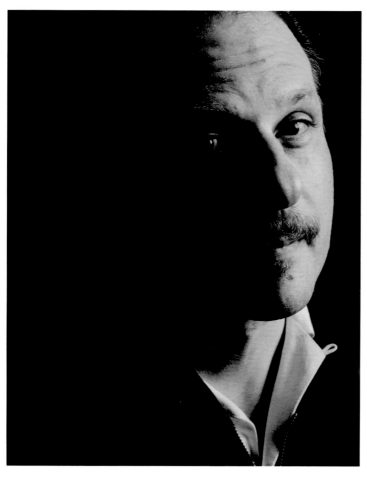

RONNIE EARL (RONALD HORVATH)
New York, New York

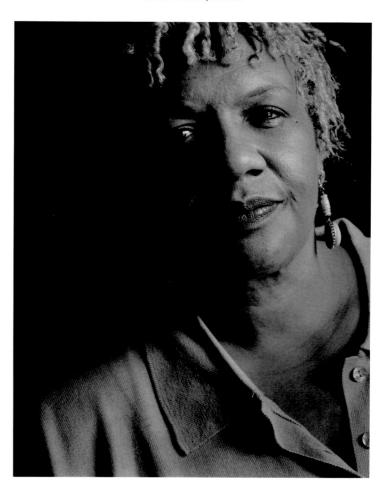

BARBARA MORRISON
Ypsilanti, Michigan

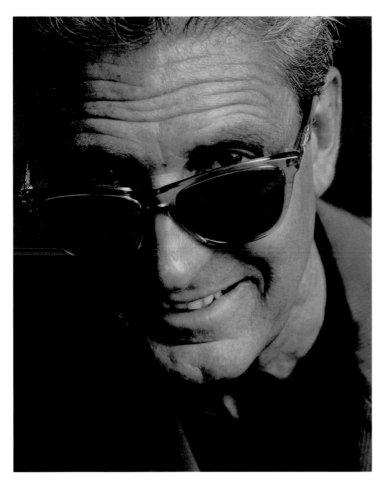

ROD PIAZZA
Riverside, California

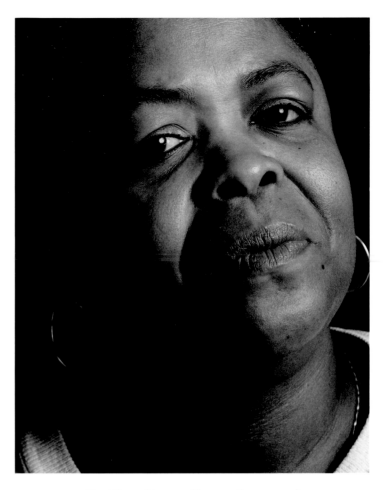

BIG TIME SARAH (SARAH STREETER)
Coldwater, Mississippi

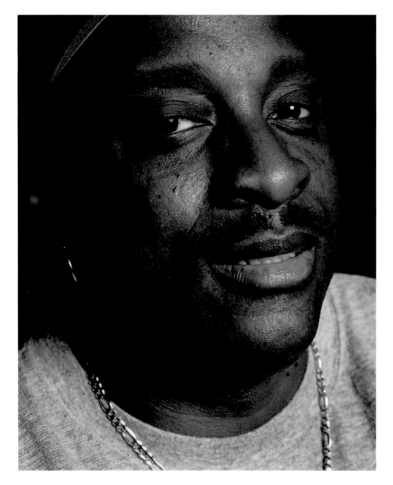

RICO McFARLAND
Chicago, Illinois

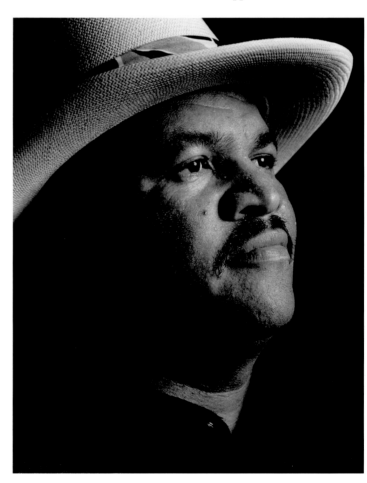

SHERMAN ROBERTSON
Beaux Bridge, Louisiana

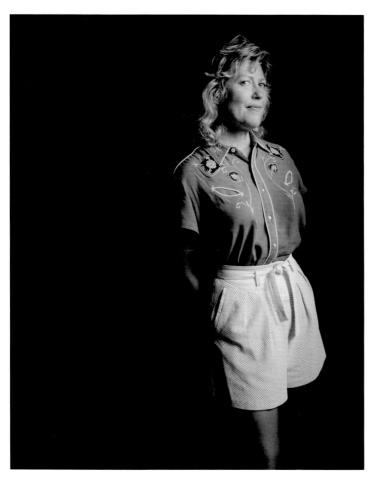

ANGELA STREHLI
Lubbock, Texas

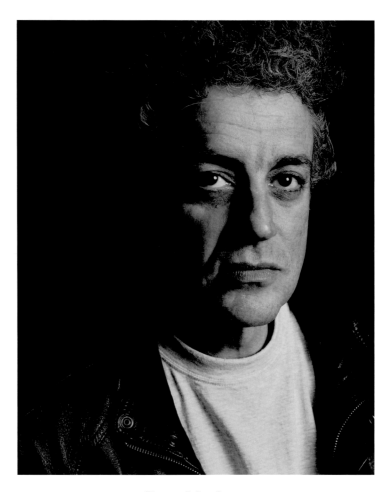

DOUG MACLEOD
New York, New York

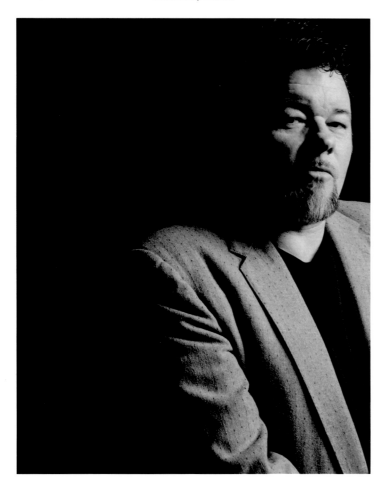

JAMES HARMAN
Anniston, Alabama

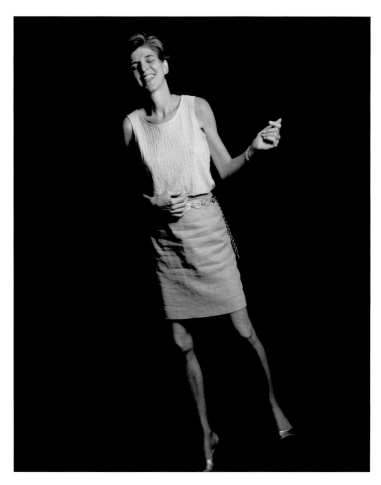

MARCIA BALL
Orange, Texas

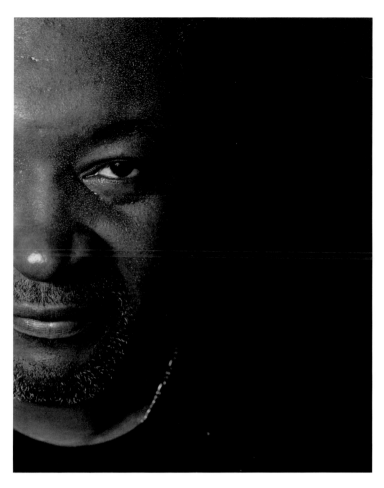

CARL WEATHERSBY
Jackson, Mississippi

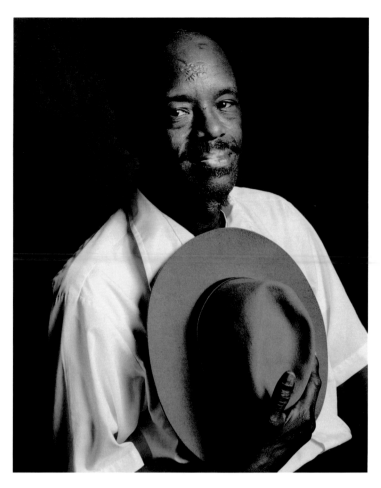

PAUL "WINE" JONES (JOHN PAUL JONES)
Flora, Mississippi

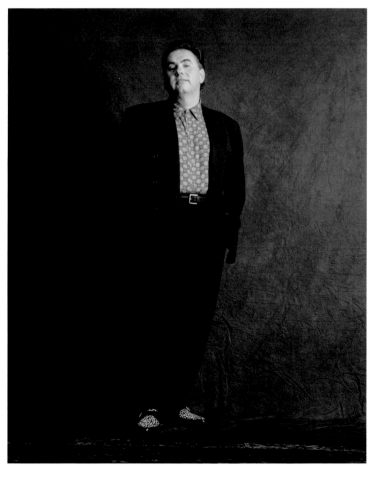

DUKE ROBILLARD (MICHAEL ROBILLARD)
Woonsocket, Rhode Island

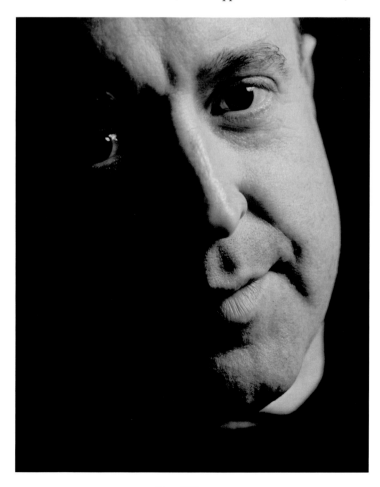

KIM WILSON
Detroit, Michigan

AFTERWORD
"Sunshine" Sonny Payne, The Voice of the Delta

I never considered that the *King Biscuit Radio Show* might become my life's work. I told my boss when he hired me, "This damned show won't last a week." All I've got to say is that I got on my hands and knees and asked the Lord to forgive me for being so wrong. I not only apologize to Him, but in my prayers I apologize to all the musicians for thinking such a thing.

I feel like someone handed me ten dollars like you see on TV: send it off and you might win ten million dollars. I feel like someone handed me the ten million and I said, "Thank you." That's exactly how I feel. Gary Martin of the Kentucky Headhunters paid me the nicest compliment I've ever had in my whole life. He wrote in his little local paper when I received my "Keeping the Blues Alive" award from the Blues Society, "Every man, woman and child that's never met you should walk up to you and shake your damned hand." I said, "For what? All I do is play the music." He said, "I know you do, but they should walk up and shake your hand for keeping the damned blues alive." That was like receiving a ten-million-dollar check.

I did the 12,944th *King Biscuit Flour Show* today. I was there for the very first time Sonny Boy [Williamson II] and Robert Jr. [Lockwood] first tuned that old Spanish guitar for the first show, and I'm still here.

I came to work on November 14, 1941, the first day they opened KFFA. I wasn't on the air yet. I knew a man named Quinn Floyd. He and John Franklin, who started the station, decided to hire a school superintendent out of Nettleton, Arkansas, by the name of Sam Anderson. I knew him and he told me that when I got out of school he'd see about putting me to work. We didn't fill out applications then, everybody knew everybody. When I showed up after school the first day, I realized I wasn't going on the air—he was going to teach me how to get my license. Well, I worked there until December of 1942, engineering the *King Biscuit Flour Show*. Then I went into the army, did two three-year hitches and returned to KFFA and *King Biscuit* in 1948. I've been here ever since. I've done 11,482 shows myself.

The *King Biscuit Time* show runs a half-hour now. Back in the old days, they were only fifteen minutes. KFFA was the first radio station to broadcast blues in the Delta. Still doin' it. It's still sponsored by King Biscuit too. At the time we didn't know we were keep-

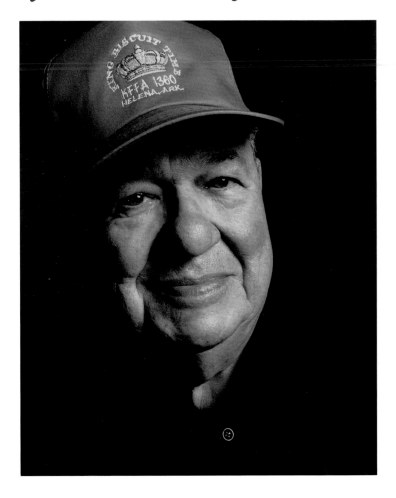

ing the blues alive. We were doing something that we loved. I do feel privileged and very honored that the blues artists, both past and present, have shared the music and feelings of their culture with me. That's what I call trust and faith that can't be beat.

Since I started in the blues, I have met and gotten acquainted with some of the best friends that I've ever had in my life. When I was a kid, I didn't think I would have any friends, but I wind up having friends like Robert Jr. Lockwood, Sonny Boy Williamson, and a host of others like Sam Carr and Jimmy Cotton, a whole lot of them. Everywhere I go—nothing but kindness to me and I love every one of them. They just don't make people any better than that. Hearts of gold.

As for *State of the Blues*: What a book! If you really want to learn about the blues, here you have an all-star book with an all-star line-up in it. And, it's from the good old US of A!

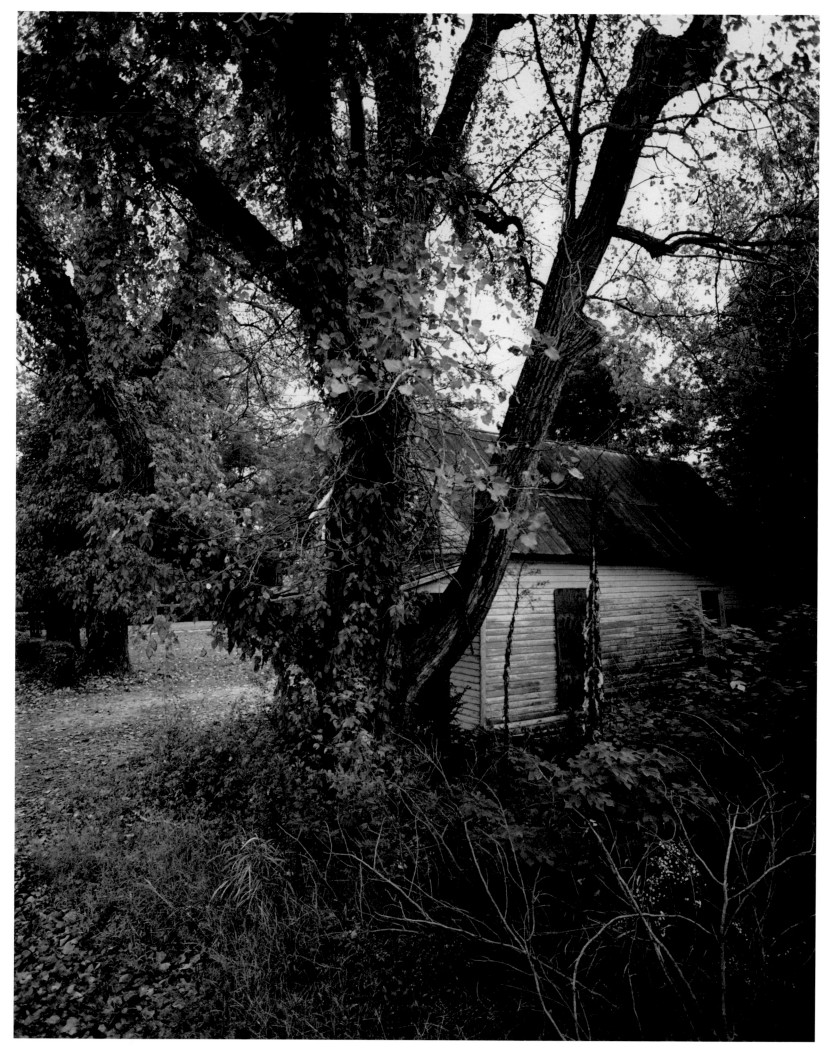

Robinsonville, Mississippi

POSTSCRIPT *Jeff Dunas*

So how does a 39-year-old white photographer get the blues? In the mid-sixties my favorite music was performed by the Rolling Stones, the Beatles, the Yardbirds, Eric Clapton, Chuck Berry, Fats Domino, Jimi Hendrix, Canned Heat, Fleetwood Mac, Derek & The Dominos, Cream, and, yes, John Mayall and Paul Butterfield. I knew what music I liked, but what I didn't know at the time was that all the music I listened to was linked by a common thread: the blues. I thought Clapton wrote "Crossroads." How was I to know that most of my favorite music was in fact not written by Jagger and Richards but by Robert Johnson, Muddy Waters, Big Joe Turner, and Willie Dixon?

I had the pleasure and good fortune in my late teens to have met and become friends with the great radio personality Wolfman Jack. Over the years, he opened my eyes to the blues. He used to come home from his radio shows after having played soul and R&B music for hours and unwind listening to the blues. He showed me that my favorite music was derivative of the great blues tradition.

The blues soon became a great passion in my life. Consequently, in the late eighties I decided that I wanted to record the faces of the great blues artists that I listened to so often. I didn't know yet exactly how I was going to render them, nor did I know how I would obtain access to them, but I decided to pursue this as a portrait project.

Very little happened until 1993, when I went to the opening night of the House of Blues (HOB), a new club within walking distance from my studio in Los Angeles. As soon as I walked into the club I realized that I was looking at the opportunity of a lifetime: all the greatest living blues artists in America would be performing in this club, and all I had to do was find a way of photographing them. I made contact with Nigel Shanley of the HOB and arranged to show him my personal portrait work. Nigel looked at it and gave me the green light. Not only the green light, but a room in which to set up my "studio" and access to any performer who was booked at the HOB. I showed my early portraits to Isaac Tigrett, the founder of the HOB, whose enthusiasm for them prompted us to work toward the making of a future "Wall of Fame" in the Foundation Rooms of the HOB. A reality since December of 1996, this exhibition entitled "Legends of the Blues" took nearly four years to complete, with over sixty setups and countless challenging situations to overcome.

Nigel Shanley and I soon realized that to go through normal channels for each portrait would be unwieldy, so we adopted a unique method. I would bring the equipment over and set everything up, and Nigel would show the artist my work and ask if they would agree to give me a few minutes to make their portrait. Literally a few minutes, as in most cases I took these portraits moments before the artists were due to go on stage in front of 600 to 1,500 people. The artists themselves would decide if they were interested after seeing my portraits.

Having so little time in which to make these portraits, and making them at a time when most of the artists were in a highly charged mental state, was a logistical nightmare, but it was also a wonderful challenge and has produced images that I believe contain a rare spontaneity and insight.

Another unusual factor is the absence of musical instruments. I decided early on in the series to exclude on-stage and performance portraits altogether and focus instead on capturing the pure essence of each individual artist as a person, as well as a great performer and musician. The portraits required between five and eight minutes, which was all the time I had in most cases. Sometimes surprised and often intrigued by the fact that I was clearly looking for something other than a classic and often clichéd promotional picture, many of the artists responded by abandoning their standard poses and revealed instead a new and previously undocumented side of their personalities. Their faces resonate with the blues. I have endeavored to create photographs that transmit the feeling of blues music.

In addition to these portraits, I spent approximately eight weeks in the South creating "The Blue Highway," a documentary series of toned black-and-white portraits of the Mississippi and Arkansas Deltas, northern Louisiana, and eastern Texas, the birthplaces of the blues. My intent was to marry the faces and the places, although not literally. I wanted to feel the place where the music was born. I wanted to understand the lives these people lived and the world from which they wanted to

escape. I wanted to know what they saw as they wrote and played the blues. To see them on stage in our big cities today is not to see the real heart of the blues. I wanted to see their origins, to feel the blues in a much more profound way. I had to go there. You should, too. To travel in the South is to reach back into the blues. You will always hear the music differently if you do.

Having met and photographed over 150 blues artists, I would like to comment on them as a group. Unlike many rock musicians, they are a totally unpretentious, open, and warm group of people. Their faces contain so much evidence of this that indeed it practically goes without saying, but because I'm often asked about them, I wanted to put my impressions to print.

Why the title *State of the Blues*? For me it has three meanings. First, it refers to Mississippi, which is where close to 80 percent of the first- and second-generation blues artists were born. Second, it refers to the state of mind when one has "the blues." Lastly, it refers to this book's overview of the state of blues music today—an overview of the people making blues music in our time.

I have tried my very best to contact and photograph every blues performer who forms a part of this group. Of course, in spite of my best efforts, I couldn't get them all to sit for me. This collection is by no means conclusive. I can say, however, that I have been fortunate to photograph the vast majority of those who have shaped and continue to shape the world of the blues, and if there are exceptions not represented here, I hope to photograph them later.

Obviously most early influential artists passed on before I began this project. You won't find Muddy Waters or Howlin' Wolf here. I missed the opportunity to photograph the great Willie Dixon, Sunnyland Slim, Memphis Slim, Sonny Boy Williamson, Elmore James, Lightnin' Hopkins, and Little Walter, but I have listened to them extensively and I urge you to do so as well. Their music is represented in so much of the music being listened to today that they will never die. A number of the artists I photographed have recently passed on. Johnny Clyde Copeland is gone, as are Brownie McGhee, Jimmy Witherspoon, Luther Allison, William Clarke, Jimmy Rogers, Junior Wells, Junior Kimbrough, and Johnny "Guitar" Watson. This says

to me that I started this project not a moment too soon. These artists have left a great deal of themselves behind in their music, and I hope they are playing in Muddy's big blues band in the sky as I write these words. Some day we'll all be able to hear them play again.

The first and second generations of blues men and women created the blues and made it theirs. They matured between the two world wars, in the rural South, clearing the Delta and working in the cotton fields, or in other equally menial professions. The great Albert Collins drove a tractor for much of his life. John Lee Hooker left Clarksdale, Mississippi, and worked as a janitor in Detroit City before he was discovered. Billy Boy Arnold drove a bus in Chicago for twenty years after recording his 1956 seminal harmonica work with Bo Diddley on "I'm a Man." Muddy Waters worked on the Stovall Plantation outside of Clarksdale as a young man. They, like the many other founders of the blues, would get together in each other's homes, at dances, fish-fries, or in makeshift clubs known as juke joints to play their music. It is said that the blues grew out of Negro spirituals, gospel music, the chain gangs, and ragtime. Whatever its origins, its significance lies in the fact that the men and women who created this unique musical form did so because they "had the blues," a very particular kind of blues linked to a specific geographical area and a period in American history.

I encourage you all to listen to the real blues. Check out the work of the great Charley Patton, Robert Johnson, Son House, Blind Boy Fuller, Blind Lemon Jefferson, Big Bill Broonzy, and Sonny Boy Williamson I (John Lee Williamson). Listen to Mance Lipscomb, Professor Longhair, Arthur "Big Boy" Crudup, and others, such as the legendary guitarist T-Bone Walker, Memphis Slim, Albert King, Lonnie Johnson, Hound Dog Taylor, Elmore James, Sonny Boy Williamson II (Rice Miller), Muddy Waters, Little Walter, Howlin' Wolf, Willie Dixon, Albert Collins, Lightnin' Hopkins, and Jimmy Reed. If I had only begun this project in 1968 instead of 1994!

—JEFF DUNAS, LOS ANGELES, 1998

ACKNOWLEDGMENTS

This book would not have been possible without the dedicated help of Nigel Shanley of the House of Blues. I owe him a great debt. His enthusiasm, energy and sheer guts convinced many of my subjects to sit for me. He made it his business to pave the way for me in the beginning and without him this could not have happened. He worked on this project right up to the end with his customary full commitment. He made it possible for me to work at the House of Blues, photograph the subjects that I needed for this book and took it upon himself to create the Wall of Fame of my photographs that is displayed in the Foundation Rooms of the Los Angeles House of Blues. His contribution was immeasurable.

Another person who helped me enormously was Gary Chiachi, producer of the *Nothin' But the Blues* nationwide radio program and co-producer of the great Long Beach Blues Festival, where I made many of these portraits over the years. His knowledge and interest in the blues has always been a great resource for me. He put me in touch with countless of the subjects for this book and with his recommendations, many agreed to sit for me. He accompanied me on two trips to Mississippi, Tennessee and Arkansas while making the documentary photographs for this book. He has been like the little bird on my shoulder throughout this project making suggestions and offering his advice.

I feel a great friendship for Mr. William Ferris, not only for his excellent text written for this book, but also for his early and consistent enthusiasm for my portrait work. Even with his busy schedule as Director of the Center for the Study of Southern Culture, his teaching position at "Ole Miss"(University of Mississippi at Oxford) and his chair of the National Endowment of the Humanities, he always remained available to discuss this project and e-mail me with his thoughts, support and encouragement. He is a gracious and intelligent gentleman in the true Southern sense of the word.

Gary "The Wagman" Wagner, host of the radio program *Nothin' But the Blues* has been a great friend, resource and enthusiast of my work. His personal rapport with many of the blues performers featured in this book paved the way for a number of portraits. Many were made during several on-the-air Christmas Blues parties held at his radio station, KLON, in Long Beach, California.

I need to mention the help and support that I had from the beginning from Isaac Tigrett, Beth Grant, Marc Princi and the staff of the House of Blues. They have been wonderful to work with and I value their friendships. With their kind permission, I often rearranged their offices in order to make room for a portrait. I thank them with all my heart.

A number of the photos in this book were made on location at the Blue Café in Long Beach, California. Many thanks to Vince Jordan, Ken McClintok and friends for their kindness and enthusiasm for this project. Also necessary to thank is Saul Davis, formerly of B. B. King's in Universal City, California, for the same reason. Thanks to the Ash Grove in Santa Monica, California, for kindly allowing me to photograph Pinetop Perkins and Lester Davenport at their club.

Jerry Pillow from the King Biscuit Blues Festival in Helena, Arkansas, was very helpful in allowing me to work during this wonderful annual event. Also thanks to Rayne Gordon for his kindness.

Thanks to Mike Kappus at the Rosebud Agency, who was instrumental to bringing about John Lee Hooker's contribution to this book.

I'd like to thank my friend and first assistant Astor Morgan who kindly donated his valuable time to collaborate with me on many of the set-ups this book required. His knowledge and professionalism is always appreciated. Also I'd like to thank my assistants Thomas Stratten and Frank Terry for their help.

Ms. Betty Miller, a great friend of the blues, introduced me to many of the subjects that I photographed at the Long Beach Blues festivals. Her generous spirit has been known in the blues world for many years.

Michael Sand at Aperture has always been behind this project and I credit him with a great deal of vision in guiding this project to fruition. Michael Hoffman, Michelle Dunn, Steve Baron, and the staff of Aperture have always been determined to see this book made in such high quality and I owe them all a great debt of gratitude. Being published by Aperture has always been one of my dreams.

Others who were instrumental in making this project a reality include: Agnes Reynaud, Alexa Kate Dunas, Alain Labbé, Amanda Cruise, Anne Donnellon, Barry Dolins, B. B. King, Bill Messer, Billy Boy Arnold, Bonnie Raitt, Bruce Iglauer of Alligator Records, Charlie Holland, Clémence Ajzner, Caroline Choquet, David

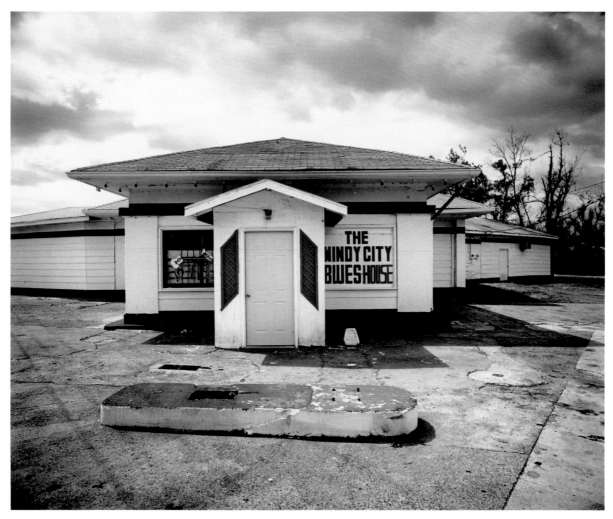

Windy City Blues House, Highway 32, Shelby, Mississippi

Friend, Doug Ingall, Felicia Murray, Frederic and Valerie Oggier, Frederic Huijbregts, Galen Metz, George Pitt, Gordon R. Smith, Goro Kuramochi, Grazia Neri, Guiseppe Damiani, H. G. Von Zydowitz, Hans Figge, Honeyboy Edwards, Howard Stovall of the Blues Foundation, Jean Claude Lemagny, Jeffrey Hersh, Jimmy Dawkins, Jimmy McCracklin, Joe Louis Walker, John Cain of Rounder Records, John Gabrysiak of Monterrey International, Johnny Nugget, John Ruskey, Ken Browar, Ken Damy, Ken Kinsey, Ken Marcus, Koko Taylor, Lisa Coburn, Lou Lamb Smith, Marty Salzman, Matthew Johnson of Fat Possum Records, Michel Gaillard, Michael Going, Michael Murphy Productions, Nancy Bishop, Patty Johnson, Paul Kopeikin, Phil Givant, Phillip Nardulli, Ralph Gibson, Robert Bacall, Ross Whitaker, Rufus Thomas, Sam Lay, Samy & Heddy Kamienowicz, Sonny Payne, The Santa Barbara Bowl, Thomas Bertotti, Thomas Heimdal, Karen Frank, Ian Spanier, Patti Wilson, Tyler Pappas, Jean-Jacques Naudet and David Schonauer of *American Photo* magazine, Dolores Lusitana, Miles Barth, Arich Berghammer, and Teddy Slatus.

Most of all, I thank my wife, Laura Morton-Dunas, for her patience with me as I worked endlessly on this project, for the hours she lost me to the darkroom and the company she kept with me on the many road trips we made documenting the Blues Highway. She acted as my assistant while shooting, prepared excellent meals in a multitude of trailer parks and always offered her help and support and understanding. She has encouraged me since the first portrait and always believed in the book that was to come of it. She is my closest friend and I dedicate this book to her.

For many years I have enjoyed the support of Mamiya France. I've used their cameras since 1982 and consider the RZ-67 to be the best medium-format camera in existence. For this book I used the 90-, 110- and 140-millimeter lenses for the portrait work and the 50mm and 60mm lenses for much of the documentary photography. I also use the Leica M-6 for all my 35mm work. My choice in electronic flash has been Balcar for over 20 years.

I work primarily with Agfapan 400 film. I thank Agfa France and Agfa GmbH Germany for their enduring support of my personal work. All my Agfa film is developed in Rodinal 1:50. Agfa's excellent warm-tone developers complete the process. I've used Forté Polywarmtone paper for the portrait work, and Agfa's excellent Brovira papers for the documentary photography in this book.

174

PORTRAIT INDEX

THE EXHIBITION OF "STATE OF THE BLUES" WILL BE PRESENTED AT
THE DELTA BLUES MUSEUM, CLARKSDALE, MISSISSIPPI, FROM OCTOBER 16, 1998
THROUGH JANUARY 15, 1999; AT THE AFRICAN AMERICAN MUSEUM
IN PHILADELPHIA, PENNSYLVANIA, FROM JUNE 1 TO AUGUST 31, 2000; AND WILL TRAVEL
THROUGHOUT NORTH AMERICA AND EUROPE THROUGH DECEMBER 2002.

A SPECIAL EDITION OF ORIGINAL TONED GELATIN-SILVER PRINTS
OF JEFF DUNAS' PORTRAIT OF B. B. KING, SIGNED BY JEFF DUNAS AND B. B. KING,
IS AVAILABLE FROM APERTURE. THE EDITION IS LIMITED TO ONE HUNDRED PRINTS AND
TWENTY ARTIST'S PROOFS, PRINTED ON 16 x 20" PAPER.

Library of Congress Catalog Card Number: 98-84500
Hardcover ISBN: 0-89381-799-6
Paperback ISBN: 0-89381-843-7

Book design by Michelle M. Dunn
Jacket design by Pentagram

Printed and bound by L.E.G.O., Vicenza, Italy
Separations by Robert Hennessey

The Staff at Aperture for *State of the Blues* is:

Michael E. Hoffman, *Executive Director*
Vince O'Brien, *General Manager*
Michael L. Sand, *Editor*
Stevan A. Baron, *Production Director*
Helen Marra, *Production Manager*
Lesley A. Martin, *Assistant Editor*
Jacqueline Byrnes, *Production Work-Scholar*
Launa Beuhler, *Exhibition Coordinator*

Aperture Foundation publishes a periodical, books, and
portfolios of fine photography to communicate with serious
photographers and creative people everywhere. A complete
catalog is available upon request. Address: 20 East 23rd Street,
New York, NY 10010. Phone: (212) 598-4205. Fax: (212)
598-4015. Toll-free: (800) 929-2323.

Visit Aperture's website at: http:// www.aperture.org

Additional work by Jeff Dunas can be seen at:
http://www.dunas.com

Aperture Foundation books are distributed internationally
through: CANADA: General Publishing, 30 Lesmill Road,
Don Mills, Ontario, M3B 2T6. Fax: (416) 445-5991.
UNITED KINGDOM, SCANDINAVIA, AND CONTINENTAL
EUROPE: Robert Hale, Ltd., Clerkenwell House,
45-47 Clerkenwell Green, London EC1R OHT, United
Kingdom. NETHERLANDS: Nilsson & Lamm, BV, Pampuslaan
212-214, P.O. Box 195, 1382 JS Weesp. Fax: 31-294-415054

For international magazine subscription orders for the periodical
Aperture, contact Aperture International Subscription Service,
P.O. Box 14, Harold Hill, Romford, RM3 8EQ, England.
Fax: 1-708-372-046. One year: $50.00. Price subject to change.

To subscribe to the periodical *Aperture* in the U.S.A. write
Aperture, P.O. Box 3000, Denville, NJ 07834. Tel: 1-800-
783-4903. One year: $40.00. Two years: $66.00

First edition
10 9 8 7 6 5 4 3 2 1